A Room of Their Own

The Bloomsbury Artists in American Collections

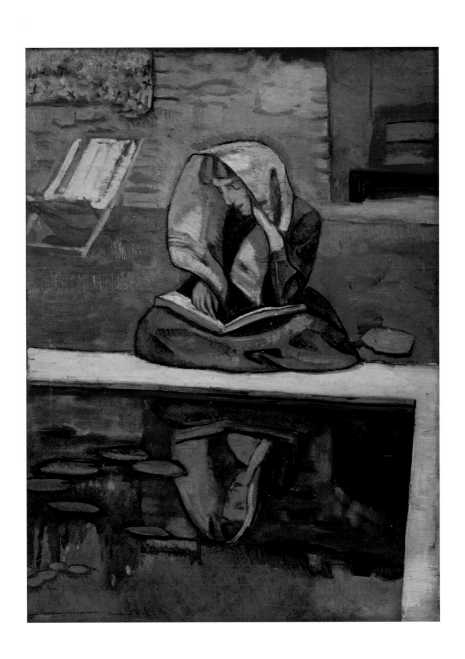

A Room of Their Own

Own

The Bloomsbury Artists in American Collections

Gretchen Holbrook Gerzina
Nancy E. Green
Benjamin Harvey
Mark Hussey
Christopher Reed

Edited by Nancy E. Green
and Christopher Reed

HERBERT F. JOHNSON MUSEUM OF ART · CORNELL UNIVERSITY

This catalogue accompanies an exhibition organized by
the Herbert F. Johnson Museum of Art at Cornell University,
and curated by Nancy E. Green.

COVER: Vanessa Bell, *Virginia Woolf*, ca. 1912 (detail, see cat. 5)

ENDPAPERS: Vanessa Bell, *Design for furnishing fabric*,
ca. 1946 (see cat. 126)

FRONTISPIECE: Roger Fry, *Winifred Gill by the Pool at Durbins*,
1912 (see cat. 42)

BACK COVER: Dora Carrington, from *Portfolio of Woodcuts
for Bookplates*, 1915–20 (see cat. 179)

An earlier version of "Virginia Woolf in America" by
Mark Hussey was published as "Virginia Woolf in the U.S.A."
in *Woolf Across Cultures*, edited by Natalya Reinhold
(New York: Pace University Press, 2004).

Library of Congress Control Number:
2008938122
ISBN-13: 978-1-934260-05-0
ISBN-10: 1-934260-05-3

Published by:
Herbert F. Johnson Museum of Art
Cornell University
Ithaca, New York 14853
www.museum.cornell.edu

Distributed by:
Cornell University Press
Ithaca, New York 14850
www.cornellpress.cornell.edu

Museum editor: Andrea Potochniak ·

This exhibition has been made possible in part by the
National Endowment for the Humanities, promoting
excellence in the humanities.

NATIONAL ENDOWMENT FOR THE HUMANITIES

Any views, findings, conclusions, or recommendations
expressed in this publication do not necessarily represent those
of the National Endowment for the Humanities.

Table of Contents

Exhibition Itinerary

This catalogue accompanies an exhibition organized by the Herbert F. Johnson Museum of Art at Cornell University, in conjunction with the Nasher Museum of Art, Duke University.

This project was organized by the curator, Nancy E. Green, the Gale and Ira Drukier Curator of Prints, Drawings, and Photographs at the Johnson Museum.

Nasher Museum of Art
Duke University
Durham, North Carolina
December 18, 2008 – April 5, 2009

Herbert F. Johnson Museum of Art
Cornell University
Ithaca, New York
July 18 – October 18, 2009

Mills College Art Museum
Oakland, California
November 7 – December 13, 2009

Mary and Leigh Block Museum of Art
Northwestern University
Evanston, Illinois
January 15 – March 14, 2010

Smith College Museum of Art
Northampton, Massachusetts
April 3 – June 15, 2010

Palmer Museum of Art
The Pennsylvania State University
University Park, Pennsylvania
July 6 – September 26, 2010

Lenders to the Exhibition

The Art Institute of Chicago

The Art Gallery of Ontario, Toronto

Lisa Baskin

The Henry W. and Albert A. Berg Collection,
New York Public Library

BNY Mellon

Mitch Bobkin

Leslie and Neil Bradshaw

Mary Ann Caws

Susan Chaires

The Cleveland Museum of Art

The Cornell Museum, Rollins College

Roy and Cecily Langdale Davis

Anne and Allen Dick

Jennifer Eplett and Sean Reilly

Penelope Franklin

Wendy Gimbel and Douglas Liebhafsky

Nancy and Craufurd Goodwin

Jasper Johns

The Herbert F. Johnson Museum of Art,
Cornell University

The Fred Jones Jr. Museum of Art

Dean Malone and Dr. Richard Purvis

Bannon and Barnabas McHenry

Pauline Metcalf

The Metropolitan Museum of Art

The Mills College Art Museum

The Milwaukee Art Museum

The Museum of Modern Art, New York

Mortimer Rare Book Room, Neilson Library,
Smith College

Janice and Roger Oresman

Patricia and Donald Oresman

Mona Pierpaoli

The Harry Ransom Center,
The University of Texas at Austin

William Kelly Simpson

The Smith College Museum of Art

The Speed Museum

Peter Stansky

Douglas Blair Turnbaugh

Victoria University Library, Toronto

Charles Whaley

The Worcester Art Museum

The Wolfsonian–Florida International University

The Yale Center for British Art

Preface

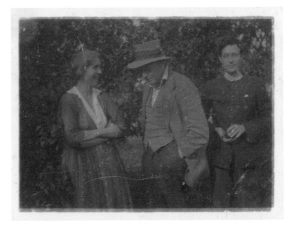

Vanessa Bell, Clive Bell, and Duncan Grant at Charleston. Courtesy of the Harvard Theatre Collection, Houghton Library, Harvard University.

A PROJECT LIKE THIS is never simple, no matter how enjoyable, and thanking the legion of people who have helped with *A Room of Their Own* over the (literally) years it has been in the making becomes an almost daunting task of recall. But without everyone's help, down to those who provided the smallest details, this project would never have happened, so I am very grateful to all those who were involved, on every level.

Firstly, I want to thank two people who were so instrumental in making the exhibition happen. Tony Bradshaw, who runs the Bloomsbury Workshop in London, has been inspiring both scholars and collectors for many years. Nearly two decades ago, I walked into his shop near the British Museum and we began to discuss a potential exhibition almost immediately. While many other projects intervened, neither of us lost sight of the fact that this show should happen "one day," and Tony has been infinitely helpful on every level, offering advice, enthusiasm, and humor.

Equally, over the past fifteen years, I have discussed this project with our director, Frank Robinson, whose support and interest were key to moving this idea to the next level. His introduction of Deborah Gage to me was an additional boon; Debo's enthusiasm, energy, and generosity made it tangibly clear why the restoration of Charleston, the home of Vanessa Bell and Duncan Grant for so many years, was such a success.

This project never could have happened without the generous support of the National Endowment for the Humanities, and I am so very grateful to them for making it possible. I particularly want to thank Clay Lewis, who kindly and patiently responded to my questions and e-mails throughout the application process.

Like many people, I came to the art of the Bloomsbury group through the literature, but two biographies, Frances Spalding's 1983 *Vanessa Bell* and Gretchen Gerzina's 1989 *Carrington: A Life*, made the lives of these two fascinating women come alive for me. Once I had traveled to Charleston, I was thoroughly hooked. The ghosts of so many of the Bloomsbury group still linger there, and the house remains a living monument to their achievements. Though I missed meeting Quentin Bell, I have been fortunate to meet others who still keep the spirit of the place very much alive, particularly Olivier Bell and her daughter Virginia Nicholson, as well as Wendy Hitchmough, Charleston's curator. All of them have been incredibly supportive and helpful.

I was fortunate enough to receive important fellowships from the Paul Mellon Centre in London and the Harry Ransom Center at the University of Texas. These allowed me the luxury of extensive research time with original sources, time that was both precious and profitable, and I remain in their debt for this privilege and the pleasure afforded me by these experiences. Librarians everywhere offered aid, and

I specifically want to thank two who were particularly helpful in my many visits to their institutions: Karen Kukil at the Mortimer Rare Book Room at Smith College, and Patricia McGuire at King's College in Cambridge. I also want to thank the incredibly kind and efficient staffs at Sussex University, the National Art Library, the New York Public Library, the Ransom Center Library, and the Pratt Library at Victoria University. Their help in accessing resources and their thoughtful suggestions about my subject made for a thoroughly enjoyable experience.

My colleagues at other museums have been immensely helpful in making this behemoth take form. I want to thank particularly Kim Bergen at the Wolfsonian, Kim Spence at the Speed Museum, Jane Glaubinger at the Cleveland Museum of Art, and all the staff at the Williamstown Art Conservation Center for their help, sound advice, and good cheer. Kimerly Rorschach at the Nasher Museum, Jessica Hough at the Mills College Art Museum, Corinne Granof at the Block Museum, Aprile Gallant and Linda Muehlig at the Smith College Museum, and Joyce Robinson at the Palmer Museum have all been a pleasure to work with. But above all, I want to thank Anne Schroder at the Nasher, who has shared much of the intense day-to-day process of this project with me and whose advice, good humor, and patience have been invaluable.

A show like this could not happen without the extreme generosity of the lenders, all of whom have helped me at various stages along the way with suggestions, introductions, conversation, and enthusiasm. I particularly want to thank all the private collectors who have willingly agreed to lend works that they live with every day; I know for many of them the works will be sorely missed, and I am grateful that they were willing to lend. But most importantly, this show would have been completely different without the generosity, enthusiasm and interest of Nancy and Craufurd Goodwin. They are key to this exhibition's existence.

I work with a staff that pulls rabbits out of hats on a daily basis. Our registrar, Matt Conway, and exhibitions assistant, Liz Emrich, are magicians in making the details of even mammoth projects like this seem to flow smoothly. Andrea Potochniak, our publications and publicity guru, is a wizard in her own right, juggling dozens of balls, which never seem to hit the ground. Our preparators, George Cannon, Wil Millard, and David Ryan, are masters of creative design and for the elegant look of the show, I have to thank them as well as Gregory McCartney and the staff at Artistry in Wood. Our education team, led by Cathy Klimaszewski, have once again created an array of programming to entice visitors of all ages. To Nancy Haffner and Steve Brosnahan at RBH Multimedia, I offer my sincere thanks for their thought-provoking and thoroughly enjoyable media components.

Our grants coordinator, Rita Townend-Boratav, saw this project successfully through the National Endowment for the Humanities application process, for which she has my deepest appreciation. Photographers Julie Magura and Laura Kozlowski, helped by intern James Orlando, overcame great odds to produce many of the lovely illustrations for the catalogue.

A special thanks to my fellow essayists, Gretchen Gerzina, Benjamin Harvey, and Mark Hussey, for their thoughtful contributions. But it is to Chris Reed, essayist, editor of the catalogue, and a wonderful colleague, that I want to offer my most heartfelt thanks for keeping me laughing, offering important suggestions, and answering my myriad e-mail queries quickly and with humor.

Lastly, I want to thank my husband, Douglas Fowler, who has listened to me, given thoughtful suggestions, made dinners, and fed the cats throughout the entire project.

NANCY E. GREEN
The Gale and Ira Drukier Curator of Prints, Drawings, and Photographs
Herbert F. Johnson Museum of Art

9

Bloomsbury and Art: An Overview

Gretchen Holbrook Gerzina

In the early 1980s, when I was a graduate student at Stanford University, Quentin Bell and Angelica Garnett came to campus to raise money for the restoration of their childhood home, Charleston, in Sussex, England. Most of us at the event were delighted to meet the man whose biography of his aunt in the preceding decade had almost single-handedly revived interest in Virginia Woolf and her circle of relatives and friends. With a characteristically British play on words, he referred to her modern acolytes as the "lupines." Bell's current mission, however, was to resuscitate the house, where his mother, Vanessa Bell, and her companion, Duncan Grant, had painted until the ends of their lives. He showed slides of the house, from its fascinating past to its then fragile and dilapidated present. It was easy to convince us that the house was worth saving as a monument to art and a way of life, but not so easy to raise the money to do so.

Some people in attendance that evening had known members of Bloomsbury. Several were good friends of Quentin and his wife Olivier, of Angelica and her ex-husband David Garnett, of Leonard Woolf; one man had even lived in Virginia and Leonard's Sussex home, Monk's House, where his daughter took lessons on the Woolfs' piano. The friends and relations who made up Bloomsbury had been argued over, dismembered, dissected, and fetishized, so it was wonderful to have among us ordinary people who grew up in an extraordinary place and in an extraordinary way, and to be reminded that at the center of their world was art.

The changes that came to British art at just the time that Vanessa Bell and Duncan Grant were

becoming artists have been described in various ways. Bell—then Vanessa Stephen—entered the Painting School of the Royal Academy in 1901; her biographer, Frances Spalding, writes that it must have been "much like visiting an elderly relative: it was all very familiar."[1] Neither the professors, nor the methods, seemed to have changed much since the Academy's eighteenth-century origin. About the same time, in 1902, Duncan Grant also entered art school in London, at the Westminster School of Art. His surviving early paintings—primarily still lifes and portraits—show a darkness of palette and, like Vanessa's, display a reliance on tradition that would soon undergo a radical change. Vanessa, with her sister Virginia, was freed by the death of their demanding father in 1904. Although still mourning the earlier losses of their mother and sister, for the Stephen sisters "the Victorian scene… and much else went out of the window as it opened, gradually but firmly, onto a different landscape."[2] They moved with their brothers to 46 Gordon Square, where a newer way of life and art opened for them.

What we now call Bloomsbury was at first composed of Vanessa and Virginia and their brothers' Cambridge friends at Gordon Square. Grant was a regular visitor, as was his cousin Lytton Strachey. There, the characteristics that came to define the group developed: conversation, a commitment to the arts, and a determination to find a more congenial way of life that never entirely shook off its Victorian origins. Angelica Garnett later commented that life at Charleston was not entirely bohemian, despite its unconventionality: they had

full-time servants and dressed for dinner, after which the men smoked cigars and drank brandy while Angelica played the piano.[3]

Still, from its earliest days, Bloomsbury turned tradition on its head. Unmarried men and women lived together and conversed together without chaperones. There were parties and love affairs, art galleries and long days spent with the pen and the brush. However, the biggest change awaiting them came in the form of a critic and fellow painter, Roger Fry. His perspectives on ancient and modern art, on painterly ways of seeing the world, affected the painters and writers alike.

Virginia Woolf's famous statement "that on or about December, 1910, human character changed"[4] is now generally taken to refer to an art exhibition organized by Fry and Clive Bell at the Grafton Galleries. Now known as the First Post-Impressionist Exhibition, it ran from November 1909 until February 1910, and the publicity it aroused introduced the British public—an audience barely acquainted with Impressionism—to the works of Cézanne, Matisse, Picasso, and Gauguin. The show became an immediate cause célèbre, reviled in the press, laughed at by those who went in order to declare that their children produced better art, denounced by others who found the colors and lines and lack of narrative shocking, even obscene. Professors at the Slade School of Art, where a young woman who had dropped her first name and was called Carrington was studying, forbade their students to visit the exhibition, since the works on display ran contrary to all of the Slade's teaching.

Addressing the public's discomfort with this new art, Fry went to great pains to explain that this new way of seeing, of representing the truth of what the artist actually saw, made sense:

> Anyone who will look, without preconception, merely at the general effect of the walls of the Grafton Gallery must admit that in no previous exhibition of modern art has the purely decorative quality of painting been more apparent. If only the spectator will look without preconception as to what a picture ought to be and do, will allow his senses to speak to him instead of his common-sense, he will admit that there is a discretion and a harmony of color, a force and completeness of pattern, about these pictures, which creates a general sense of well-being.[5]

The painters of Bloomsbury, who had known and admired Fry for some time, had already begun to take to heart these ideas of "what a picture ought to be and do," and were already "allowing their senses" to speak. With solid traditional training behind them, they began using bolder brushstrokes and colors. This new approach also affected the way that other people in Bloomsbury, and England, began to look at art, even if they were not artists themselves. When Fry talked about a Cézanne painting, Virginia Woolf commented, "the apples positively got redder & rounder & greener."[6]

So, too, did Bloomsbury's paintings, as new pinks, greens, and ochres found their way onto canvases. Bell's 1915 portrait of Mary St. John Hutchinson (cat. 9), formerly in Kenneth Curry's collection, is worked entirely in these colors, with the startling addition of teal blue in the eyes where the whites should be and an elongated, slanting, curved shape of the body. In Grant's 1915 portrait of Bell, *At Eleanor* (cat. 72), now at the Yale Center for British Art, Bell's face, reflected in the colors of the armchair in which she reclines, is rendered in mauve and ochre. Fry's landscapes, such as the 1912–14 *Winter Landscape* (cat. 44), also from Curry's collection, took on the architectonic qualities of Cézanne's paintings. Duncan Grant's many paintings of dancers show the influence of Matisse and the other Fauves. When Fry mounted the Second Post-Impressionist Exhibition in 1912, Bloomsbury works hung alongside those of the French painters.

Yet it would be difficult to suggest a single influence, or even several, on Bloomsbury's art. It was as though after years of training in traditional techniques, a window had opened, allowing all winds to blow in. With delight and yet utter seriousness, they tried out, on their canvases and boards, the forms and colors from all continents. Thus we find them, and other young painters of their time, experimenting with African shapes, French light and coloring, Byzantine portraiture, and Greek nudes. They flirted with color, Pointillism, Cubism, and abstraction. In looking forward they also looked back, sometimes to the work of cultures about which they knew little, but the forms of whose art they admired, as when Virginia and Vanessa's brother Adrian Stephen and his wife collected African sculpture. From the very beginning, their work spilled over into the decorative arts.

Fry's other major influence on Bloomsbury art was in domestic design. Together, Fry, Grant, and Bell opened the Omega Workshops in 1913, hoping to change the way people began to think about decoration. Eschewing factory-created Victorian clutter, the Omega championed the original, the handmade, and the colorful, and put paint on nearly any surface. Textiles blossomed in the form of rugs, dresses, and chair cushions. Ideas taken from European frescoes were transferred onto tables, chairs, and screens. Influenced by music and ballet (Nijinsky and the Ballets Russes were all the rage), the Omega artists threw themselves headlong into breathing life and light and air and color into the staid and the stodgy.

In the preface to the Omega catalogue, Fry argued—sometimes in a primitivizing language that makes us wince today—that in introducing the influences of "primitive art" he was doing nothing less than redefining the definition of the artist and the consumer of art: "The artist is the man who creates not only for need but for joy, and in the long run

mankind will not be content without sharing that joy through the possession of real works of art, however humble or unpretentious they may be."[7] With that, he declared that art needed to be available to everyone, even at home.

At the Omega no single artist took credit for any single piece, since the point was to create beautiful and singular utilitarian and decorative works without signatures. Their showrooms gave ideas for entire rooms, with tables, chairs, rugs, curtains, and clothing all displayed together. Few of these Omega pieces survive, except in photographs, a fact attributed for many years to the artists' enthusiasm for painting on inexpensive pieces of furniture. Art critic Richard Shone disputes the myth that Omega works disappeared because they were painted on shoddy products, and Christopher Reed points out that it was Bloomsbury that first initiated this myth as a way of distinguishing their more spontaneous work from the more regimented work of the Victorians.[8] The disappearance of Omega objects more likely reflects the fact that these items were meant to be used, rather than displayed as precious art.

Although the Bloomsbury artists were, as Angelica Garnett later said, primarily easel painters, it is easy to see how they took the Omega ideals to heart and into the fabric of their domestic lives.[9] For many of those interested in Bloomsbury, Charleston, the home of Vanessa Bell, Duncan Grant, Vanessa's children, and others, *is* Bloomsbury's greatest work of art. Over the years after they moved into it in 1916, the house became a canvas for decoration. The artists playfully transformed the house, in which no surface went untouched. But they were serious in their belief in the way a house itself influenced art: one's surroundings provided not only aesthetic pleasure, but also inspiration for other forms of art. Thus walls were a joy to look at, but having congenial surroundings also inspired the creative impulse.

Describing one room, Quentin Bell wrote, "the face of Charleston is to be painted and it was here…that the mistress of the house first took a brush and, with a few sure-handed strokes across the window embrasure, brought Charleston into the Post-Impressionist world."[10] From those first few brushstrokes blossomed, surface by surface, a new extension for their work. Patterns climbed the walls and fireplaces; rugs designed by Duncan were stitched by his mother; chairs were upholstered in fabrics re-created in the 1980s by Laura Ashley; the round table around which they had their meals sported their designs. And everywhere else their paintings hung, along with those of other painters. For Bloomsbury's painters, art and life were one and the same, and they produced painting after painting: portraits of family, friends, and employees, flowers from the garden, landscapes of Sussex and France. Charleston is now a tourist destination, painstakingly renovated and preserved, and those who visit come away with a deep sense of how the occupants lived. While this exhibition pulls together the many works of Bloomsbury that migrated across the Atlantic, it is only when one sees the art in the places where it came from that one really understands the paramount position of art for the group.

Christopher Reed writes in this volume that many who became enchanted (if that is the word) with Bloomsbury came to that appreciation through literature, usually the novels of Woolf, secondly through the much-discussed gossip about their fluid romantic and sexual relationships, and often only thirdly through the visual arts. That is not how it happened for me, however. Before going into the PhD program at Stanford, I read with fascination about Bloomsbury's way of seeing life. I knew long before I entered graduate school that someday I would write about Carrington, the original young painter whose life and work often seemed a coda to the "great" "Bloomsberries," even though she made

a home with, and for, Lytton Strachey. I remember reading about her in Leon Edel's gossipy *Bloomsbury: A House of Lions* the year I applied to my graduate school. Who was this young "boy-girl from the Slade School with strong lesbian…leanings and marked ability as a painter"?[11] I longed to know more, and after reading Michael Holroyd's biography of Strachey, I turned to David Garnett's edition of her delightful illustrated letters,[12] and her brother Noel Carrington's little edition of her art.[13] There, I found a talented woman who often worked in isolation, without much encouragement from others in Bloomsbury, and whose life resonated with so many women I had known in the 1960s and '70s. As with my generation, there was a history of resistance to a terrible war; a break from the terrible social and domestic restrictions of their parents' generation; a fierce desire to find a new communal and creative way of life; a dedication to her work.

Trained at the Slade from 1910—the year of the first Post-Impressionist Exhibition, and when Woolf pronounced the change in human character —Carrington was the first of the women there to lop off her hair as well as her first name. She was both dedicated to and diffident about her work, which formed the center of her life, but which she rarely let others see. She played less with passing trends than Bell or Grant, preferring landscapes, portraits, and flowers. Her painting of her father, for example, shows deep love but also great skill, but when she was invited to paint Lady Strachey, Lytton's mother, the other Bloomsbury painters tried, unsuccessfully, to share the sittings.

Although I entered an English department, I wanted to find a way to incorporate Carrington into my own work. I was fortunate in my directors: Lucio Ruotolo was the Woolf scholar who had lived in Monk's House and was a friend of the Bells, and Will Stone had written a book on Forster and knew the Garnetts. Because Carrington had been inserted

as a character in several novels, I had my literary connection. My dissertation explored the reasons for her work being virtually ignored by others in the Bloomsbury group, despite her spending her adult life with one of them. When S. P. Rosenbaum, editor of the comprehensive anthology *The Bloomsbury Group* at the University of Toronto, suggested that I write her biography, I threw myself into it.

I saw a few of Carrington's paintings—her portrait of E. M. Forster hangs in the National Gallery in London, for instance—but it wasn't until my visits to Carrington's brother Noel and his wife, Catharine, at their cottage that I got the full impact of the work. On their walls hung the Carrington paintings I'd only seen in books: the portraits of their father and their brother Teddy, who died in the war; the house at Watendlath, in Wales, where she first went away with Lytton; their first home in Pangbourne; the young boy musician in Spain, the paintings of flowers. I also saw the influence of her manner of domestic life in the pottery bowls on the bookshelves, and in the bathtub, surrounded by tiles Carrington had painted, carefully removed and transplanted to this new home. We sat in the garden and talked for hours, and on my last visit Catharine showed me a lock of Carrington's hair. She also sold me a drawing.

Over the years of working on the biography, I got to know many others connected to Bloomsbury. The first time I met him, Michael Holroyd, Strachey's biographer, gave me tea in his house, with Stephen Tomlinson's bust of Woolf in the room. I met both of Quentin Bell's daughters. I visited Carrington and Strachey's home, Ham Spray, where the owners had hung reproductions of Carrington's paintings on the walls, and I spent many happy hours in Tony Bradshaw's store, the Bloomsbury Workshop. In long evenings in art dealer Sandra Lummis's homes, we looked at paintings by Fry and Bell and Grant; another of

Tomlinson's busts of Woolf stood there. I got to know the Bloomsbury biographers Frances Spalding and Hermione Lee. Later, in America, I met a friend in whose library sits Virginia Woolf's writing desk, decorated by Quentin Bell (cat. 109).

Most importantly, I became a friend of Frances Partridge, the remarkable woman who married Carrington's husband after the artist's suicide. Off and on for nearly twenty years I would visit whenever I was in London. We drank tea in her sitting room, with Carrington's famous portrait of Strachey on the wall, and the mantel holding more of Carrington's work. Sometimes we talked so long that the tea was exchanged for gin, and once or twice we continued on through dinner. Our talk ranged over Frances's life and modern times, and issues like race, since I am of mixed racial heritage. During those long visits, Bloomsbury was very much alive.

The last time I saw Frances, I waited at her doorstep in Belgravia. A minicab pulled up, and the black driver carefully helped her out of the car and up the stairs. She thanked him gratefully—she was over one hundred years old—and as I watched them I could not help but wonder what Clive Bell and Roger Fry, who wrote so loftily about primitivism and savages, would have made of modern London, in which real people replaced stylized images.

I thought I had put Bloomsbury and its art behind me, but when I was asked to write this introduction I began to take stock of its influence on my own aesthetic sense. Looking around my house I saw a Duncan Grant drawing, a Carrington drawing, and a painting attributed to her. In my bathroom hangs a shower curtain made of the reproduction fabric originally designed by Grant for Charleston. Books about them sit on my shelves. Bloomsbury has indeed found homes in America.

What I learned when Quentin Bell and Angelica Garnett came to Stanford was that

Bloomsbury was not an intellectual abstraction, but something that happened to real people. As Quentin and Angelica spoke that day, it became clear that these were people to whom the mind, the aesthetic sense, and the dailiness of life were all interconnected with family, friends, and art. This is something that we, in our modern academic approaches to Bloomsbury, would do well to remember and appreciate.

NOTES

1 Frances Spalding, *Vanessa Bell* (New York: Harcourt Brace Jovanovich, 1983), 33.

2 Richard Shone, *Bloomsbury Portraits: Vanessa Bell, Duncan Grant, and their Circle* (Oxford: Phaidon, 1976), 22.

3 Angelica Garnett, interviewed in *A Painter's Paradise: The Restoration of Charleston Farmhouse*, Channel Four Television, 1989.

4 Virginia Woolf, "Mr. Bennett and Mrs. Brown," in *The Captain's Deathbed and Other Essays* (New York: Harcourt Brace Jovanovich, 1950), 96.

5 Roger Fry, "The Grafton Gallery-1," in *A Roger Fry Reader*, ed. Christopher Reed (Chicago: University of Chicago Press, 1996), 88.

6 Virginia Woolf, *Diary*, I, 18 April 1918: 140–41. Quoted in Hermione Lee, *Virginia Woolf* (London: Chatto & Windus, 1996), 290.

7 Quoted in Isabelle Anscombe, *Omega and After: Bloomsbury and the Decorative Arts* (London: Thames and Hudson, 1981), 32. Not only is the artist a "he," but the preface refers to "the negro savage of the Congo."

8 Richard Shone, in *A Painter's Paradise*. He is taking issue with Anscombe (among others), who wrote in *Omega and After* that the "cupboards and tables…were obviously cheaply produced" (28). Christopher Reed, *Bloomsbury Rooms: Modernism, Subculture, and Domesticity* (London: Yale University Press, 2004), 121.

9 Angelica Garnett, in *Painter's Paradise*.

10 Quentin Bell and Virginia Nicholson, *Charleston. A Bloomsbury House and Garden* (New York: Henry Holt, 1997), 24.

11 Leon Edel, *Bloomsbury: A House of Lions* (New York: Avon, 1979), 249.

12 David Garnett, ed., *Carrington: Letters and Extracts from her Diaries* (New York: Holt, Rinehart and Winston, 1971).

13 Noel Carrington, *Carrington: Paintings, Drawings and Decorations* (New York: Thames and Hudson, 1980).

From Little Holland House to Charleston: Bloomsbury's Victorian Inheritance

Nancy E. Green

"It is by imagination that we mostly live, after all."
—JAMES RUSSELL LOWELL[1]

BLOOMSBURY'S IMPACT on the fields of literature, criticism, and art has granted the group an almost mythic stature, prompting a torrent of conflicting responses from both sides of the Atlantic. Usually left out of discussions of Bloomsbury—or, if mentioned, invoked in a denigrating manner—are the valuable precedents in the Victorian era that provided initial stimuli (and, in some cases, role models) for the group, and, later, criteria to react against. It is, however, the ingrained dependency on the familiarity of home—often contradicting the modernist conception of the solitary creative impulse, negligent of friends and family—that ties Bloomsbury most closely to the previous generation.

For Virginia Woolf and her sister, Vanessa Bell, their Victorian great-aunts, the famous Pattle sisters, nourished their childhood concepts of community. So, too, did two of their family houses—Little Holland Park, home to Sara Prinsep and her family; and Dimbola in Freshwater, home to Julia Margaret Cameron, on the Isle of Wight[2]—and their own mother's Sunday afternoon at-homes in Hyde Park Gate. Their aunt through marriage on their father's side, Anny Thackeray Richie,[3] daughter of William Makepeace Thackeray, had as a young girl been a close friend of Julia Margaret Cameron, and later recorded what life at Freshwater, with its Morris wallpapers (Cameron was an early enthusiast of his style) was like in the 1860s:

> [It] was a life peculiar to the place, quiet and self-contained, completely out of the world, and yet at the same time in touch with its larger interests. In this green and sunshiny little republic each person went his own way, following his own bent.... Something of what William Morris has done for the homes of intelligent people; what the aesthetic school ought to have done (only it took too long a step towards the sublime), these ladies [the Pattle sisters] were the first to suggest and what some of her sisters did for everyday life, Mrs. Cameron devised for the world of beautiful shadows which she loved so dearly.[4]

Like Richard Avedon or Annie Leibovitz over a century later, Mrs. Cameron was *the* portrait photographer of her generation, and she created iconic images of many of the great Victorians. William Morris seems to have been one of the few to avoid her lens; in an 1869 letter he wrote: "I have never mustered courage enough to get my photograph taken; I suppose I shall soon; Mrs. Cameron threatened me with the operation, but it has not come off yet, though I don't suppose I shall escape long."[5] While "escape" may seem like a strong word to associate with having one's picture taken, Cameron reputedly locked one sitter into a cupboard for several hours for a picture called *Despair*, "to obtain the appropriate expression."[6] Julia Margaret

Cameron's favorite (and, some would say, most successful) model was her niece and namesake, Vanessa's and Virginia's mother, Julia (figs. 1a, b). Despite the "Bloomsberries'" tendency to reject the Victorians, it was Roger Fry and Virginia Woolf who resurrected interest in this eccentric relation when the Hogarth Press published their tribute to her, *Victorian Photographs of Famous Men and Fair Women*. As the title implies, they connected Cameron to the penchant for a romantic medievalism so popular in the Victorian era (and in her photographic subjects), particularly among the supporters of the Pre-Raphaelite group.

Virginia wrote of her great-aunt with affectionate humor, admitting, "There were visitors who found her company agitating, so odd and bold were her methods of conversation, while the variety and brilliance of the society she collected round her caused a certain 'poor Miss Stephen' to lament: "Is there *nobody* commonplace?" as she saw Jowett's four men drinking brandy and water, heard Tennyson reciting *Maud*, while Mr. Cameron wearing a coned hat, a veil, and several coats paced the lawn which his wife in a fit of enthusiasm has created during the night."[7] This picture of an extravagantly lived life in an age that seemed to breed eccentrics, many of them her own relatives, appealed to Woolf's humor; she affectionately lampooned it in her 1923 play *Freshwater*. Even her brother-in-law, the irascible Clive Bell, detected the photographer's appeal:

> Mrs. Cameron was an artist, with a nice gift for selection and a sure sense of design. Also she possessed the sensitive vision of a painter. She looked for significance everywhere and generally found it. Never, I think, did she fall into the vulgar error of supposing that what the average man sees is all that there is to be seen.… Once I showed some of her work to Derain. He became unwontedly enthusiastic and exclaimed

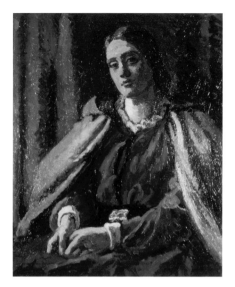

FIG. 1a
Vanessa Bell, *The Red Dress*, 1929. Oil on canvas, after a photograph by Julia Margaret Cameron.

FIG. 1b
Julia Margaret Cameron (British, 1815–1879), *Julia Duckworth*. Albumen print reproduced in *Victorian Photographs of Famous Men and Fair Women*, Hogarth Press, 1926.

suddenly—"*C'est le perfectionnement de l'appareil qui a tout gâté*" [It is the perfection of the apparatus that has ruined everything].[8]

The lives of the Pattle sisters were so closely intertwined that their circle was known as "Pattledom," not unlike the epithet of "Bloomsberry" applied to their descendants. As historian Clarissa Campbell Orr has said, "Their upper class Bohemian style was tolerated within high society. Nevertheless, although a sophisticated woman like Lady Charlotte enjoyed the atmosphere of Little Holland House, she would not allow her daughters to do so: 'I know there cannot be a worse place to go alone than Little Holland House, amidst artists and musicians—and all the flattery and nonsense which is rife in that (otherwise) most agreeable society,' she declared."[9] The Stephen girls inherited their great-aunts' disdain for so-called Victorian propriety and would certainly have appreciated their openness, particularly after their own remove to Bloomsbury and the corresponding negative response of their parents' friends and their own half-brothers.

Bloomsbury's counterpoints to Freshwater and Little Holland House were Gordon Square in the Bloomsbury section of London and, most particularly, Charleston Farmhouse in Sussex, which provided a rural haven. With very little revamping, much that was said of social life at Freshwater in the 1860s and Little Holland House a decade later could be said of the life Vanessa Bell established at Charleston for her family and friends in the 1920s.

While rejecting the straitlaced morals and cultural milieu of their parents, the Bloomsbury artists were (with the possible exception of Dora Carrington, who was born in 1893 near the end of Victoria's reign) clearly formed in the Victorian mode, and they retained unambiguous ties to these connections.[10] The Holland Park and Freshwater circles of artists and writers bred eccentrics as controversial as those in Bloomsbury itself. These Victorian women, who went beyond the bounds of expected feminine behavior, gave Virginia and Vanessa strong role models. Sara Prinsep was a leading hostess, who at Little Holland Park entertained and supported many of the artists and writers of the day—including the painter G. F. Watts, who, it was said, came for a three-day visit and stayed thirty years. Prinsep's other frequent guests included the young actress Ellen Terry, Rossetti, Browning, Carlyle, and Tennyson; Edward Burne-Jones, whom she nursed to health after a debilitating illness, was a close friend of her son Valentine Prinsep.[11] When William Morris first married the socially inferior but beautiful Jane Burden, Sara Prinsep took her under her wing.[12] As Ellen Terry remembered, "Little Holland House, where Mr. Watts lived, seemed to me a paradise, where only beautiful things were allowed to come. All the women were graceful and all the men were gifted."[13] One can only assume that, as in Lake Woebegone, all the children were above average.

The Bloomsbury artists' attitude toward the Victorians was, much like our own in the twenty-first century, a half-ironic, half-fond identification. The Industrial Age brought rapid and radical changes to the Victorians' lives, creating an intense longing for a purer time when life was simpler and perceived as more romantic, with an element of "back-to-the-land" nostalgia. Many in Bloomsbury played out this dynamic with pieds-à-terre in London and a country home to retreat to, with its healthful environment conducive to painting, writing, and raising children.

In many ways, it was the Victorian environment of their parents, with its romantic Pre-Raphaelite vision of fair maids and distinguished men, that nurtured the childhoods of the Bloomsbury artists. Roger Fry, in his youth, was a close friend of C. R. Ashbee, the founder of the Guild of Handicraft, and his vision for the Omega Work-

shops was clearly based on a nineteenth-century Arts and Crafts model.[14] Like the Pattle sisters, the Stracheys and their cousin Duncan Grant were products of the British Raj system in India and were nurtured in this exotic atmosphere. Even Carrington's background, which was decidedly middle-class, boasted a father who had been a civil engineer for the Far East India Company for over thirty years before returning to England and marrying her mother. Carrington seized upon the adventurous and exotic aspect of this legacy to counter the otherwise repressive Victorian inheritance she associated with her mother. Others in Bloomsbury were similarly enabled by an intellectual inheritance from their Victorian ancestors who were, on the whole, more liberal than most of their contemporaries, questioning conventional religion, ideas, and ideals.

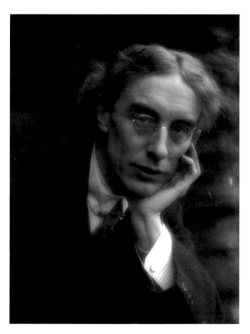

FIG. 2
Roger Fry, by Alvin Langdon Coburn (American, 1882–1966). Courtesy of the George Eastman House.

"In so far as taste can be changed by one man, it was changed by Roger Fry."
—SIR KENNETH CLARK, 1934[15]

The father figure of the Bloomsbury group was indisputably the multitalented Roger Fry (fig. 2), the artist, critic, entrepreneur, and connoisseur who, at Cambridge in the 1880s, had trained for a scientific career, something he would have undoubtedly made a success of, having attained a double first in Natural Science. While putting aside this career for art, Fry never rejected his university training. Craufurd Goodwin notes, "Tension between the contrasting methods of art and science presented a continuing challenge for Fry over his life, which he tried to resolve by bringing the two together whenever possible. For the arts he developed a theory of aesthetics that was intended to explain the behavior of both artist and patron of the arts. In his science he reflected some of the behavioral characteristics of the artist, in particular paying scant attention to disciplinary lines and rules. He was by preference more a theorist than an experimentalist, but he played both roles with gusto."[16] Clive Bell qualified him as "the most open-minded man I ever met: the only one, indeed who tried to practice that fundamental precept of science—that nothing should be assumed to be true or false until it has been put to the test. This made him willing to hear what anyone had to say even about questions on which he was a recognized authority, even though 'anyone' might be a schoolboy or a housemaid."[17] Fry understood the infinite possibilities, and his success as a critic can be attributed to his quest for objectivity.

Fry was born to well-to-do Quakers; his father was a knighted lawyer who, in 1883, became a Lord Justice of Appeal. In October 1885, Roger went to Cambridge where, in 1887, he was elected to the secret society, the Apostles;[18] following university,

having convinced or, at the least, persuaded his father to let him try his hand at being an artist, he studied at the Académie Julian in Paris[19] and traveled extensively in Italy. He met and married his wife, the Arts and Crafts designer Helen Coombe, and wrote his first, important book of art criticism, on Giovanni Bellini, during Victoria's reign. He was thirty-five when Edward ascended the throne, and he could easily have remained tied to the era of his youth.[20] But his scientific training kept him restlessly inquisitive—so much so that his Bloomsbury friends took advantage of what they saw as his gullibility by playing practical jokes on him—as he continued to pose questions to himself and those around him, searching in his profoundly honest and unbiased manner for new answers.

Fry was in many senses a visionary, unafraid of risks or of reexamining his position on many issues, publicly admitting changes in his attitudes. It was perhaps in his lectures, though, that the agility of his intellect could be most appreciated (fig. 3) and certain themes recurred in these public talks throughout his life: the relationships of art to religion,[21] of representation to design, and of art to life. His homes—both Durbins, near Guildford, built in 1909 with the hopes of bringing Helen there to live a quiet, settled life in the country; and the house on Dalmeny Avenue in London where he moved after leaving Durbins in the financial debacle of the Omega[22]—reflected the personality of the man. Vanessa Bell recalled Durbins, which had been inspired by A. H. Mackmurdo's style: "It was built on the side of a hill and faced south and seems to me in memory to have been nearly always filled with blazing sunshine.... The floors were bare polished wood with rugs, the walls were pale greys and dull greens, the doors and all the wood a smoky brown, unpainted. I came to think the house perhaps one of Roger's most successful works, for everywhere it depended on a most carefully balanced proportion."[23] In planning the garden for Durbins, Fry consulted his neighbor, Gertrude Jekyll, whose garden designs have come to epitomize the English garden of the Edwardian era. Jekyll would have appealed to Fry, for she was, like him, an active participant in the art of which she wrote so eloquently, not merely an observer—she was "never separated from the practical efforts of the gardens that she created for herself and for others, [and] returned to her own garden over and over again not just to plan or plant but to write on location—not from the scrim of memory. Two times a month she would pick a spot and sit there for a while, saturating herself in its sights and scents."[24]

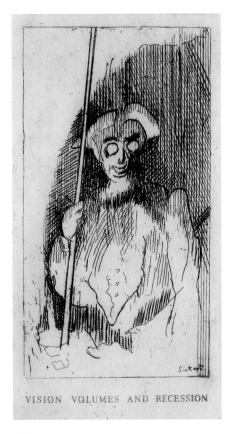

VISION VOLUMES AND RECESSION

FIG. 3
Walter Sickert, *Vision Volumes and Recession*, ca. 1923, published 1929. Etching, 7⅞ × 4⅜ inches. Collection of Peter Stansky. This is based on a drawing Sickert made around 1911–12 of Roger Fry lecturing.

Such a scene puts one in mind of the kind of concentration Fry notoriously brought to bear when assessing a painting.

Along with Ashbee (fig. 4),[25] at Cambridge, Fry's closest friend was Goldsworthy "Goldie" Lowes Dickinson. Their arrival at university coincided with a particularly fertile era at Cambridge, described by their mentor, the socialist Edward Carpenter, as "a fascinating and enthusiastic period —preparatory, as we now see, to even greater developments in the twentieth century. The Socialist and Anarchist propaganda, the Feminist and Suffragist upheaval, the Huge Trade-union growth,

FIG. 4
C. R. Ashbee by Frank Lloyd Wright, December 1900. Courtesy of Alan Crawford. Courtesy of Felicity Ashbee and the Frank Lloyd Wright Estates.

the Theosophic movement, the new currents in the Theatrical, Musical and Artistic world, the torrent even of change in the Religious world—all constituted so many streams and headwaters converging as it were, to a great river."[26] Many of these same issues continued to engage Fry and other members of Bloomsbury well into the next century.

Carpenter (fig. 5) was an important conduit for Fry and his friends who all went to visit him in his home at Millthorpe. Though "temperamentally the least susceptible of the three friends, [Fry] was soon describing Edward Carpenter as quite one of the best men he had ever met."[27] Eventually, Ashbee and Fry differed in their response to Carpenter's socialist views, and they continued to debate these issues in their correspondence after they left Cambridge.

On April, 26, 1886, Ashbee wrote to Fry: "No, you seem to me most completely wrong when you say 'tis easy to be 'hopeful, not to say enthusiastic about England's future'—(poor England…thanks you for your confidence in it)—to me it seems the most difficult thing in the world to be optimistic just at the present time." Later in the same letter, Ashbee says, "There was nothing so strongly impressed upon me while discussing the universe with Edward Carpenter, than the feeling of this sense of transition, & I believe that till one has fully realized the *fact of transition* one *must* be pessimistic.…"[28]

FIG. 5
Roger Fry, *Edward Carpenter*, 1894. Oil on canvas, 29½ × 17½ inches. Courtesy of the National Portrait Gallery, London.

In some ways, Ashbee proved the more democratic in his approach, taking his cue from Morris and Ruskin. After Cambridge he went to work at Toynbee Hall, the Settlement House in London's poverty-stricken East End. There he gave classes on Ruskin's teaching and started the Guild of Handicraft, which trained local boys to be skilled craftsmen; Fry was enlisted to teach them drawing. In an effort to expand his educational offerings, Ashbee invited leading writers of the day to come and speak, Leslie Stephen among them.[29] Fry's reaction to Carpenter was always tempered by a Morrisian aesthetic ideal, and he wrote to Ashbee about his own attitude: "There is a standard of beauty somewhere, and if there is not, the sooner we chuck the whole business the better. Just as to a morally-minded person it is inconceivable that there is not a right and wrong absolutely, to which we constantly approximate, so to the artistically-minded man it is inconceivable that we have not got something at which we constantly aim."[30]

Among the most significant of Fry's Victorian connections was his wife, Helen (fig. 6). Fry first met Helen Coombe in 1896, when Edward Marsh[31] brought her by 29 Beaufort Street where Fry was renting a flat with the writer R. C. Trevelyan, in order to introduce her to the poet. Though the latter was out, Fry was at home, and he seems to have immediately been smitten by the woman whom Bloomsbury biographer Frances Spalding described as the "tall, large-limbed creature whose slow movements and seeming nonchalance hid a quick wit and an instinctive intelligence."[32] Marsh, who could not decide if she was beautiful or not, finally temporized, saying, "She is so completely out of the common that the question of beautiful or ugly scarcely seems to me to arise…. Her personality is out of my ken altogether, I feel it as something mysterious and grandiose made human by her frank and generous humour. Her aloofness and impenetrability give way at once on any common ground of fun…."[33]

FIG. 6
Helen Fry, ca. 1895. Courtesy of Frances Spalding.

Helen Coombe seems to have made a distinct and favorable impression on nearly everyone she met; C. R. Ashbee described her as "one of the most interesting and attractive women I knew in London…. She was an artist herself of real talent, but she was also a musician and played for a time with the Dolmetsches, of whose domestic life she could give lively sketches. Tall and graceful with pale wavy hair and light blue eyes, she suggested a Norse goddess, but she was clever and witty and excellent company."[34] Vanessa Bell retained a memorable first impression, writing thirty years after she first met the Frys: "I suppose it was about 1902 or 1903…. I remember one summer afternoon in the Fellows Garden at King's seeing across the lawn two tall figures, the woman perhaps taller than the man and certainly looking so in her long straight dress. 'Those are the Roger Frys,' said Walter Headlam."[35]

Helen came from a large family and, after her father's early death, left home to train as a painter and stained glass designer, which she studied under the renowned Arts and Crafts stained glass artist Christopher Whall. This resulted in the "Mary and

Martha" window in the south aisle at High Cross Church, Hertfordshire. In the 1880s, she became very involved with the Century Guild, established by Herbert Horne and A. H. Mackmurdo in Fitzroy Square, later the home of the Omega, and did her most successful work inspired by this association. Years later Horne and Fry met again, working for the *Burlington Magazine*, an outgrowth of Horne and Mackmurdo's publication, *The Hobby Horse*.

As witnessed by their letters to each other, Roger's and Helen's romance was occasionally fraught, not least because of what Roger worried about their two temperaments "both strongly individual finding a meeting point."[36] In another undated letter from the same period, he expounds in more detail: "You who live in appearance & care nothing about the *whyness* of the *what* to whom. The what is sufficient—I who am always grubbing in the entrails of things to find out their causes. I who believe in reality you don't. Yes all that makes it very difficult but not impossible." Helen, in a letter just prior to their marriage, expresses concern about the attitude of his family, particularly of his father, accusing him of being more interested in her lack of social position than in what she is as a person: "If you think you can't go through with all the worry about my people's position & all that, just say so now and I'll not say a word—that I can assure you. Please take this suggestion quite seriously."[37]

Roger Fry was too far committed to want to back out at this point, and their relationship intensified over Helen's greatest project, the so-called "Green Harpsichord" (figs. 7, 8) that she decorated for the celebrated musician Arnold Dolmetsch,[38] which today remains a glittering glimpse of what she might have achieved had her subsequent years been unmarked by mental illness. Her letters to Fry during much of 1896 are filled with references to the harpsichord project, asking for help and suggestions for her design—which he was glad to supply—and

about the vexing problem of finding fritillaries to draw from: "That's stumping me more than anything: is there a kind of botanical florist where one could order them?" and, in another letter, "I think I am too late for the fritillaries & shall have to go to the museum & make drawings from herbals." On July 18, 1896, she records that Dolmetsch "tries to keep me a prisoner till the Harpsichord is finished, in the manner of the Italian Popes…and I am only let out by the hour." As it turned out, though her interior decorations for the harpsichord were ready

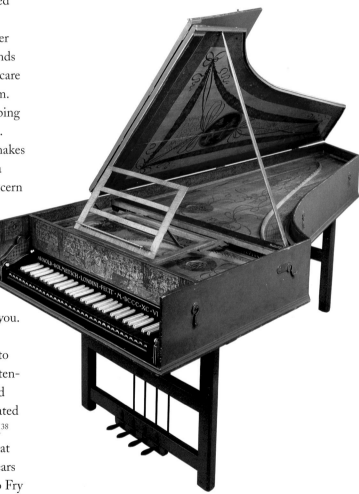

FIG. 7
The Green Harpsichord, 1896, by Arnold Dolmetsch and decorated by Helen Fry, Selwyn Image, and Herbert Horne. Courtesy of the Horniman Museum, London.

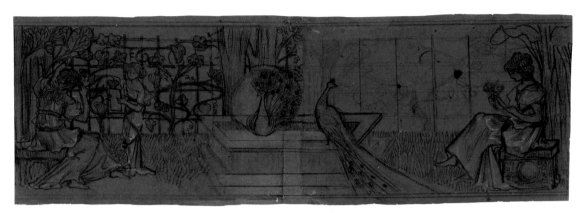

FIG. 8
Helen Fry, *Design for the Green Harpsichord*, 1896. Pencil, pen, and ink with white heightening, 5½ × 17 inches. Private collection.

for the Arts and Crafts Exhibition of 1896, the exterior was not and had to be covered with a plain green lacquer, from which the instrument got its name. Finally, she was able to write: "I will only tell you of the Harp—'our child' as Miss Dodge now calls it—I rushed off to the Arts & Crafts & found Dolmetsch performing on *it*—he jumped up & exclaimed 'here comes the Artist who painted it!' Tableau & admiring throng—all the rest is compliments & I shan't repeat them to you: but alas! I was met at Paddington by the announcement of Morris's death so all the influential people stayed away! Poor me!"[39] Like so many of the productions of the Arts and Crafts movement, the harpsichord was a group effort, with both of the Frys, Horne, and Selwyn Image involved in the decoration, while the actual design of the instrument was Dolmetsch's own, created at Morris's instigation.

Fry himself was actively involved with the second generation of Arts and Crafts practitioners, most closely his old friend C. R. Ashbee. Though their tastes would later diverge drastically, they collaborated on a project in the early 1890s, the decoration of the house Ashbee designed and built for himself on the site of a sixteenth-century hostelry named Magpie & Stump, which had burned in 1886. Here Ashbee established his mother and sisters, with studios for himself and his sister, Agnes, an Arts and Crafts designer and bookbinder in her own right whose input on the home's decoration included painting the dining room frieze. Fry's contribution was a wall painting over the drawing room fireplace which *The Studio* made due note of (fig. 9):

> The originality which distinguishes the house reveals itself here [in the drawing room] as you study the details, the most notable innovation being a wall painting on the chimney breast. The room is papered with peacock-blue paper of a formal pattern in two shades, and the painting by Mr. Fry is cleverly planned in the same key of colour so that it grows out of the walls as part of them, and does not at first detach itself as a painting is apt to do; indeed, it is only after a few minutes that you observe it at all. Its symmetrically treated formal garden, with a central fountain, is very happily imagined.[40]

This interest in the Arts and Crafts was one of the early bonds between Helen and Roger, and though hindsight suggests that Fry might have been happier had he not married her, he never spoke disparagingly of his decision. In some ways it may

have been the financial burden and emotional distress caused by her illness that spurred him on to a productivity that might not have been his had she been well. Fry planned Durbins in the countryside near Guildford for Helen, although by the time the house was completed, it was too late to serve as a refuge. By 1909 Helen was permanently committed to an institution, and Durbins instead proved a haven for Fry, his children, and his sister Joan, who took charge of caring for Julian and Pamela (fig. 10).

Fry remained interested in the Arts and Crafts movement, designing bookplates for Bernard Berenson, a drawing room frieze for his old friend Robert Trevelyan, and furniture for the philosopher John Ellis McTaggart. He continued supporting Ashbee's Guild of Handicraft through contributions and remained a member of the Art Workers Guild from 1900 until 1910, the year in which, as

Virginia Woolf famously put it, "human character changed." Importantly and not coincidentally, it was the year Fry's friendships with Clive and Vanessa Bell, Virginia Stephen, and Duncan Grant were cemented, and the year of the first Post-Impressionist Exhibition, with its celebration of the French modernism of Cézanne, Gauguin, and van Gogh and connections to their contemporaries, particularly Matisse and Picasso, which seemed to leave the Victorian era behind once and for all. Vanessa responded to it with enthusiasm: "That autumn of 1910 is to me a time when everything seemed springing to new life—a time when all was a sizzle of excitement, new relationships, new ideas, different and intense emotions all seemed to be crowding into one's life." She added, "Perhaps I did not realize then how much Roger was at the center of it all."[41]

![The "Magpie and Stump," the drawing-room fireplace](THE "MAGPIE AND STUMP" THE DRAWING-ROOM FIREPLACE)

FIG. 9
"Magpie and Stump," the drawing-room fireplace with design by Roger Fry, reproduced in *The Studio*, 1895, vol. V, page 68.

FIG. 10
Pamela and Julian Fry with their father at Durbins, ca. 1910, by Alvin Langdon Coburn (American, 1882–1966). Courtesy of the George Eastman House.

*"Those of genius in the Victorian sense
were like prophets; different, another breed."*
—VIRGINIA WOOLF [42]

Vanessa and Virginia Stephen were the daughters
of Leslie Stephen and his second wife, the lovely
Julia Jackson Duckworth (fig. 11),[43] from whom
it has been noted that they both inherited their
looks.[44] The widow Julia Duckworth met Leslie
Stephen at her aunt Julia's house, Dimbola, on the
Isle of Wight, and after several years of friend-
ship they married in 1878. Soon after, Henry James
wrote to his sister marveling that such a "charm-
ing woman" had consented to become, matrimo-
nially, "the receptacle of Leslie Stephen's ineffable
and impossible taciturnity and dreariness."[45] Julia
brought from her first marriage three children—
George, Stella, and Gerald Duckworth—and Leslie
had one daughter by his earlier marriage to Minnie
Thackeray—Laura—who, though she lived at home
during her childhood years, was eventually sent
to an institution, suffering from mental instability.
With the addition of the four children that Julia
and Leslie had together—Vanessa, Thoby, Virginia,
and Adrian—as well as Julia's widowed mother,
theirs became a crowded household with seven
servants to oversee their needs.

It was a busy household as well; Julia was com-
mitted to doing good works, and her children often
felt that, unless they were ill, they came second in
her concern. Leslie Stephen, the famed compiler of
the *Dictionary of National Biography*, spent nearly
all his time writing or, for leisure, particularly in his
younger days, alpine climbing, although he could
also on occasion enjoy the simple pleasures of enter-
taining his children.[46] The boys were sent to school
while the girls were taught at home by their mother
and, later on, rather randomly, according to their
interests, Vanessa choosing to attend art classes and
Virginia gaining a tutor in Greek and Latin. One of

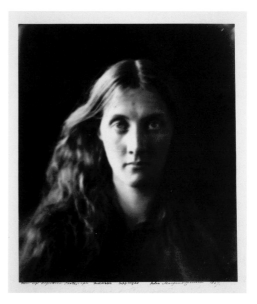

FIG. 11
Julia Margaret Cameron (British, 1815–1879),
Julia Duckworth, 1867. Albumen print. Courtesy
of the George Eastman House.

her tutors was Walter Pater's sister, Clara, and in
an undated letter to Raymond Mortimer, respond-
ing to his request for memories of the Pattle sisters,
Vanessa recalled, "Their room was perhaps stuffy
but absolutely neat and carefully considered Morris
papers and stuffs, a cabinet of old china, exquisite
tea things, a lean and beautiful cat whom they
adored."[47] Virginia remembered the house succinctly
as "all blue china, Persian cats, and Morris wallpa-
pers."[48] Clara was rather shocked by Virginia's room
at Hyde Park Gate, which she had managed to get
whitewashed, seemingly anticipatory of the domes-
tic style the sisters would impose on their home
in Gordon Square.

Such a childhood bred a longing in Virginia,
who remembered her mother in snippets: "I hear the
tinkle of her bracelets, made of twisted silver, given
her by Mr. Lowell, as she went about the house;
especially as she came up at night to see if we were
asleep, holding a candle shaded; this is a distinct

memory, for, like all children, I lay awake sometimes and longed for her to come. Then she told me to think of all the lovely things I could imagine. Rainbows and bells."[49]

Julia Stephen had been a renowned beauty, raised in the rarefied atmosphere of the social life at Little Holland House where she was admired by the leading artists of the day. Two Pre-Raphaelite artists, painter William Holman Hunt and sculptor Thomas Woolner,[50] courted her, and both proposed, though she chose the young barrister Herbert Duckworth as her first husband. Watts paid homage to her beauty in painting, as did Burne-Jones, for whom Julia sat sometime in the late 1870s (fig. 12).[51] Another Arts and Crafts artist, Henry Holiday, who was best known for his stained glass work, also drew Julia. For many of the Pre-Raphaelite painters, she fulfilled their idea of a "stunner."

When imagining her mother's youth, Virginia noted, "How easy it is to fill in the picture with set pieces that I have gathered from memoirs—to bring Tennyson in his wideawake; Watts in his smock frock. Ellen Terry dressed as a boy; Garibaldi in his red shirt—and Henry Taylor turned from him to my mother—'the face of one fair girl was more to me'—so he says in a poem. But if I turn to my mother, how difficult it is to single her out as she really was; to imagine what she was thinking, to put a single sentence into her mouth! I dream; I make up pictures of a summer's afternoon."[52] Woolf's obsession with the remembrance of her mother continued into her forties: "I could hear her voice, see her, imagine what she would do or say as I went about my day's doings. She was one of the invisible presences who after all play so important a part in every life." She finally was able to excise the ghosts of both her parents in *To the Lighthouse*.[53]

Virginia saw her father differently, though equally a part of this Victorian milieu:

> He was a little early Victorian boy, brought up
> in the intense narrow, evangelical yet political,

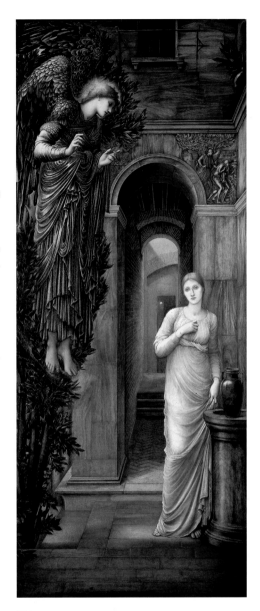

FIG. 12
Edward Burne-Jones, *The Annunciation*, 1876–79. Oil on canvas, 98½ × 41 inches. Courtesy of the Trustees of the National Museums and Galleries on Merseyside (Lady Lever Gallery, Port Sunlight).

highly intellectual yet completely unaesthetic, Stephen family, that had one foot in Clapham, the other in Downing Street. Such is the obvious first sentence of his biography…he went to Eton and was unhappy; went to Cambridge and was in his element; was not elected an Apostle, was muscular; coached his boat; and Christian, but shed his Christianity—with such anguish; Fred Maitland once hinted to me, that he thought of suicide, and how then, like Pendennis or any other of the Victorian young men of intellect—he was typical of them—took to writing for the papers, went to America; and was, so far as I can see, the very type, or mould, of so many Cambridge intellectuals….[54]

Virginia maintained an affinity with her father (fig. 13), who was also a writer, though for much of her life she tended to view him through the eyes of an adolescent, with both admiration and rebellious disdain. In the 1930s, she was able to describe her teenage years at Hyde Park Gate with more equanimity: "Here of course, from my distance of time, I perceive what one could not see then—the difference of age. Two different ages confronted

one another in the drawing room at Hyde Park Gate: the Victorian Age and the Edwardian Age. We were not his children, but his grandchildren. …The cruel thing was that while we could see the future, we were completely in the power of the past. That bred a violent struggle. By nature, both Vanessa and I were explorers, revolutionists, reformers. But our surroundings were at least fifty years behind the times."[55] The younger Stracheys and Dora Carrington shared this condition; Lytton was born when his father was sixty-three (followed when his father was seventy by his younger brother James), and Carrington's father was sixty-one when she was born. While this age difference seemed to matter less in these families, for Woolf it seemed a

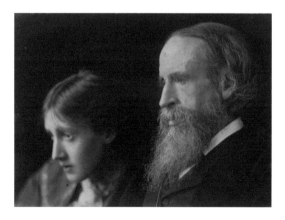

FIG. 13
Leslie and Virginia Stephen, by George Charles Beresford, December 1902. Courtesy of the Harvard Theatre Collection, Houghton Library, Harvard University.

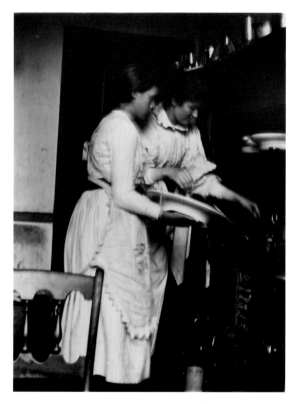

FIG. 14
Vanessa Stephen with Lisa Stillman, Talland House, St. Ives, ca. August 1892. Courtesy of the Harvard Theatre Collection, Houghton Library, Harvard University.

liability that had to be overcome. In later years she mentioned being delighted to have found her way back to her father through his books, and in retrospect, she respected his largeness of character, which allowed his daughters their freedom:

> If at one moment he rebuked a daughter sharply for smoking a cigarette—smoking was not in his opinion a nice habit in either sex— she had only to ask him if she might become a painter, and he assured her that so long as she took her work seriously he would give her all the help he could. He had no special love for painting; but he kept his word. Freedom of that sort was worth thousands of cigarettes.[56]

The Stephens' childhoods were spent in an atmosphere of intellectual liveliness, with frequent distinguished visitors arriving in their home. Henry James, George Meredith, G. F. Watts, and John Addington Symonds were remembered for particular attributes—Meredith for his growly voice, Watts for his distinctive manner of dressing and eating, Henry James for his habit of tilting his chair back as he talked, resting his bulk on only two legs until, occasionally, he would topple himself over, much to the children's glee. For Virginia, "Greatness still seems to me a positive possession; booming; eccentric; set apart; something to which I am led up dutifully by my parents. It is a bodily presence; it has nothing to do with anything said. It exists in certain people. But it never exists now. I cannot remember ever to have felt greatness since I was a child."[57]

In addition, Julia Stephen's at-homes on Sundays brought a diverse group to the house, including Mrs. Dolmetsch (wife of the musician), the Pre-Raphaelite painter Maria Spartali Stillman and her daughters and stepdaughters[58] (figs. 14, 15), Edward Burne-Jones and his family, John Everett Millais, and numerous relatives from the Prattle side of the family. Julia Stephen enjoyed the role of matchmaker and encouraged relationships, including one between the elderly G. F. Watts and Mary Tytler Fraser, a

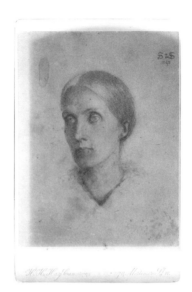

FIG. 15
H. H. Cameron (British, 1856–1911), photograph of a drawing of Julia Stephen by Lisa Stillman, 1893. Courtesy of the Harvard Theatre Collection, Houghton Library, Harvard University.

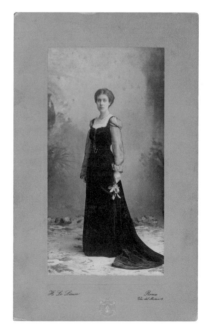

FIG. 16
H. Le Lieure (Italian, active late 19th–early 20th century), Vanessa Stephen, Rome, ca. 1901. Courtesy of the Harvard Theatre Collection, Houghton Library, Harvard University.

29

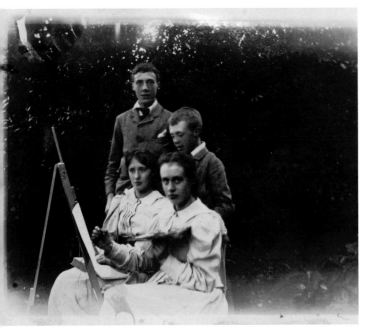

FIG. 17
Vanessa, Virginia, Thoby, and Adrian Stephen. Stella
Duckworth Photograph Album, Henry W. and Albert
A. Berg Collection, the New York Public Library, Astor,
Lenox, and Tilden Foundations.

distant relative.[59] Woven through this panoply of
visitors were names that would become familiar to
the Stephen girls years later, glimpses only, but later
deeper friendships. Rupert Brooke first met them as
a child in St. Ives. Molly MacCarthy, before her
marriage, was Molly Corne Warrish, a second cousin
through their aunt Anny. Desmond MacCarthy
remembered seeing Vanessa during their teenage
years when she was being escorted to balls and par-
ties by her stepbrother George, remarking on her
resemblance to "a Greek slave,"[60] which is probably
exactly what Vanessa felt like, her youthful beauty
subjected to the gimlet eye of the Victorian matri-
monial market (fig. 16).

As children, the Stephen girls established
the perimeters of their own interests, painting for
Vanessa and writing for Virginia (fig. 17). Virginia

remembered that for Vanessa, "beneath the serious
surface…there burnt also the other passion, the
passion for art…with her long fingers grouping,
and her eye considering, she surely painted many
pictures without a canvas. Once I saw her scrawl on
a black door a great maze of lines, with white chalk.
'When I am a famous painter—' she began, and
then turned shy and rubbed it out in her capable
way."[61] Virginia also recalled the halcyon days at
Talland House during which Nessa, "painting in
water-colours, and scratching a number of black
squares, after Ruskin's prescription," worked from
his standard book on the subject, *Elements of Draw-
ing*, published in 1857. In her memoir of Virginia's
early life, Vanessa noted, "I cannot remember a time
when Virginia did not mean to be a writer and I
a painter. It was a lucky arrangement, for it meant
that we went our own ways and one source of jeal-
ousy at any rate was absent.

> Our happiest afternoons were spent in a small
> room handed over to us, opening from the
> large double drawing room. It was a cheerful
> little room, almost entirely made of glass, with
> a skylight, windows all along one side looking
> on to the back garden, a window cut in the wall
> between it and the drawing room, and a door
> (also a half window) opening into the drawing
> room. Also another door by which one could
> retreat to the rest of the house. In this room we
> used to sit, I painting and she reading aloud.
> We read most of the Victorian novelists in this
> way, and I can still hear much of George Eliot
> and Thackeray in her voice.[62]

The children also had nicknames for each
other, which lasted into adulthood: Virginia was
"Goat," Nessa was "Dolphin" or, sometimes, when
too fastidiously acting the role of older sister, "The
Saint," an epithet she loathed.[63]

Their half-sister, Stella Duckworth, was an
avid amateur photographer, recording family life

in numerous images, many informal, that capture the carefree life of holidays and a family enjoying the leisurely pleasures of summer, both indoors and out. One picture of Vanessa reading (fig. 18) shows a typical Victorian interior, complete with Morris's "Trellis" wallpaper in the background. May Morris knew intimately the stories behind each of her father's wallpaper images and wrote about them in her biography of him: "In my Father's 'Trellis' there was a certain one of the birds who gave anxiety to a child in her cot high-up in the Queen Square house because he was thought to be wicked and very alive, but there were such interesting things going on behind that rose-trellis that one had not time to worry much about him."[64] One can easily imagine the Stephen children, particularly Virginia, creating similar fanciful personalities and tall tales for the birds in "Trellis."

Another group of photographs from Stella's album attempts to replicate the appearance of their mother from one of their great-aunt Julia's photo-graphs (figs. 19, 20), which were displayed in the house at Hyde Park Gate and were among Leslie's favorite pictures of his wife: "To us, who remember her distinctly, they recall her like nothing else— Her beauty was of the kind which seems to imply— as it most certainly did accompany—equal beauty of soul, refinement, nobility and tenderness of character; and which yet did not imply, as some beauty called 'spiritual' may seem to do, any lack of 'material' beauty."[65] Stella's versions of Vanessa and Virginia mirror the young Julia's unguarded, sensuous look, captured in a Cameron photograph of their mother, "loose-haired, passionate and diony-siac"[66] (see fig. 11).

FIG. 19
Vanessa Stephen, Talland House, St. Ives. Stella Duckworth Photo-graph Album, Henry W. and Albert A. Berg Collection, the New York Public Library, Astor, Lenox, and Tilden Foundations.

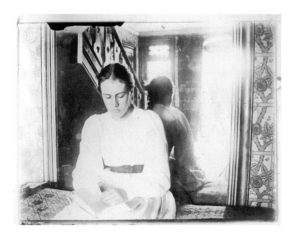

FIG. 18
Vanessa Stephen reading at Dimbola Lodge, home of Julia Margaret Cameron. Stella Duckworth Photograph Album, Henry W. and Albert A. Berg Collection, the New York Public Library, Astor, Lenox, and Tilden Foundations.

FIG. 20
Virginia Stephen. Stella Duckworth Photograph Album, Henry W. and Albert A. Berg Collection, the New York Public Library, Astor, Lenox, and Tilden Foundations.

In 1895, this serene childhood came to an abrupt halt, with the death of their beloved mother. "If what I have said of her has any meaning," Virginia later wrote, "you will believe that her death was the greatest disaster that could happen"[67] (fig. 21). The following year, rather than return to Talland House in Cornwall, the site of so much happiness, they took up Anny Thackeray Richie's offer of the use of her cottage, the Porch, on the Isle of Wight. In the 1860s, after Thackeray's death, Cameron had lent the Porch to Minnie and Anny as an asylum in which to come to terms with their grief. Anny, who had spent many happy summers there, acquired the lease. The effect, however, on the Stephens family was not salutary, and Virginia

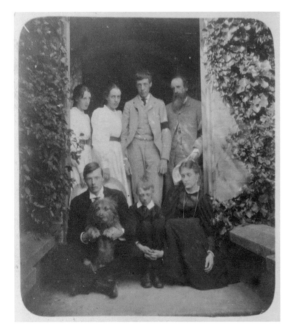

remembered it afterward as an unsuccessful holiday for them all.

Their half-sister Stella quietly stepped into her mother's shoes, taking over the running of the household and nurturing her younger siblings. She, like her mother, was astonishingly beautiful (fig. 22). Stella was drawn by Holman Hunt in the late 1880s as a study for his famous painting *The Lady of Shalott*, and she was likely Val Prinsep's model in his 1888 engraving "Marianna from *Measure for Measure*" (fig. 23). Leslie Stephen, deprived for the second time of a wife, turned to Stella, exacting sympathy and attention for his loneliness, while Stella began to lean on Vanessa as a helpmate. When Stella made the decision to marry her long-time suitor, Jack Hills, Leslie extracted a promise from her that they would continue to live in the house at 22 Hyde Park Gate and take care of them all. Before the wedding, however, it became clear that this arrangement was not acceptable to the about-to-be-married couple; a compromise was reached with the purchase of a house two doors down from the Stephens, creating at least the illusion of independence. Stella, sadly, died of peritonitis shortly after their return from their honeymoon, and Vanessa, the next in line, was promoted to position of chatelaine.

Virginia described the misery of her sister's new position: "Vanessa then at the age of eighteen was exalted, in the most tragic way, to a strange position, full of power and responsibility. Everyone turned to her, and she moved, like some young Queen, all weighed down with the pomp of her ceremonial robes, perplexed and mournful and uncertain of her way." Bereft of two of his "Angels in the House,"[68] Leslie took his toll on Vanessa: "When he was sad, he explained, she should be sad; when he was angry, as he was periodically when she asked him for a cheque, she should weep; instead she stood before him like a stone. A girl who had character would

not tolerate such speeches, and when she connected them with words of the same kind, addressed to the sister lately dead, to her mother even, it was not strange that an uncompromising anger took possession of her."[69] It was an anger that she never quite relinquished, even in old age.[70]

After the deaths of Julia and Stella, their stepbrother George took to escorting Vanessa in society, but, as Virginia recalled, "Unfortunately, what was inside Vanessa did not altogether correspond with what was outside. Underneath the necklaces and the enamel butterflies was one passionate desire—for paint and turpentine, turpentine and paint. But poor George was no psychologist. His perceptions were obtuse. He never saw within. He was completely at a loss when Vanessa said she did not wish to stay with the Chamberlains at Highbury; and would not dine with Lady Arthur Russell...."[71] In desperation, George turned to Virginia, and, on one memorable occasion, after dining with Lady Carnarvon and attending a play, Virginia remembered George opting to finish the evening with a visit to the Holman Hunts:

> Directly I came in I recognized the Stillmans, the Lushingtons, the Montgomeries, the Morrises, the Burne-Jones.... The effect of the Moorish Hall,[72] after Bruton Street, was garish, a little eccentric, and certainly very dowdy. The ladies were intense and untidy; the gentlemen had fine foreheads and short evening trousers, in some cases revealing a pair of bright red Pre-Raphaelite socks. George stepped among them like a Prince in disguise.... There we found old Holman Hunt himself dressed in a long Jaeger dressing gown, holding forth to a large gathering about the ideas which had inspired him in painting 'The Light of the World', a copy of which stood upon an easel. He sipped cocoa and stroked his flowing beard as he talked, and we sipped cocoa and shifted our shawls—for

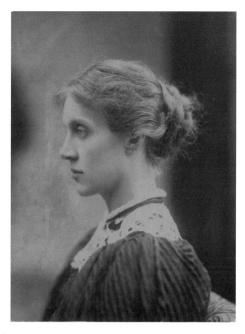

FIG. 22
Stella Duckworth, Rome. Courtesy of the Harvard Theatre Collection, Houghton Library, Harvard University.

FIG. 23
Valentine Prinsep (British, 1838–1904), *Marianna from "Measure for Measure,"* 1888. Engraving, 10 × 7¾ inches. Courtesy of Diane Gillespie.

the room was chilly—as we listened…the tone of the assembly was devout, high-minded, and to me after the tremendous experiences of the evening, soothingly and almost childishly simple. George was never lacking in respect for old men of recognized genius, and he now advanced with his opera hat pressed beneath his arm; drew his feet together, and made a profound bow over Holman Hunt's hand. Holman Hunt had no notion who he was, or indeed who any of us were; but went on sipping cocoa, stroking his beard, and explaining what ideas had inspired him in painting 'The Light of the World', until we left.[73]

The Stephen children, thus, grew up within the artistic and literary milieu of late-Victorian London. In 1894, Vanessa and Virginia were visiting G. F. Watts's family at their home Limnerslease, in Compton, when the Walter Crane family arrived. Crane was an important and talented Arts and Crafts designer (though at the time of this visit the Stephen girls most likely knew him best from his children's book illustrations). He was also a close associate of William Morris and fellow socialist, so he would have shared many friends in common with the Stephen family. A few years later, when Vanessa and George were visiting Limnerslease, Vanessa wrote to a friend from art school, Margery Snowden, of Watts's apparent interest in her opinions and his remarkable kindness to her, while also noting, "Georgie remarked (can you imagine it!) that he had been ashamed to look at the drawings [of nudes] at the R. A. prize-giving and had felt in want of a fan all the time. Watts took him perfectly seriously, and embarked upon a long monologue on the place of the nude in art,"[74] which one can only imagine baffled George while it amused Vanessa. But he must not have left in complete disgrace, as George was one of the last visitors to see Watts before his death in June 1904.[75]

As sons, Thoby and Adrian were able to escape the family home at Hyde Park Gate for long stretches of time while attending school. The Cambridge University Thoby attended was as exciting in the early 1900s as it had been when Fry attended in the 1880s. Lytton Strachey, one of his classmates, wrote to his mother describing the intense atmosphere at King's where the whole college was "wracked by the social work and agnosticism question" and the University was flooded by "so-called 'working men.'"[76] At Cambridge, Lytton, Thoby, Leonard Woolf, and Clive Bell formed the Midnight Society, which met regularly every Saturday at 12:00 a.m. to recite and discuss literature. In 1902, Strachey and Woolf were, like Fry before them, elected to the Apostles. Its membership over the years included such luminaries as Tennyson, the historian F. W. Maitland, Francis Warre-Cornish (provost of Eton College and Molly MacCarthy's father), the poet Rupert Brooke, and the philosophers Bertrand Russell and Ludwig Wittgenstein. Of the Bloomsbury friends, Desmond MacCarthy, E. M. Forster, and Maynard Keynes were elected during their time there.

For the young Cambridge men who eventually formed the Bloomsbury circle, the most important influence was that of the philosopher G. E. Moore, brother of the Arts and Crafts artist and poet T. Sturge Moore.[77] In his quiet way, he gave them permission to reject the Victorian moral code and offered them a philosophical justification for their rebellion. In his *Principia Ethica*, Moore posited the all important question, "What things are goods or ends in themselves?" and his answer became their guiding mantra: "By far the most valuable things, which we know or can imagine, are certain states of consciousness, which may be roughly described as the pleasures of human intercourse and the enjoyment of beautiful objects…. It is the ultimate and fundamental truth of moral philosophy…. Personal affec-

tions and aesthetic enjoyments include *all* the greatest, and by far the greatest, goods we can imagine."[78]

From Hyde Park Gate, Virginia wrote longingly to her brother about his advantages: "I don't get anybody to argue with me now, & I feel the want. I have to derive from books, painfully & all alone, what you get every evening sitting over your fire & smoking your pipe with Strachey, etc. No wonder my knowledge is but scant."[79] Vanessa was able to escape to art classes, and Watts, their old family friend, took Vanessa under his wing after Julia's death, writing to Leslie, "I shall be delighted to give Vanessa any help I may."[80] In late 1902 she was taking classes with John Singer Sargent who, Virginia wrote to Thoby, "is a splendid teacher, & very kind to her."[81]

In 1904, the death of Leslie Stephen freed his daughters from what they increasingly perceived as the confines of their insular Victorian upbringing. "The four of us were therefore left alone. And Vanessa—looking at a map of London and seeing how far apart they were—had decided that we should leave Kensington and start life afresh in Bloomsbury," Woolf recalled.[82] As a symbol of their rebellion, this move from their father's fashionable, staid neighborhood in Kensington to the comparatively inglorious locale of Bloomsbury was a physical cutting of old ties and offered a chance to escape their stultifying Victorian obligations. Bloomsbury had previously hosted the domiciles of many of the democratically inclined Pre-Raphaelite and Arts and Crafts artists, but these had never brought social cachet to the area. For the Stephen girls, it was a fearless act of revolt, severing many old relationships while triggering the beginnings of a distinctive circle of lifelong friendships.

Through their brother Thoby and his Cambridge friends, a new world opened up to the Stephen sisters, one that, with their vivid imaginations and inquisitive minds, they grabbed by the proverbial horns. Led by Vanessa, the young and unmarried Stephen siblings set up house at Gordon Square, establishing a salon of sorts, with an exclusive membership that could only be expanded by personal invitation of one of the members. They unabashedly professed their difference in their dress, their conversation, and their lifestyle, determined to throw off the gloom of the past, both figuratively and literally, by removing themselves and their ideas from the confines of Kensington. As Todd Avery has noted, "The historical distance between Leslie Stephen and Bloomsbury may be measured by the fact that, as [Virginia] Woolf notes, the famous G. F. Watts portraits of Julia and Leslie Stephen, which the Stephen siblings had inherited, did not adorn the walls of their sitting room; rather, 'they were hung downstairs if they were hung at all.'"[83] Watts's portraits, including a panoply of images of famous men, faced the Cameron photographs of Julia in the ground-floor entry hall to Gordon Square, ushering visitors through the Stephens' Victorian heritage before they ascended to the whitewashed modernity of the sitting room.[84] While in essence they rejected the fustiness of their family home, the Stephen siblings retained their father's sentiments on friendship: "My love of those who are nearest to my sympathies must be the ultimate ground of any love that I can have for anybody else."[85] Such thoughts were close to Moore's ideal and would be one inherited Victorian tenet that the "Bloomsberries" continued to nurture throughout their lives.

The early days in Gordon Square were ones of experimentation and freedom, a time when the dust of the Victorian era could be brushed off their feet with no regrets. Often in the evenings the whole family would spend a couple of hours drawing after dinner, and occasionally Vanessa read while they drew. Virginia reported to her friend Violet Dickinson that Thoby "draws murderers escaping and criminals being hung—and once, I'm sorry to

say, the back view of God Almighty—and Adrian drew foxes, as large as deer, running along with their tongues out, and a beautiful gent, on a horse, who's himself, galloping up in front of the hounds."[86] Virginia herself copied drawings of Blake and Rossetti, most notably a portrait of William Morris's wife Jane. It was at Gordon Square in 1905 that Vanessa Stephen formed the Friday Club to promote the work of young artists, though Virginia remembered that it had a dual identity, with half the group supporting the British traditionalists, the other half the more advanced work of Whistler and the French Impressionists. The club became an important forum in which Clive Bell, and, later, Roger Fry, argued their artistic theories, using this group as a sounding board for their later published criticism.

The life at Gordon Square was a real draw for Thoby's friends, with two young, beautiful, and immensely intelligent young women[87] and no parental restrictions. But in the autumn of 1906 tragedy struck when Thoby, recently returned from a trip with his sisters and their friend Violet Dickinson to Greece, died of typhoid. The circle was devastated; Thoby had been the beautiful one, the "Goth" who brought both sides, his Cambridge friends and his family, together. Vanessa, who had refused marriage to Clive Bell on previous occasions, accepted him shortly after her brother's death, creating not one but two sudden shifts within the group. [88] After their marriage, Lytton, on a visit to Gordon Square, claimed to have been entertained by the newlyweds as they lay in bed[89]—sex was no longer a taboo subject, and the polite formalities of a Victorian upbringing were gone. Adrian and Virginia moved around the corner to 29 Fitzroy Square and held their own salon on Thursday evenings, and thus Bloomsbury endured its first great transition. And Duncan Grant, at 8 Fitzroy Square, was installed in a studio with a rich pedigree, having belonged to Whistler, Augustus Johns, and Walter Sickert before him.

"After all, you are a lucky dog to have your Life simplified by the passion for Paints…. Other forms of existence are so exhausting & so unsatisfactory."
—OTTOLINE MORRELL TO DUNCAN GRANT[90]

Lytton Strachey's young cousin, Duncan, was introduced to Bloomsbury in 1905. As the youngest of the original Bloomsbury group, he had, perhaps, the fewest ties to the Victorians. The only child of Bartle and Ethel Grant, Duncan lived until he was nine with his parents in India and Burma, where his father was stationed. In 1894 he was sent back to England to attend Hillbrow School, staying with his grandmother in Chiswick during the holidays and, after her death, with his Strachey relatives in London at their eccentric home in Lancaster Gate. His grandmother's love of art may have helped influence his career choice, but it was apparent from a very young age that his talent and interests lay almost exclusively in this area. At Hillbrow, Grant's skill was recognized and fostered; the headmaster's wife lent him a large volume of reproductions by Burne-Jones, who was then at the height of his popularity, and the "sensuous treatment of the human figure, lingering *sfumato* and highly wrought sense of design made a terrific impact on him. 'For years I would ask God on my knees at prayers to allow me to become as good a painter as he.'"[91]

Lancaster Gate, with its ugliness and inconveniences, its Halsey Ricardo fireplace (a prize from the Great Exhibition, which Lytton noted "combined, with an effect of emasculated richness, the inspiration of William Morris, reminiscences of the Renaissance, and a bizarre idiosyncrasy of its own"[92]), must have seemed a world apart to the young Grant. For this only child, the antics of the ten Strachey children, twenty-seven years separating the oldest and youngest, and each with a distinct, outspoken personality, as well as high intelligence

and quirky senses of humor, might have been completely overwhelming. But Pippa Strachey, and then Lytton, took Duncan under their wings, initiating a lifelong friendship among the cousins.

When Duncan failed entrance to the Royal Academy Schools, he took art classes from Louise Jopling, a successful artist and teacher in London. She deserves a mention in her own right, for she was among those who made careers in the arts possible (and acceptable) for the post-Victorian generation of female artists. She probably came recommended to Duncan through her third husband, George Rowe, a distant relative of the Grants, and her life intersected with Victorian Bloomsbury at several junctures. Through her second husband, the watercolorist Joseph Jopling, she became friends with John Everett Millais and James Whistler, who both painted her. In the 1880s Jopling shared a studio with the Pre-Raphaelite painter and model (and Burne-Jones mistress) Maria Zambuco, part of the Greek expatriate community in London to which the painter Marie Spartali also belonged. After Joseph Jopling's death in 1884, Louise established a successful school of art, becoming the breadwinner in her family. Indefatigable, she also lectured widely, wrote books, poems, and articles, and was one of nine female exhibitors, along with Spartali, in the first Grosvenor School show.

In 1905 Pippa took Duncan along to a meeting of the Friday Club, though his friendship with Bloomsbury did not immediately blossom. The following year, at the age of twenty-one, he was able to study in Paris, having received a gift of one hundred pounds from his aunt, Lady Colville. By living frugally, he made this money last nearly a year. Once there, he joined up with two friends who—like Roger Fry and many other nineteenth-century artists before them—studied at the Académie Julian and lived in attic rooms at the Hôtel de l'Univers et de Portugal.[93] He had a letter of introduction to Jacques-Emile Blanche from the artist Simon Bussy,

who was married to Lytton's sister Dorothy. From Bussy he learned an important lesson he followed throughout his life: "A painter had to paint every day no matter what he felt like," Duncan remembered. "'Every picture should have in it *un clou*,' he used to say: 'a point which pins the whole design together.'"[94] Like many a Victorian art student before him, he spent his mornings in taking painting classes, and his afternoons were almost always reserved for observation and copying in the Louvre.

Clive, Vanessa, Adrian, and Virginia arrived in Paris soon after Duncan. Lytton had written to Vanessa asking that they look up his cousin, but it would probably have surprised all concerned if they knew how this visit would affect the rest of their lives; it was at this meeting that they all realized how much they enjoyed each other's company. Like many people who came into contact with Duncan, they were immediately attracted to his hypnotic charm (fig. 24).[95] Years later, his daughter Angelica described his appeal for her mother: "He was a sympathetic companion, beautiful rather than handsome and extraordinarily sensitive to the prevailing atmosphere. Albeit a cousin of the Stracheys, he was neither highly educated nor literary, in Vanessa's understanding of the term, and in consequence she did not find him threatening."[96] And here lies the divide for many of the Bloomsbury circle, between art and literature. For

FIG. 24
Duncan Grant, ca. 1910, by Alvin Langdon Coburn (American, 1882–1966), Courtesy of the George Eastman House.

Virginia, who adored her sister and held her talent in great respect, it was a line that she refused to accept as a barrier. But in her memoir, *Moments of Being*, she recalls a dinner with Carrington's friend, the painter Mark Gertler, who "denounced the vulgarity, the inferiority of what he called 'literature'; compared with the integrity of painting. 'For it always deals with Mr and Mrs Brown,'—he said—with the personal, the trivial, that is; a criticism which has its sting and its chill, like the May sky. Yet if one could give a sense of my mother's personality one would have to be an artist. It would be difficult to do that, as it should be done, as to paint a Cézanne."[97]

Young, susceptible, and open-minded, the Bloomsbury artists and their work changed dramatically with their introduction to Post-Impressionism. Their response was made manifest in their canvases, exhibited at the Second Post-Impressionist show (fig. 25) in 1912, which gave Britain its first taste of their own avant-garde set against the work produced on the Continent. An apt assessment of the striking innovation of these two exhibitions, which seem so tame in our time, was made by Richard Morphet in the introduction to a 1967 exhibition of Vanessa's work:

Roger Fry's two Post-Impressionist exhibitions of 1910 and 1912 were a severe shock to the art-world of the immediate Post Victorian years. Brought up to understand that paintings told a story—albeit in the other-worldly language of Burne-Jones and Watts—the art conscious public of 1910 were beginning to see English artists turning to a new interest in light and "intimisme"—the diluted Impressionism of the New English Arts Club. This was not a difficult idea to stomach—but Roger Fry and his Paris-imported group consisting of Gauguin, Cézanne, van Gogh, Redon, Denis, Vlaminck, Rouault, Matisse and Picasso were, to the majority of those that read about Fry's first

Post-Impressionist show of 1910, heading for an obscurity not only beyond comprehension, but to some perverse and obscene. That the climate should have changed so sharply by July 1913 when Fry opened a commercial organization based on an application of Post-Impressionism to applied design is surely evidence of the immense power Fry had as a critic.[98]

In his autobiography, written fifty years later, the American expatriate photographer Alvin Langdon Coburn recalled that this show offered him his first view of Matisse's work. He also remembered the controversy it engendered:

The conventional critics poured abuse and derision upon him [Fry] and his fellows, but time

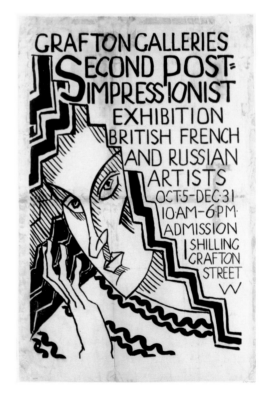

FIG. 25
Poster for the Second Post-Impressionist exhibition, 1912. Collaborative design by Bell, Etchells, Fry, and Grant. Lineblock print, 47 × 37 inches. Courtesy of the Victoria and Albert Museum, London.

has reversed their decision. Art lovers used to worship what was termed beauty, and people came to think that beauty and art were synonymous, but the Post-Impressionists, the Fauves, and the German Expressionists have shown that art and what we may have thought was ugliness can produce a harmonious and striking effect, for it is expression, not conventional beauty, which gives to art a power and to life a significance.[99]

In 1913, once again acting as the stimulus for his friends, Fry turned his attentions to a new venture, the opening of the Omega Workshops. Though Fry would have rejected comparison to the Arts and Crafts aesthetic of William Morris, his scheme for the Omega traded on the methods of the Pre-Raphaelites.[100] An appeal Fry sent to influential friends, in the hopes of raising the necessary funds, explains:

> The Post-Impressionist movement is quite as definitively decorative in its methods as was the Pre-Raphaelite, and its influence on general design is destined to be marked.... Since the complete decadence of the Morris movement nothing has been done in England but pastiche and more or less unscrupulous imitation of old work. There is no reason whatever why people should not return to the more normal custom of employing contemporary artists to design their furniture and hangings if only the artists can produce vital and original work.[101]

Fry wrote to Dolmetsch at this time with the idea of placing an order for a set of virginals that could be decorated at the Omega (fig. 26), suggesting that he might order several of these at a special rate. It says something for what must have been a continuing affection for Helen that Dolmetsch agreed to at least one experiment in this genre[102] as he generally did not like outsiders to take part in the production of his instruments— even when the celebrated Burne-Jones painted one

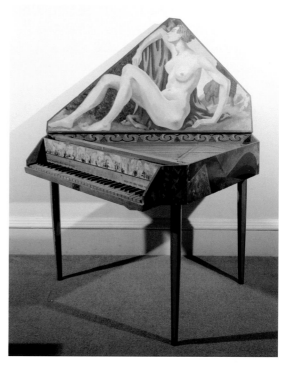

FIG. 26
Omega Virginal, painted by Roger Fry, 1917–18. Oil on wood, 40¾ × 41⅛ × 12⅝ inches. Private collection. Courtesy of the Samuel Courtauld Trust, Courtauld Institute of Art Gallery, London.

of his harpsichords and gave it to his daughter Margaret, Dolmetsch viewed the result as completely unsatisfactory. One of the few happy exceptions had been the Green Harpsichord, and Dolmetsch, as witnessed by Helen's letters, had insisted on severe control.

The Post-Impressionist shows encouraged an unprecedented period of experimentation in decorative art design for the Bloomsbury artists. At the Omega they created humble bowls and cups as well as extravagant inlaid bedsteads, allowing their imaginations to invent domestic interiors that embodied the essence of a Matisse painting. While in style it was a complete rejection of their Victorian precedents, it still encapsulated many of Morris's ideals. As Vanessa's son Quentin summed it up many

decades later, "Morris was trying to say something important about art and everyday life. Fry's 'message,' if you call it that, was not dissimilar, but he had no use for the language which Morris had used. He found what he needed in the practical idiom of Cézanne and, even more, in that of the Fauves. The use of bold and brutal color, the acceptance of pictorial conventions so rude and rapid that they made questions of verisimilitude almost irrelevant, gave the decorator a vocabulary which could be taken without adaptation from the easel picture to furniture, pottery, textiles, lampshades and hats."[103] The Omega style was not appreciated by everyone, however, and never became de rigueur in middle-class British home decoration the way Morris's style was.

Work by the Omega was displayed at the 1916 Arts and Crafts Society exhibition at Burlington House, twenty years after the 1896 show in which Helen Fry's harpsichord had made its debut. May Morris had suggested that the occasion should be used to celebrate the achievements of the founding fathers of the Arts and Crafts movement, most notably, of course, with representative work by her father. It is not surprising, then, with a war raging and a nostalgic display of the comforting furnishings of their youth, that visitors reacted to the Omega display with dismay. The reviewer from the *Manchester Guardian* called the work "perfunctory" and chastised Fry for the high prices charged—"one cannot help thinking that Mr. Roger Fry and his friends have gone back to the Ruskinian principle of art for the rich."[104] The work had "a challenging character that in context was almost wild"[105] which made it unappealing to a pedestrian middle-class audience.

By the beginning of the First World War, it was apparent that in many ways Bloomsbury had moved far beyond its parents' generation. As S. P. Rosenbaum has noted, "There may have been some nostalgia for the age's vitality, simplicity and security, but there was also a great relief at having got free from the tyranny of moral and economic law

that governed the unaesthetic households of the patriarchies and matriarchies in which they grew up."[106] But while it is clear that many of the mores of their Victorian parents had been discarded, the importance of hearth and home and intellectual companionship would remain a constant carried forward from Victorian childhoods. Despite their professed disdain for Victorianism, the "Bloomsberries" frequently mirrored the lives of their Victorian forebears, who themselves could not easily be labeled as typical of their period. The lives and artistic milieu of the members of Bloomsbury were intricately knit with the previous generation; from the establishment of a satisfactory though differently hued domestic life to an involvement in the political issues of their day, from an inbred snobbish intellectualism and a confirmed atheism, this group sustained crucial aspects of the attitudes of their families. A close examination of the eccentricities of their parents' generation shows the Bloomsbury coterie retained much that they insisted they had forsworn. Rather, they tended to assimilate the best of their ancestors' legacy while protesting that their own vision was above all "new." This is not to argue that the Bloomsbury members were not as unusual as they thought themselves to be, for they certainly lived lives radically different from most of their generation. And yet, one of the great criticisms of the group's artists—that they addressed the concerns of a small portion of their own class, restricting themselves and their audience—invites the response that they wrote about and painted what they knew well. The painters in the group gave visual credence to the same subjects, often repeating motifs over and over—portraits of family and friends, views of Charleston and still lifes—each image compounding, rather than diminishing, the overall impact of their importance to modern art. More to the point, the supposedly insular themes of domesticity and family life that characterize Bloomsbury art and literature continue to resonate with audiences today.

NOTES

1 Quoted from a letter written by Lowell to Julia Stephen, February 20, 1888, in *Letters of James Russell Lowell*, vol. II, ed. Charles Eliot Norton (New York: Harper and Brothers, 1894), 433. Lowell was a poet and a critic and the American Ambassador to the Court of St. James from 1880 to 1885; he was a frequent guest at Hyde Park Gate and the Stephens' summer home, Talland House. Virginia was his goddaughter.

2 Many years later, Virginia Woolf wrote a play about a day in the life at Freshwater in the 1860s, featuring her great aunt, G. F. Watts, Ellen Terry, and Charles Dodgson (the real name of Lewis Carroll, author of *Alice in Wonderland*) as the main characters. It was performed during Virginia's lifetime only once, in 1935, at Gordon Square with Vanessa acting the role of their great-aunt. In a typical example of convoluted Victorian relationships, Clive Bell's aunt (his mother's sister) was married to the brother of Alice Liddell, the original Alice. And Alice herself, as a young adult, having outgrown Carroll's lens, was the subject of several of Cameron's photographs.

3 Anny Thackeray's sister Minnie was Leslie Stephen's first wife. After Minnie's death in 1875, Anny kept house for Leslie and his young daughter Laura until her own marriage to her cousin Richmond Ritchie, seventeen years her junior. Anny wrote many books and remained an important part of the circle of relations that frequented Hyde Park Gate. Leonard Woolf affectionately remembered meeting her after the announcement of his engagement to Virginia: "Aunt Anny was the rare instance of the child of a man of genius inheriting some of that genius.... Her genius, like most things about her and in her, were a shade out of control. This erratic streak in her made her miss trains, confuse dates, and get the chapters of most of her novels so muddled that the last chapter was printed as the first (and nobody noticed). This flightiness was absurd.... But it—and still more she —was not entirely absurd. It was part of her great charm and her flashes of genius and imagination. Virginia noted that 'she said things that no human being could possibly mean; yet she meant them.'" L. Woolf, *An Autobiography of the Years 1911 to 1918* (New York: Harcourt, Brace and World, Inc., 1963, 1964), 70–71. Less kindly and more succinctly, Leslie Stephen wrote to his future wife, Julia Duckworth, that Anny "has two facts in her head and one of them is a mistake." July 20, 1877, Berg Collection, New York Public Library. Anny would serve as the model for Virginia Woolf's character Mrs. Hilberry in *Night and Day*.

4 See Anne Thackeray Richie, *Alfred, Lord Tennyson and His Friends*, with an introduction by H. H. Cameron (London: T. Fisher Unwin, 1893), 10–13.

5 Letter from Morris to Edward Williams Byron Nicholson, an undergraduate at Trinity College, Oxford, August 12, 1869. *The Collected Letters of William Morris*, vol. I, ed. Norman Kelvin (Princeton: Princeton University Press, 1984), 86.

6 Amanda Hopkinson, *Julia Margaret Cameron* (London: Virago Press, 1986), 136.

7 *Victorian Photographs of Famous Men and Fair Women by Julia Margaret Cameron*, ed. Tristam Powell (Boston: David R. Godine, 1973), 17–18. Woolf took her information from a letter her aunt Anny wrote to Walter Senior: "There we all sat round a table and looked at the pictures, while the young men each had a tumbler of brandy and water. Everybody is either a genius, or a poet, or a painter or peculiar in some way; poor Miss Stephens says 'Is there nobody commonplace?.... Mr. Prinsep wears a long veil and a high coned hat and quantities of coats." And in another letter, to John Everett Millais, she noted "Last night 'King Alfred' read out *Maud*. It was like harmonious thunder and lightning." Quoted in Hester Thackeray Fuller and Violet Hammersley, *Thackeray's Daughter* (Dublin, 1951) 113–115. There are two notable differences between Woolf's rendition: she refers to Miss Stephen (not Miss Stephens, as Anny does) and she outfits Mr. Cameron, not Mr. Prinsep, Sara Prinsep's husband, in the veil, hat and coats.

8 Helmut Gernsheim, *Julia Margaret Cameron*, with an introduction by Clive Bell (London: The Fountain Press, 1948), 7–8.

9 Clarissa Campbell Orr, *Women in the Victorian Art World* (Manchester and New York: Manchester University Press, 1995), 24.

10 Carrington was loud in her complaints of her mother's puritanical moral code and rigid adherence to propriety, a sticking point throughout their lives and one that kept them at odds. "She openly despised her mother who in crude Victorian terms had been an old maid governess who had caught a well-off old bachelor in need of settling down in the shires after long years abroad.... [Carrington] gives her no credit for putting nothing in her way when she wanted to leave Bedford High School for Girls to be a Slade student. And this when both her parents were ill, her father partly paralyzed by a stroke and her mother rheumatic

and lame." Ronald Blythe, *First Friends: Paul and Bunty, John and Christine—and Carrington* (Huddlesfield: The Fleece Press, 1997), 13–14.

11 Val Prinsep was one of the group of Pre-Raphaelite artists, along with Burne-Jones and Morris, who helped Rossetti paint the ill-fated Oxford Union murals. With no real knowledge of fresco painting, they covered the walls and ceiling of the library with paintings that today remain a shadow of their former short-lived splendor. Prinsep later married Florence Leyland, daughter of the ship owner and art patron, Frederick Leyland, for whom Whistler had decorated the famous "Peacock Room."

12 Jan Marsh, *Jane and May Morris, A Biographical Story 1839–1938* (repr., Horsham: The Printed Word, 2000), 38. "It was later remarked that Mrs. Prinsep was very kind to 'take Jane up' and introduce her to society. Morris was generally unimpressed with the intellectual snobbery of Mrs. Prinsep's circle (where Ned [Edward Burne-Jones] was a firm favorite) and Jane had few assets beyond her strange and statuesque looks. Again, she seems to have acquitted herself well in a new and challenging situation, perhaps once more using intelligence and self-possession, silence and careful observation.

In the Prinseps' drawing room silly chatter was not welcome, and Jane's shyness would not have been a social handicap."

13 Gernsheim, 15.

14 Christopher Reed, *Bloomsbury Rooms: Modernism, Subculture, and Domesticity* (London: Yale University Press, 2004), 36–37, 113–15.

15 Quoted by Virginia Woolf in *Roger Fry: A Biography* (New York: Harcourt Brace and Company, 1940), 259.

16 Goodwin goes on to reflect on the possible influence of John Addington Symonds, the socialist and art historian (who was also a friend of longstanding in the Leslie Stephen family) whom Fry met in Venice in 1890. Symonds saw relationships among morality, art, and science —fields concerned respectively with 'goodness, beauty and truth.' He found that 'art, on its formal and technical side, partakes of the scientific spirit in all that concerns its mental content and influence upon our nature, it no less certainly partakes of the ethical spirit. Yet art has its privileges and rights and independence. It is not really a sub-species of Science, nor is it really a sub-species of Ethic [*sic*].'" Craufurd D. Goodwin, *Art and the Market: Roger Fry on Commerce in Art* (Ann Arbor: University of Michigan Press, 1998), 7. Symonds' daughter, Madge,

married a Stephen cousin, William Vaughan, and was a close friend to Virginia in her adolescence.

17 Clive Bell, *Old Friends* (London: Chatto and Windus, 1956), 69.

18 Fifteen years later, the seeds of Bloomsbury were sown in this society among several members elected in the early 1900s: Leonard Woolf, Lytton Strachey, and Maynard Keynes, who were all profoundly influenced by the young philosopher G. E. Moore and his book, *Principia Ethica*.

19 Clive Bell was incredulous that, at the age of twenty-six, living in Paris, and attending Julian's, Fry seemed unaware of the excitement of the Impressionists and "found in the Luxembourg nothing more exciting than Bastien Lepage" (*Old Friends*, 67). This is less unusual than Clive would think; Bastien Lepage died romantically young, in 1884, and the memorial exhibition held in 1885 at the Ecole des Beaux Arts was a sellout which influenced many of the students in Paris at the time.

20 In contrast to the quixotic and adventurous Fry, Virginia and Vanessa Stephen's half-brother George Duckworth, who was born two years after Fry in 1868, was described by Virginia as the exact opposite: "George accepted Victorian society so implicitly that to an archaeologist he would be a fas-

cinating subject. Like a fossil, he had taken every crease and wrinkle of the conventions of upper middle class society between 1870 and 1900. He was presumably the right material. He flowed into the mould without a doubt to mar the pattern…No more perfect fossil of the Victorian age could exist" (*Moments of Being*, ed. Jeanne Schulkind [New York: Harcourt, Inc., 1985], 151).

21 "'I use the spiritual,' he wrote with his usual care to make his meaning plain, 'to mean all those human faculties and activities which are over and above our mere existence as living organisms.'" Quoted in Virginia Woolf, *Roger Fry: A Biography*, 236.

22 Although it is widely stated that Fry sold Durbins in 1919, according to documents generously shared by the house's current owner, the house was in fact owned by a trust established by his father in the interest of Fry's children—evidence of the elder Fry's skepticism concerning his son's artistic career—until 1934. The house was rented to a variety of tenants, the first of whom was Lytton's mother, Lady Strachey, from 1917 onward. In addition to a lawyer and an accountant presumably chosen by his father or his agents, Fry must have been allowed a say over the third trustee, as this position was taken by his Cambridge friend the philosopher

John McTaggart at the start of the trust, and by Leonard Woolf at the end (information provided by Christopher Reed).

23 Vanessa Bell, *Sketches in Pen and Ink*, ed. Lia Giachero (London: Pimlico, 1997), 122–123.

24 Barbara T. Gates, *Kindred Nature: Victorian and Edwardian Women Embrace the Living World* (Chicago and London: University of Chicago Press, 1998), 188.

25 In a journal entry for June 26, 1886, Ashbee wrote, "I say it again—why am I blessed with such good friends. To me looking back on Cambridge now that is the one solid thing that I have gained—Friendship. Friendship which is so meaningless a word to one till one understands what it is…. My last friend is Fry. He is the last that Cambridge will give me, & he is one of the innermost circle, the circle immediately around ones [*sic*] heart. Goldy holds first place but I think almost Fry comes next—though perhaps not!—His nature is a most beautiful one. So sacred to me at the present that I suppose I cannot write about him with unbiased judgment." King's College Library, Cambridge University, Ashbee Papers, Notebook 1.2, 1886.

26 Quoted in *Letters of Roger Fry*, ed. Denys Sutton (London: Chatto and Windus, 1972), 5.

27 Fiona MacCarthy, *The Simple Life: C. R. Ashbee in the Cotswolds* (Berkeley: University of California Press, 1981), 21.

28 C. R. Ashbee to Roger Fry, April 26, 1886, King's College Library, Cambridge University. Fry later lost this confidence in England and would refer to the English as "Bird's Custard Islanders."

29 The Monk's House photo album in the Harvard Theatre Collection contains *cartes de visites* of famous men and women of the Victorian age, which were collected by the Stephen children, including one of Toynbee.

30 Letter from Fry to Ashbee, October 18, 1886 (*Letters of Roger Fry*, 109). Fry met Morris in April 1889 when Morris gave a talk on "Gothic Architecture" at a meeting sponsored by the Guild and the School of Handicraft in the Lecture Room at Toynbee Hall. The lecture was given for the University Settlement program, and Fry helped with providing some of the images to Morris.

31 There are several conflicting stories of who introduced Fry to Helen. A. H. Mackmurdo claimed, incorrectly, to have introduced them through the Century Guild. In his biography of Marsh, Christopher Hassall says, "Roger Fry's romance had been furthered by Eddie's not being at home when R. C. Trevelyan called [with Helen] at Bruton Street earlier in the year." But Frances Spalding, in her biography of Roger Fry, reverses the roles of Marsh and Trevelyan: "One afternoon in 1896… Edward Marsh, accompanied by a young lady, called at 29 Beaufort Street where he hoped to introduce his companion to Bob Trevelyan. The poet was out…." This version makes sense, as Fry and Trevelyan were sharing a house at the time. Marsh was a civil servant, most notably secretary to Winston Churchill, who became friends with the poets Siegfried Sassoon and Rupert Brooke (whose literary executor he became after Brooke's death in 1915). Marsh was also a patron of the arts and collected works by the Bloomsbury artists.

32 Frances Spalding, *Roger Fry: Art and Life* (Berkeley: University of California Press, 1980), 57.

33 Quoted in Christopher Hassall, *Edward Marsh: A Biography* (London: Longmans, 1959), 109.

34 From an unpublished typewritten sheet in King's College Library, Cambridge University, Ashbee Papers.

35 Vanessa Bell, "Memories of Roger Fry" in *Sketches in Pen and Ink*, 117. Walter Headlam was an old family friend of the Stephens and was a classical scholar and fellow at King's College.

36 Undated letter, Roger Fry to Helen Coombe, probably late fall 1896, King's College Library, Cambridge University, Roger Fry Papers.

37 Undated letter, King's College Library, Cambridge University, Roger Fry Papers.

38 Margaret Campbell in *Dolmetsch: The Man and His Work* (London: Hamish Hamilton, 1975), 100, notes: "It is not known exactly when Dolmetsch started work on the harpsichord that he intended to display at the Arts and Crafts Exhibition Society's Show at the New Gallery in October, but the fact that it was started at all was due to William Morris, who had suggested that he should complete it for the exhibition. By the middle of July the work was well enough in advance for the decorative paintings to be made on the inside of the lid and for this Dolmetsch engaged the artist Helen Coombe. Following her own designs she worked in tempera to produce some exquisite decoration on what was already a truly beautiful example of Dolmetsch's craftsmanship." Dolmetsch was renowned for his revival of medieval music and his use of traditional instruments. Stella Duckworth, Virginia's and Vanessa's half-sister, studied violin with him, and Pippa Strachey played

recorder and, later, contrabass viol in the Dolmetsch ensemble. The four youngest Dolmetsch children were for a time taught in a private school run by Roger Fry's sister Isobel Fry.

39 Undated letter, Helen Coombe to Roger Fry, King's College Library, Cambridge University, Roger Fry Papers.

40 "The New 'Magpie and Stump'—A Successful Experiment in Domestic Architecture" in *The Studio* (vol. V, 1895), 73–34. The reference to "peacock blue" invokes Whistler's Peacock Room for the Leyland family, which was decorated in 1876 and made famous by the public falling out of artist and patron. Fry and Ashbee would both have been familiar with the room and, as followers of Whistler's aestheticism, have sought a similar ambience in their own surroundings.

41 Quoted in Judith Collins, *The Omega Workshops*, 8.

42 V. Woolf, *Moments of Being*, 109.

43 This Cameron portrait of her niece is sometimes referred to as "Julia as Stella," after one of Jonathan Swift's loves, Esther Johnson. Vanessa, who was born on her half-sister Stella's tenth birthday in 1879, was rather romantically named as the second of Jonathan Swift's loves—Esther Vanhomrigh.

Swift always referred to his two Esthers as "Stella" and "Vanessa." Swift was a favorite writer of Leslie Stephen's.

44 Leonard Woolf remembered meeting them when they visited their brother Thoby at Cambridge in the early 1900s: "Their beauty literally took one's breath away, for suddenly seeing them one stopped astonished and everything including one's breathing for one second also stopped, as it does when in a picture gallery you suddenly come face to face with a great Rembrandt or Velasquez." But he proceeds with this warning: "The observer would have noticed at the back of the two Miss Stephens' eyes a look which would have warned him to be cautious, a look which belied the demureness, a look of intelligence, hypercritical, sarcastic, satirical" (*Sowing, An Autobiography of the Years 1880 to 1904* [New York: Harcourt, Brace and Company, 1960], 199–200).

45 Henry James to Alice James, February 17, 1878, in *Henry James: Letters* (Cambridge: Harvard University Press, 1985), 2:157.

46 Virginia remembered that "it was his dexterity with his fingers that delighted his children.… He would twist a sheet of paper beneath a pair of scissors and out would drop an elephant, a stag, or a monkey with trunks, horns, and tails delicately

and exactly formed. Or, taking a pencil, he would draw beast after beast— an art that he practiced almost unconsciously as he read, so that the fly-leaves of his books swarm with owls and donkeys as if to illustrate the 'Oh, you ass!' or 'Conceited dunce,' that he was wont to scribble impatiently in the margin." From "Leslie Stephen" in *The Captain's Death Bed and Other Essays* (New York: Harcourt Brace Jovanovich, Inc., 1950), 70.

47 V. Bell to Raymond Mortimer, undated letter, Princeton University, Mortimer Papers.

48 V. Woolf, letter to William Plomer, December 6, 1931. See *The Letters of Virginia Woolf IV*, eds. Nigel Nicolson and Joanne Trautmann (New York and London: Harcourt Brace Jovanovich, 1976), 411.

49 V. Woolf, *Moments of Being*, 82.

50 Leslie Stephen's *Mausoleum Book* notes that "about 1861–2 Woolner asked leave to make busts from the daughters (J[ulia] and M[ary], I suppose) and that Mrs. Jackson declined on the ground that their simplicity might be injured by the implied homage to their beauty" (28). Holman Hunt eventually married Fanny Waugh and Woolner married her sister Alice. When Fanny died in childbirth, Hunt married a third sister, Edith, who was said to look remarkably like Julia Stephen.

This marriage took place in Switzerland as under the Marriage Act, widowers were forbidden to marry their deceased wife's sister. This was finally revoked in the Deceased Wife's Sister's Marriage Act of 1907.

51 Though *The Annunciation* has been described by one Burne-Jones biographer as depicting Julia "in all the grave beauty of early pregnancy," implying that this was done in late 1878 or early 1879, before Vanessa's birth, it is not known exactly when Julia posed and it has been noted that the model has the distinct look of the artist's wife, Georgie, and the final painting may be more of a composite of the two women. For a discussion of this painting, see Stephen Wildman and John Christian, *Edward Burne-Jones: Victorian Artist-Dreamer* (New York: The Metropolitan Museum of Art, 1998), 240–242.

52 V. Woolf, *Moments of Being*, 86.

53 Ibid., 80.

54 Ibid., 108.

55 Ibid., 33.

56 V. Woolf, *The Captain's Death Bed and Other Essays*, 74.

57 V. Woolf, *Moments of Being*, 158. The story of Henry James tipping his chair was told to Leonard Woolf by Virginia and recounted in his *Sowing*, 122.

58 Lisa Stillman, like her stepmother, was a painter

and Vanessa, Virginia, and their mother all sat for her. Stella noted going to the New Gallery to see Lisa's picture of Nessa. (Stella Duckworth's 1896 diary, entry for April 13, Berg Collection). Marie Spartali was, before her marriage to William Stillman, another of Julia Margaret Cameron's favorite models.

59 October 24, 1886, Watts to Mary: "Mrs. Leslie Stephen says, 'Why delay. Persuade Miss Fraser Tytler to marry and carry you off out of the fogs.' How do you like that advice?" Quoted in Ronald Chapman, *The Laurel and the Thorn A Study of G. F. Watts* (London: Faber and Faber Limited), 125. Given his earlier, short marriage to the young Ellen Terry, it is not surprising that at the age of sixty-nine (Mary was thirty-three years younger than him) that he was shy about the situation. It was through Julia Stephen that Watts asked the word to be spread about his impending marriage.

60 V. Woolf, *Moments of Being*, 106. Virginia goes on to say, "Had Stella lived the recollection makes me reflect, how different 'coming out' and those Greek slave years and all their drudgery and tyranny and rebellion would have been!"

61 Ibid., 29.

62 V. Bell, "Notes on Virginia's Childhood" in *Sketches in Pen and Ink*, 63–64.

63 Ibid., see 31. Her mother Julia was also often saddled with this title and this may be another reason it rattled Vanessa so much.

64 May Morris, *William Morris Artist Writer Socialist*, vol. I (Oxford: Basil Blackwell, 1936), 35–36.

65 L. Stephen, *The Mausoleum Book* (Oxford: Clarendon Press, 1977), 31.

66 Angelica Garnett, prologue to Vanessa Bell, *Sketches in Pen and Ink*, 15.

67 V. Woolf, *Moments of Being*, 40.

68 From Coventry Patmore's 1854 poem extolling a woman's virtues of devotion and sacrifice, traits his own wife Emily manifestly possessed. Patmore was a close friend of Julia Stephen's mother, Maria Jackson, though Leslie, in fact, never liked him. Virginia, in *Professions for Women* (1966, 284) wrote of "The Angel in the House:" "It was she who used to come between me and my paper when I was writing reviews. It was she who bothered me and wasted my time and tormented me that at last I killed her…." For a further discussion of this topic see *Julia Duckworth Stephen*, eds. Diane F. Gillespie and Elizabeth Steele (Syracuse: Syracuse University Press, 1987), 11.

69 V. Woolf, *Moments of Being*, 53, 56. Virginia was never in the same position as Vanessa, though she was witness to many of the scenes. In later years she wrote: "Through his books I can get at the writer father still; but when Nessa and I inherited the rule of the house, I knew nothing of the sociable father, and the writer father was much more exacting and pressing than he is now that I find him only in books; and it was the tyrant father—the exacting, the violent, the histrionic, the demonstrative, the self-centred, the self-pitying, the deaf, the appealing, the alternately loved and hated father—that dominated me then. It was like being shut up in the same cage with a wild beast" (116). After Stella's death, Jack Hills continued to visit the Stephens, desiring sympathy and eventually falling in love with Vanessa. As with Holman Hunt, who had married his dead wife's sister, marriage would have been impossible in England and they would have had to elope to the Continent but Virginia recalled that her father, "with that backbone of intellect which would have made him, had we lived to be at ease with him, so dependable in serious relations, had said simply, she must do as she liked; he was not going to interfere. That was what I admire in him; his dignity and sanity in the larger affairs; so often covered up by his irritations and vanities and egotisms" (142).

70 Vanessa and Duncan's daughter Angelica assessed Leslie's effect: "He observed his children's differing personalities, and as their minds developed they came to appreciate his honesty, integrity and unworldliness: whether they realized it or not they adopted many of his values. Vanessa greatly admired his rejection of the Christian belief, which seemed to her both courageous and clearheaded: she admired and was seduced by the rationalist point of view, to which she accorded an importance in inverse ratio to the strength of her own emotions" (Angelica Garnett, *Deceived by Kindness: A Bloomsbury Childhood* [Oxford: Oxford University Press, 1984], 19).

71 V. Woolf, *Moments of Being*, 171.

72 Virginia mistakenly identified Holman Hunt's home with Sir Frederic Leighton's home, Leighton House, across the park from Little Holland House.

73 V. Woolf, *Moments of Being*, 176.

74 Wilfred Blunt, *England's Michelangelo A Biography of George Frederic Watts* (London: Hamish Hamilton, 1975), 210.

75 While the Bloomsbury artists would later reject the style of Watts, Roger Fry wrote a complimentary article on "Watts and Whistler" published in *The Quarterly Review* in April 1905, and Duncan Grant copied a Watts portrait.

76 Fiona MacCarthy, *The Omega Workshops 1913–19 Decorative Arts of Blooms-*

bury (London: Crafts Council Gallery, 1984), 11.

77 T. Sturge Moore was a close friend of Lady Ottoline Morrell, the society hostess who entertained members of Bloomsbury regularly at her home, Garsington Manor, with, among others, Aldous Huxley, T. S. Eliot, and William Butler Yeats. In the 1890s Moore was associated with several of the Arts and Crafts presses, including the Vale Press and the Eragny Press.

78 F. MacCarthy, 7.

79 V. Woolf to Thoby Stephen, May 1903, King's College Library, Cambridge University.

80 Letter from Watts to Leslie Stephen, August 2, 1896, Berg Collection, New York Public Library.

81 V. Woolf to Thoby, October/November 1902, King's College Library, Cambridge University. Sargent was a close friend of Henry James and James may have been influential in arranging this.

82 V. Woolf, *Moments of Being*, 18. Vanessa described the change: "It seemed as if in every way we were making a new beginning in the tall, clean, rather frigid rooms, heated only by coal fires in the old-fashioned open fireplaces. It *was* a bit cold but it was exhilarating to have left the house in which had been so much gloom and depression, to have come to these white walls, large windows open-ing onto trees and lawns, to have one's own rooms, be master of one's own time, have all the things in fact which come as a matter of course to many of the young today but so seldom then, to young women at least." V. Bell, *Sketches in Pen and Ink*, 99.

83 Avery, 19.

84 See Reed, *Bloomsbury Rooms*, 23. In *Deceived with Kindness*, Angelica Garnett recalled moving back to Charleston after her father's death: "In the passage of Charleston I had hung some photographs of my grandmother, Julia Jackson, taken by my great-great-aunt, Julia Margaret Cameron. As I looked at them I became conscious of an inheritance not only of genes but also of feelings and habits of mind which, like motes of dust spiraling downwards, settle on the most recent generation" (12).

85 Avery, 17; L. Stephen, *Science of Ethics*, 1882.

86 V. Woolf, *Letters*, vol. I, 172.

87 Sarah M. Hall, *Before Leonard The Early Suitors of Virginia Woolf* (London and Chester Springs: Peter Owen, 2006), 213. Sydney Waterlow, who met the Stephen girls through their brother Thoby, noted this difference, on dining with them in 1910: "Vanessa icy, cynical, artistic; Virginia much more emotional, & interested in life rather than beauty" (quoted from Waterlow's diary, Berg Collection, New York Public Library, September 28, 1910). Waterlow was connected to London literary circles through his cousin, the writer Katherine Mansfield, and his aunt, the Edwardian writer who wrote such books as *Enchanted April* and *Elizabeth and Her German Garden* under the pen name of Elizabeth von Armin. Virginia admired the work of the former but found the writings of von Armin tepid. At the time of this dinner, Waterlow, as a casual acquaintance, was most likely unaware of the strain Vanessa was under, with a new baby, Clive's infidelities, and a hurtful flirtation between Virginia and Clive, causing her to withdraw into herself.

88 Clive, whose background was very different from the intelligentsia of other Bloomsbury members, was always a little out of their ken; Leonard wrote, "The first time I ever saw him he was walking through Great Court in full hunting rig-out—unless that is wishful imag-ination—hunting horn and the whip carried by the whipper-in. He was a great horseman and a first-rate shot, very well-off, and to be seen in the company of 'bloods,' not the rowing, cricket, and rugger blues, but the rich young men who shot, and hunted, and rode point-to-point races. He had a very attractive face, par-ticularly to women, boyish, good-humoured, hair red and curly, and what in the eighteenth century was called, I think, a sanguine complexion.... He was one of those strange Eng-lishmen who break away from their environment and become devoted to art and letters. His family of wealthy philistines whose money came from coal [as did William Morris's] lived in a large house in Wiltshire" (*Sowing*, 141).

89 This was typical Strachey exaggeration—the Bells had a sofa made from a Louis XV head-board in their sitting room.

90 Lady Ottoline Morrell to Duncan Grant, letter in Sussex University Collec-tion, April 29, no year.

91 Frances Spalding, *Duncan Grant* (London: Chatto and Windus, 1997), 13. She goes on to say, "Even at the age of ninety, when inter-viewed on radio, Duncan said of Burne-Jones, 'Never in a way have I ever forgot-ten him, though I've had many other influences.'" Quentin Bell remembered that, like Grant, Roger Fry, who had no affection for either art nouveau or the Pre-Raphaelites, "did always have a qualified but genuine affection for the work of Burne-Jones. His sentiment might be tiresome but his sense of design was impressive...." Q. Bell, foreword to J. Collins, *The Omega Workshops*, ix.

92 Quoted in Betty Askwith's *Two Victorian*

Families (London: Chatto and Windus, 1971), 26. Halsey Ricardo was a well-known London architect who was part of the tile-making revival in England, in partnership with William de Morgan for ten years. His finest and best-known architectural achievement is Debenham House for which de Morgan did the tiles and Ernest Gimson designed the plasterwork.

93 The Hôtel de l'Univers et de Portugal seems to have been a popular place to stay for English-speaking art students for several decades. When the American Arthur Wesley Dow arrived in Paris in 1884, it was there that he took rooms along with many of his compatriots.

94 Quoted in Douglas Blair Turnbaugh, *Duncan Grant and the Bloomsbury Group* (Secaucus: Lyle Stuart Inc., 1987), 23.

95 To understand Duncan's appeal is not difficult. Stories like this one, retold by Quentin Bell in *Bloomsbury Recalled* (New York: Columbia University Press, 1995), are typical of the type of anecdotes his friends liked to share: "Driving our little car along the Strand, its engine stalled. Duncan got out and cranked it up with the starting handle, not without effect: he just managed to leap out of its way and run alongside as it proceeded slowly down the Strand, its doors shut, finally ramming into a majestic Daimler emerging from the Savoy. The innocent victim was naturally enraged. If the culprit had been you or I this is where the story might become unpleasant. Not for Duncan. The injured party at once became his friend; it is said even that it ended with his giving Duncan a commission for a portrait."

96 Angelica Garnett, *Deceived with Kindness*, 35.

97 V. Woolf, *Moments of Being*, 85.

98 Richard Morphet, *Vanessa Bell Drawings and Designs*, November 10–24, 1967, Folio Fine Art Ltd., London, unpaginated.

99 Alvin Langdon Coburn, *An Autobiography*, eds. Helmut and Alison Gernsheim (New York: Frederick A. Praeger, 1966), 92. In the 1910s, Coburn was known both for his portraits (including ones of Duncan Grant, Roger Fry, Edward Carpenter, and Arnold Dolmetsch) and his Vorticist photographs.

100 The Omega's emphasis on collaborative artistic work reflects the values of his generation. Fry's contemporary, Alfred Thornton, compared the art student's life in the 1890s to the 1910s and found that an "element common to the two periods is the astonishing ability shown by students as a mass when at school, and the paucity of even ordinary talent that survives when they go out into the world on their own— a fact that suggests the value of working in community rather than in isolation as artists have done during the last two hundred years…the chief reason for the good paintings of the Old Masters was the *bottega* or workshop system." Alfred Thornton, *The Diary of an Art Student of the Nineties* (London: Sir Isaac Pitman and Sons, Ltd., 1938), 3. A similar system was promoted by Morris and Ruskin and these ideas informed the Bloomsbury artists' organization of the Omega Workshops, and at Charleston a modified form was adapted. Here a congenial camaraderie existed in which the artists worked side by side, learning from each other, criticizing, encouraging, and spurring each other on, contradictory to the competitive atmosphere engendered by the London art galleries. This same sympathetic atmosphere would have been found in the households of the Pre-Raphaelite painters, particularly in William Morris's home, Red House, designed by his friend Philip Webb and decorated, like Charleston, by his artist friends and family members.

101 Quoted in Fiona MacCarthy, *The Omega Workshops*, 11. Letter from Roger Fry to George Bernard Shaw, December 11, 1912.

102 Mabel Dolmetsch recalled the occasion: "When Arnold Dolmetsch delivered the completed instrument at Fry's studio, he found him in the act of painting a wardrobe with a design of orange trees whose fruits were square. He inquired of Fry as to why they were thus misshapen, and Fry answered airily: 'What does it matter! It is of no consequence at all!'" *Personal Recollections of Arnold Dolmetsch* (London: Routledge & Kegan Paul, 1957), 137.

103 Quentin Bell in his introduction to Judith Collins, *The Omega Workshops*, ix.

104 Quoted in Peter Rose, "It Must be Done Now": The Arts and Crafts Exhibition at Burlington House, 1916" in *Journal of the Decorative Arts Society*, no. 17, 7.

105 Richard Morphet, "Image and Theme in Bloomsbury Art" in *The Art of Bloomsbury Roger Fry, Vanessa Bell and Duncan Grant* (Princeton: Princeton University Press, 1999), 23.

106 S. P. Rosenbaum, *Victorian Bloomsbury* (New York: St. Martin's Press, 1987), 106.

Virginia Woolf in America

Mark Hussey

In 1863, at the height of the American Civil War, Virginia Woolf's father, "tired of the snobbery of the Confederate supporters at Cambridge," traveled to America. Noel Annan explains that Leslie Stephen "realized only too well that this upper-class dislike of the North sprang from dread of democracy."[1] While in America, Stephen established close friendships with prominent intellectuals—Charles Eliot Norton, Oliver Wendell Holmes, and James Russell Lowell. The very first letter in Woolf's published correspondence, written when she was six, is to Lowell, who at the time was American Minister in London. The Stephen household was unusual in its American sympathies and connections; unusual, too, for "certain related democratic sympathies; a vision, at least in Leslie Stephen's eyes, of what America meant and promised."[2] Broadly speaking, America has until quite recently proved more hospitable to Leslie Stephen's daughter than her own country. Leonard Woolf remarked in his autobiography on the persistence of the "myth of Virginia as queen of Bloomsbury and culture, living in an ivory drawing-room or literary and aesthetic hothouse,"[3] and despite Bloomsbury's popularity with a younger generation of intellectuals in the 1920s, by the 1930s a harsh critique had emerged, spearheaded by the Cambridge literary critics grouped around F. R. and Q. D. Leavis and their influential journal, *Scrutiny*.

The notorious English reaction against Virginia Woolf that set in during the post–World War II period might be understood as a problem of mishearing. It was difficult for the English to dissociate Woolf's words from the upper-class accent in which she spoke. Americans, on the other hand, although occasionally baffled by her humor, were not so distracted from the substance of what she wrote. Her occasional outbursts against humanity en masse notwithstanding, Woolf inherited the spirit of her father's profoundly ethical stance toward democracy, but her foremost early detractors, the Leavises, could not hear in her works the attitudes and principles of that Cambridge critic they very much admired.[4] Two years after his return from America, Stephen attacked the London *Times* for its support of the South in a lengthy pamphlet, *The Times on the American War* (1865), foreshadowing his daughter's later reaction against the newspaper of record for its promotion of the First World War: "I become steadily more feminist," Woolf wrote in 1916 to Margaret Llewelyn Davies, "owing to the *Times*, which I read at breakfast and wonder how this preposterous masculine fiction keeps going a day longer—without some vigorous young woman pulling us together and marching through it."[5] Woolf's analysis of the power of the press to "burke discussion of any undesirable subject," as she put it in *Three Guineas*,[6] was a significant thread in the bricolage of her 1930s scrapbooks of newspaper clippings and fundraising letters, the source material for much of *Three Guineas* and *The Years*.

Complementing Woolf's exasperation at the rigidity of her own culture was, as Andrew McNeillie describes it, her image of America as "a positive space, a place of democracy and futurity, of largely enabling modernity, but one hampered by European traditions, by the haunting shades of English literature." He calls Woolf's America "an imaginary world" in which she could "extend her

speculations, voice the frustrations of what we call a 'modernist' writer and a woman writer."[7] In a whimsical article for *Hearst's International* magazine in 1938, Woolf asserted that Americans "face the future, not the past." Unlike "the old families who had all intermarried, and lay in their deaths intertwisted, like the ivy roots, beneath the churchyard wall" in her last novel, *Between the Acts*, Americans "never settled down and lived and died and were buried in the same spot."[8] Concerned as she was throughout her life with the intrinsic connection between democracy and education, in this short article Woolf imagines, in an American city, a fantastic repository of literary manuscripts—a sharp contrast to the experience of her narrator in *A Room of One's Own* who is confronted by "a deprecating, silvery, kindly gentleman" who waves her away from the library where she had hoped to consult the manuscript of Milton's *Lycidas*, explaining "that ladies are only admitted to the library if accompanied by a Fellow of the College or furnished with a letter of introduction."[9] No such credentials, she imagines, would be called for in the land of the free:

> But that immense building which might be a factory or a cathedral—what is that? It occupies a commanding position. In England it would be the King's palace. But here are no sentries; the doors stand open to all. The walls are made of stainless steel, the shelves of unbreakable glass. And there lie Shakespeare's folios, Ben Jonson's manuscripts, Keats's love letter blazing in the light of the American sun.[10]

Fifteen years after Woolf's death, Leonard Woolf, considering what to do with his wife's papers, wrote to his brother that he was impressed with the way American universities made writers' papers accessible, and with the intelligence of American students. "I have never come across anything like this here," he continued, "and I feel that

if the MSS went to Cambridge or Oxford, they would be stuffed away somewhere and no one would ever look at them again except that one would be shown from time to time to the public under a glass case."[11] Thus the bulk of Woolf's archive found its way to the Berg Collection of the New York Public Library.

Woolf's reception in the United States was for a long time markedly different than that in her own country.[12] I am referring primarily to the version of Woolf established by feminist academics, for one result of the central role played by the American women's movement in Woolf's steady rise in status in the 1970s and '80s was to make Woolf studies virtually synonymous with feminist criticism. Patricia Joplin wrote in 1983 that "it would be hard to find any major work of American feminist theory, particularly literary theory, that is not to some degree indebted to *A Room*.... There Woolf provided virtually every metaphor we now use. She made available a set of questions, a way of asking them, a possible vision of what lay behind and beyond women's silence."[13] Others have warned, rightly, against drawing too much authority from Woolf, but her centrality in the foundational structures of American feminist literary criticism is undeniable. Her direct descendants in the necessary work of rewriting literary history to include women, and of examining the effect on literature of what she termed in *A Room* the "straight dark bar" of the masculine ego, include Sandra Gilbert and Susan Gubar's three-volume *War of the Words* and Kate Millett's *Sexual Politics*. Woolf's ideas and image are thoroughly imbricated with early works of American literary feminism, such as Joanna Russ's *How to Suppress Women's Writing*, and also inform the work of radical feminist writers such as Andrea Dworkin and Mary Daly. Quite apart from the ubiquitous phrase "A [insert noun here] of One's Own" that crops up in the most wildly diverse contexts (including the

title of this exhibition), Woolf's metaphors and the issues they illuminate continue to make their presence felt in women's writing and writing about women's writing. Such phrases as "we think back through our mothers if we are women," "no common sentence ready for her use," "women as looking glasses reflecting man at twice his natural size," "Chloe likes Olivia," "Anon.… was often a woman," or "interruptions there will always be" have provided a conceptual shorthand for several generations of American feminist critics.

There was intense identification with Woolf among women in the American academy in the early 1970s. Ellen Hawkes Rogat, who published the first challenge to Quentin Bell's representation of his aunt in his widely read 1974 biography of Woolf, wrote of her "pilgrimage" to the Berg Collection: "In a strange way, her experiences and mine began to reverberate. Not only did her thoughts structure mine, not only were my feelings so often filtered through hers, but I also began to understand, almost vicariously, her responses to experience." Echoing Woolf's account of studying in the British Library, Rogat recounts being across the table from a "scholar…who berated his wife, in a strained library whisper, for copying a manuscript too slowly."[14] The personal, as Woolf argued in *Three Guineas*, was political.

The relations between biography and fiction were always of particular interest to Woolf, and have been a prominent feature of Woolf studies from their earliest days. Woolf's writings and her own biography played a salient role in the transformation of autobiography and biography studies that also began in the 1970s. Linda Anderson has pointed out that "throughout her work, in both fiction and nonfiction, Woolf was profoundly concerned with the problems of how to write a life, particularly a woman's life."[15] Daniel Ferrer questions whether it is even possible "in Virginia Woolf's case, to separate

the text and what is outside it, the writing and the life?"[16] As Anderson explains, "Woolf's radicalism and importance as an autobiographer is precisely the extent to which she understood the connection between identity and writing and the need to deconstruct realist forms in order to create space for the yet to be written feminine subject."[17]

Woolf was elevated to a central position in the turbulent cultural politics of the early 1970s through her association not only with feminist criticism but also with the narratives of women's lives privileged through consciousness-raising. At just the moment that feminists were working to reify women's "ways of knowing,"[18] women's life-writing, and women's history, however, American universities were also receiving radical new theories of depersonalization, primarily in the form of translations of Continental European theorists. Roland Barthes's announcement in 1968 of "The Death of the Author" was a profound challenge to what Nancy Miller has described as "the question of female subjectivity, the formation of a female critical subject."[19] In the often bitter debate between so-called "essentialist" feminism and "social construction" theory, Woolf's writings appealed to both camps. Hermione Lee identifies as a risky strategy Woolf's "double approach" in *Three Guineas* to "masculinity as both essentialist and constructed, which it did not try to resolve,"[20] but this unresolved "double approach" is the heart of Woolf's politics, which are, after all, the politics of an *artist*. Although she uses the *Antigone* of Sophocles to make a point about dictators in *Three Guineas*, she ultimately acknowledges that when the artist preaches, art becomes propaganda: "When the curtain falls we sympathize, it may be noted, even with Creon himself. The result, to the propagandist undesirable, would seem to be due to the fact that Sophocles…uses freely all the faculties that can be possessed by a writer; and suggests, therefore, that if we use art to propagate

political opinions, we must force the artist to clip and cabin his gift to do us a cheap and passing service. Literature will suffer the same mutilation that the mule has suffered; and there will be no more horses."[21] The dynamic nature of Woolf's politics, its refusal to settle, allowed her to transcend the opposition between essentialism and construction, both in her fiction and nonfiction. Such dynamism extended also to the autobiographical subject embodied in her letters, diary, and memoirs, making her an exemplary figure for Second Wave American feminism, caught as it often was on the divide between equality and difference, between the urge to deconstruct and eradicate difference, and to emphasize difference as a political strategy.

Woolf as writer, as public intellectual, remains equal to the demands of new times and places. Ellen Messer-Davidow, describing how feminist standpoint theory developed to "refute the disciplinary epistemology, which…claimed that 'only the impersonal, disinterested, socially anonymous representatives of human reason' who used vigorous and value-neutral methods were 'capable of producing [true] knowledge,'" recalls Woolf's careful calibration of her narrative stance in her explicitly political writings like *Three Guineas*, the "Introductory Letter" to *Life as We Have Known It*,[22] or even *A Room of One's Own*. The image of Woolf that circulates as a straw lady whom cultural critics excoriate for class bias is not the Woolf of her own words. The differences in Woolf's reception now are far less a contrast between English and American readings than between political positions in the culture wars. In America, Woolf still can serve as a punching bag for nostalgic conservatives.[23]

The English reaction against Woolf's revival has been to a large extent shared by the American highbrow media which, as Brenda Silver documents in great detail, have tried to reclaim Woolf from the "feminists" whose interests are caricatured as reduc-

tive, limited, and narrow.[24] For example, a widely publicized event organized by the PEN American Center in New York in 2000 was introduced by the novelist Roxana Robinson explaining that Woolf was not a feminist but "had a wide range of interests."[25] This notion that feminism is limiting, reductive, or—worst charge of all—represents women only as *victims* has been used repeatedly to "rescue" an apolitical Woolf, the talented young lady of the ubiquitous Beresford portrait (fig. 1), from scholars

FIG. 1
George Charles Beresford (British, 1864–1938), *Virginia Woolf*, 1902. Platinum print, 6 × 4¼ inches. Courtesy of the National Portrait Gallery, London.

Virginia Woolf at Garsington by Ottoline Morrell, ca. 1930. Courtesy of the National Portrait Gallery, London.

who insist on seeing her as a radical. In England, this attitude was often allied with a tradition of anti-Americanism. Americans typically form the largest contingent at Woolf conferences in the United Kingdom.[26] For many English cultural critics, "Woolf" has been a largely American phenomenon, and, thus, fair game for mockery. Commenting on the absence of any notice of the centenary of Woolf's birth in 1982, Jane Marcus noted a London *Times* article "mocking the vulgarity of American readers and critics for the tastelessness of an interest in Virginia Woolf" and singling her out "for the folly of responding to Quentin Bell's characterization of American feminists as 'lupine critics.'"[27] Marcus had earlier informed readers of the *Virginia Woolf Miscellany* about a *Times Literary Supplement* editorial entitled "Woolf Whistles" that mocked "our existence, our Americanism, our feminism, our contributors, and Woolf herself."[28] That same year, a *Sunday Times* reviewer asked, "Are the Woolfs worth all the fuss we make of them?...does her fiction build up into quite the Mount Everest literary massif which enquiring readers gaze upon with awe? Should the Woolf achievements attract such teams of critical explorers, subsidized by American faculties of English, roping themselves together and planning how they shall reach the summit?"

At a 1988 MLA Convention event marking the fiftieth anniversary of the publication of *Three Guineas*, Cora Kaplan, an American scholar who taught for many years in England, remarked that British students disliked Woolf because of her tone. The American working-class writer Tillie Olsen responded that Woolf was addressing her own class, because it was *their* power she sought to subvert. As Alex Zwerdling argues, Woolf was more critical of her class and had a more complex relation to it than many of her well-known contemporaries.[29] Her honesty about class was unusual at the time,

a time when—after 1917—the abolition of upper-class privilege was more than just a theory. Having matured in a world shaped to some extent by the thought of Marx and Engels, Veblen, and Tawney, Woolf moved socially and politically far beyond the boundaries of her Kensington upbringing. An upper-middle-class woman who occasionally displayed her background's casual anti-Semitism, she married a socialist Jew active in the Labour party; a highbrow artist dedicated to experimental fiction, she spent two and a half years teaching once a week in one of London's poorest districts, at Morley College, and throughout her life supported socialist causes, and even published in the *Daily Worker*. Like everything about Woolf, her class consciousness cannot be reduced to simple categories.[30]

The letters that Woolf kept from correspondents who wrote to her about *Three Guineas* demonstrate convincingly that Q. D. Leavis was wrong to say the essay was "a conversation between her and her friends."[31] In "The Leaning Tower," an essay that began as a paper read to the Workers Education Association, Woolf criticized the Auden generation for its pretense to sharing working-class experience. The only sympathetic piece among responses published in *Folios of New Writing* shortly after Woolf's death in 1941 was by a Welsh miner whose autobiography, *These Poor Hands*, had been published in 1939. B. L. Coombes wrote that he agreed with Woolf that if all the working class has contributed to literature were taken away it would "scarcely suffer," but he continued by saying that "working class writing has not yet become strong on its feet and for the most part is still like an alarmed infant, whimpering at finding itself in strange company and fearing that it may be cuffed before being sent back to its home."[32] He called on the privileged to help those of the working class to learn to read and write, something Woolf would have agreed was imperative. Among those who wrote to her about

Three Guineas was a weaver from Yorkshire named Agnes Smith who at first complained that Woolf had excluded working-class women's experience from her essay. Woolf evidently replied immediately, and the women continued their correspondence until Woolf's death in 1941.[33]

Woolf's identification with Bloomsbury "civilization" as exemplified by Clive Bell, made her an easy target for English journalists and critics from the 1950s on, when a number of Bloomsbury memoirs and Woolf's own *A Writer's Diary* were published; the identification is, however, erroneous. Woolf, in fact, mocked Clive Bell's rather pompous book titled *Civilisation*, noting he "has great fun in the opening chapters but in the end it turns out that Civilisation is a lunch party at no. 50 Gordon Square."[34] In "Virginia Woolf and Offence," Lee documents half a century of class attacks on Woolf, and speculates that their virulent resurgence in England in the 1990s reflects "the continuing domination of masculine critics wielding literary axes… in the universities and on the arts pages."[35] Woolf's class biases have also been examined by American critics within the context of her canonization as a feminist saint. Mary Childers argues that feminist critics have overrated Woolf's political acumen because Woolf aestheticizes politics. Although I disagree with this estimation, believing Woolf's narrative strategies to be in themselves subversive politics,[36] Childers does usefully warn against the overpersonalizing of Woolf as a figure that "tempts some critics to defend her as if she were alive." "What remains politically remarkable about Woolf," Childers writes, "is that she was frequently more daring in confronting the way her class inflected her feminism than most feminist critics are today, and thus she continues to move us to confront the problem that she poses."[37] We can look to Woolf herself for a response to charges of elitism and class insularity. In August 1940, she took great care in replying

to Vita Sackville-West's son Ben Nicolson, who had written to her criticizing Bloomsbury after the publication of her biography of Roger Fry. Recounting her own efforts to share her learning with the working class at Morley College, and her work with the Women's Co-Operative Guild, as well as the political work of Leonard Woolf and Maynard Keynes, she identifies education as the central, vital issue for democracy: "What is the kind of education people ought to have? That it seems to me is the problem we have got to solve."[38]

Raymond Williams described Bloomsbury's members as a "fraction" that broke from their class of origin: "The point is not that [their] social conscience is unreal; it is very real indeed. But it is the precise formulation of a particular social position, in which a fraction of an upper class, breaking from its dominant majority, relates to a lower class *as a matter of conscience*: not in solidarity, nor in affiliation, but as an extension of what are still felt as personal or small-group obligations, at once against the cruelty and stupidity of the system and towards its otherwise relatively helpless victims."[39] This subtle analysis, articulated a quarter century ago, points up the stridency of ongoing critique of Woolf's "elitism," especially when one thinks of some of her contemporaries. For example, T. S. Eliot, in *Notes Toward the Definition of Culture*, warned against the "barbarian nomads of the future [who] will encamp in their mechanised caravans" upon the ground where "ancient edifices" have been destroyed to make room for them.[40] In contrast, in *A Room of One's Own*, Woolf wrote that masterpieces are not single and solitary but "the outcome of many years of thinking in common by the body of the people, so that the experience of the mass is behind the single voice."[41] Among the modernists, Woolf was a radical and unsentimental democrat. But what best explains her rise to prominence in the United States in the 1970s is that Woolf's politics and art were filtered through the prism of gender. As David Bradshaw has written, she "was all too aware that in English society intellectual liberty was a gendered privilege not a cultural touchstone."[42]

In the twenty-first century American reception of Woolf, we have witnessed another turning point in her history as icon, as figure in literary history, and as feminist exemplar. In 2003, a transition was effected in the popular imagination from the monster of Mike Nichols' 1966 movie of Edward Albee's *Who's Afraid of Virginia Woolf?* to the frowning star of Stephen Daldry's movie of Michael Cunningham's novel *The Hours*. Albee's image of a monstrous woman, and his play's "queering of the heterosexual family," appearing as it did at a time of rising fear of women's sexual independence, dispersed a complex of associations with Woolf's image and name that have been at the heart of some of the most bitter cultural battles in the United States.[43] At this later cultural moment, *The Hours* served as a lens to focus arguments that swirled around Woolf throughout the "culture wars" of the 1980s and '90s, and also, implicitly, arguments about the exhaustion of the American feminist project and the detachment of its academic practitioners.

Just as was once the case with Albee's play, it is the movie version of *The Hours* that now provides most people's point of reference for the figure called "Virginia Woolf." In this view, she is frail, homely, dour, alienated from other women, dependent on her husband, and above all suicidal—the film begins and ends with her walking into the Ouse. *The Hours* demonstrated anew the gulf separating entrenched popular conceptions of Woolf from the way she is viewed by scholars and those who read her work. As a *New York Times* article at the time summed up the furor, "The Virginia Woolf of 'The Hours' Angers the Real One's Fans."[44] In one of the most insightful of the many articles about *The Hours* phenomenon, Daniel Mendelsohn argued that the

film fails to present Woolf "as the confident, gossip-loving queen of Bloomsbury, the vivid social figure, the amusing diarist, the impressively productive journalist expertly maneuvering her professional obligations—and relationships.… If anything," he continued, "the film's Woolf is just one half (if that much) of the real Woolf, and it's no coincidence that it's the half that satisfies a certain cultural fantasy, going back to the early biographies of Sappho, about what creative women are like: distracted, isolated, doomed." Mendelsohn quoted from *A Room of One's Own* to illustrate his contention that the film devalues women, in contrast, he said, to Cunningham's novel: "The truth is, I often like women. I like their unconventionality. I like their subtlety."[45] Julia Briggs has pointed out that sixteen days after *A Room* was published in England in October 1929, Woolf changed the word "subtlety" to "completeness" in the second impression of the first edition. She writes, "Woolf's enthusiasm for women had changed: instead of liking their subtlety, she liked their completeness," and comments that "if any textual change could be considered a feminist revision, it must surely be the change from 'subtlety' to the very different claim made for women by 'completeness.'"[46] The popular icon "Virginia Woolf" incarnated in Nicole Kidman's performance may well lack subtlety *and* completeness in comparison to the "Woolf" known to—and through—American scholarship.

In *Three Guineas*, Woolf famously declared "daughters of educated men," among whom she classed herself, to belong to "no country": "As a woman I want no country. As a woman my country is the whole world."[47] And Virginia Woolf is probably now fairly described as a border-crossing global literary phenomenon, at least as far as scholarship is concerned. The American encounter with Woolf, however, continues to be unique in its affection for her as more than an important experimentalist writer of the early twentieth century. It may seem perverse that I have neglected her fiction in this account of how Woolf's contemporary reputation was forged in America in the 1970s and '80s, but I have been trying to explain why Americans—particularly women, particularly feminists—have so welcomed Woolf.[48] When an African-American single mother hears in *A Room of One's Own* passages that "speak to the concerns and experiences of black people in the same way that classical blues do," we recognize a Woolf largely inaudible to English readers.[49] Woolf's words crop up daily in essays, blogs, and book reviews. One of the most interesting—and characteristically American—recent instances of Woolf's continuing presence as mentor and guide for new generations of women has been the appearance of books that quite explicitly envision her in that role. Their titles speak for themselves: *Letters to Virginia Woolf*; *The Virginia Woolf Writers' Workshop: Seven Lessons to Inspire Great Writing*; *A Life of One's Own: A Guide to Better Living Through the Life and Work of Virginia Woolf.*[50] Woolf wrote in her diary on April 13, 1930, that she "could say that Shakespeare surpasses literature altogether, if I knew what I meant." Americans have long felt the same way about her.

NOTES

1 Noel Annan, *Leslie Stephen: The Godless Victorian* (New York: Random House, 1984), 52.

2 Andrew McNeillie, "Virginia Woolf's America," *Dublin Review* 5 (Winter 2001–2), 41.

3 Leonard Woolf, *An Autobiography*, vol. 2. (New York: Oxford, 1980), 244.

4 Ian McKillop, *F. R. Leavis: A Life in Criticism* (New York: St. Martin's Press, 1997), 276–77.

5 Virginia Woolf, *The Letters of Virginia Woolf,* vol. 2, 1912–1922, eds. Nigel Nicolson and Joanne Trautmann (New York: Harcourt Brace Jovanovich, 1976.), 76.

6 Virginia Woolf, *Three Guineas*, rev. ed. (1938; repr., Orlando: Harcourt, 2006), 191.

7 McNeillie, 42–43

8 Virginia Woolf, *Between the Acts* (New York: Harcourt, 1969), 7; "America, Which I Have Never Seen." *Dublin Review* 5 (Winter 2001–02), 58.

9 Virginia Woolf, *A Room of One's Own* (Orlando: Harcourt, 2005), 7, 8.

10 V. Woolf, "America, Which I Have Never Seen," 59.

11 *The Letters of Leonard Woolf*, ed. Frederic Spotts (San Diego: Harcourt Brace Jovanovich, 1989), 500.

12 The situation now is entirely different. Textual scholarship on and the editing of Woolf's writings has been almost entirely a British affair, spearheaded by Julia Briggs's "feminist" edition of Woolf for Penguin, where English editors dominate. The recent *Cambridge Companion to Virginia Woolf* also is dominated by British critics.

13 Patricia Joplin, "'I Have Bought My Freedom': The Gift of *A Room of One's Own*," *Virginia Woolf Miscellany* 21 (Fall 1983), 4–5.

14 Ellen Hawkes Rogat, "Visiting the Berg Collection," *Virginia Woolf Miscellany* 1 (Fall 1973), 1.

15 Linda Anderson, *Women and Autobiography in the Twentieth Century: Remembered Futures* (London: Prentice Hall and Harvester Wheatsheaf, 1987), 13. See also my "Biographical Approaches" in *Palgrave Advances in Virginia Woolf Studies,* ed. Anna Snaith (Houndmills: Palgrave Macmillan, 2007), 83–97.

16 Quoted in Anderson, 49.

17 Anderson, 13.

18 Mary Field Belenky and others, *Women's Ways of Knowing: The Development of Self, Voice and Mind* (New York: Basic, 1986).

19 Roland Barthes, "The Death of the Author" in *Image-Music-Text*, trans. Stephen Heath (New York: Noonday, 1977). Nancy Miller, "Changing the Subject: Authorship, Writing, and the Reader," in *Feminist Studies/Critical Studies*, ed. Teresa de Lauretis (Bloomington: Indiana University Press, 1986), 103.

20 Hermione Lee, "Virginia Woolf and Offence" in *The Art of Literary Biography*, ed. John Batchelor (Oxford: Clarendon Press, 1995), 681.

21 Virginia Woolf, *Three Guineas* (Orlando: Harcourt, 2006), 201–02.

22 Ellen Messer-Davidow, *Disciplining Feminism: From Social Activism to Academic Discourse* (Durham: Duke University Press, 2002), 188, quoting Sandra Harding. Virginia Woolf, "Introductory Letter" in *Life as We Have Known It by Co-Operative Working Women*, ed. Margaret Llewelyn Davies (London: Hogarth Press, 1931), xv–xxxix.

23 A recent example is provided by Theodore Dalrymple in "The Rage of Virginia Woolf" in his collection *Our Country, What's Left of It: The Mandarins and the Masses* (Chicago: Ivan R. Dee, 2005).

24 Brenda Silver, *Virginia Woolf Icon* (Chicago: University of Chicago Press, 1999).

25 Mark Hussey, "To the Readers," *Virginia Woolf Miscellany* 55 (Spring 2000), 1.

26 See, for example, a Fall 1987 report on a conference at Sussex in *Virginia Woolf Miscellany* 29; at the 11th annual conference on Woolf (2001) held at the University of Wales, Bangor, Americans were again present in significantly larger numbers than the locals.

27 Jane Marcus, "Introduction: Umbrellas and Bluebonnets" in *Virginia Woolf and Bloomsbury: A Centenary Celebration* (Bloomington: Indiana University Press, 1987), 1.

28 "Woolf Whistles." *Virginia Woolf Miscellany* 11 (Fall 1978).

29 Alex Zwerdling, *Virginia Woolf and the Real World* (Berkeley: University of California Press, 1986).

30 For further reflections on Woolf and class, see my "Mrs. Thatcher and Mrs. Woolf," *Modern Fiction Studies* 50.1 (Spring 2004), 8–30.

31 Q. D. Leavis, "Caterpillars of the Commonwealth Unite!" *Scrutiny*, September 1938, 203.

32 B. L. Coombes, "Below the Tower." *Folios of New Writing* (London: Hogarth Press, 1941), 32.

33 Woolf urged Smith to publish her autobiography with the Hogarth Press, and in fact Smith did publish *A Worker's View of the Wool Textile Industry* in 1944, but not with Hogarth.

34 Quentin Bell, *Virginia Woolf: A Biography*, vol. 2 (London: Hogarth Press, 1973), 137.

35 Lee, 131.

36 See William R. Handley, "War and the Politics of Narration in *Jacob's Room*," in *Virginia Woolf and War: Fiction, Reality, and Myth*, ed. Mark Hussey (Syracuse: Syracuse University Press, 1991), 110–33.

37 Mary Childers, "Virginia Woolf on the Outside Looking Down: Reflections on the Class of Women," *Modern Fiction Studies* 38.1 (Spring 1992), 62, 78.

38 *The Letters of Virginia Woolf*, vol. 6, 1936–1941. Edited by Nigel Nicolson and Joanne Trautmann (New York: Harcourt Brace Jovanovich, 1980), 420

39 Raymond Williams, "The Bloomsbury Fraction." *Problems in Materialism and Culture: Selected Essays* (London: Verso, 1980), 155.

40 T. S. Eliot, *Notes Toward the Definition of Culture*, rev. ed. (1948; repr., London: Faber, 1972), 108.

41 V. Woolf, *A Room of One's Own*, 65.

42 David Bradshaw, "British Writers and Anti-Fascism in the 1930s. Part Two. Under the Hawk's Wings," *Woolf Studies Annual* 4 (1998), 41.

43 Silver, 114.

44 Patricia Cohen, "The Nose Was the Final Straw: The Virginia Woolf of 'The Hours' Angers the Real One's Fans," *New York Times*, February 15, 2003.

45 Daniel Mendelsohn, "Not Afraid of Virginia Woolf." *New York Review of Books* 50.4 (March 13, 2003), 19.

46 Julia Briggs, "In Search of New Virginias," in *Virginia Woolf: Turning the Centuries. Selected Papers from the Ninth Annual Conference on Virginia Woolf*, eds. Ann Ardis and Bonnie Kime Scott (New York: Pace University Press, 2000), 171.

47 V. Woolf, *Three Guineas*, 129.

48 By 1996, however, Jane Marcus was ready to declare that it was time to repatriate Woolf: "Is she breathing a sigh of relief, so long critically captive in foreign lands, that we are now shipping that unmistakably English figure, body wrapped in the stars and stripes, with full anti-military honors, back to a country beginning to claim her as their own?" ("Wrapped in the Stars and Stripes: Virginia Woolf in the U.S.A." *The South Carolina Review* 29.1 [Fall 1996], 17).

49 Tracey Levy, "The Murmur Behind the Current: Woolf and the Blues," in *Virginia Woolf: Emerging Perspectives. Selected Papers from the Third Annual Conference on Virginia Woolf*, eds. Mark Hussey and Vara Neverow (New York: Pace University Press, 1994), 303.

50 Lisa Williams, *Letters to Virginia Woolf* (Lanham, MD: Hamilton, 2005); Danell Jones, *The Virginia Woolf Writers' Workshop: Seven Lessons to Inspire Great Writing* (New York: Bantam, 2007); Ilana Simons, *A Life of One's Own* (New York: Penguin, 2007).

Only Collect:
Bloomsbury Art in North America

Christopher Reed

RECENT SCHOLARSHIP on art collecting has shifted emphasis from product to process. Collecting, in this view, is not the discovery and acquisition of objects that have inherent meaning or quality. Collectors, rather, actively contribute to our assessments of meaning and quality. The story of collecting is, thus, "a narrative of how human beings have striven to accommodate, to appropriate and to extend the taxonomies and systems of knowledge they have inherited."[1]

Collections of Bloomsbury art in North America exemplify this proposition in the ways they accommodate, appropriate, and extend specifically American perceptions of the group. That we should have our own perspectives on Bloomsbury is no surprise. The historical links between Britain and North America are powerful, but this strength does not imply congruity. Quite the contrary. Although these two Anglophone cultures play an important part in each other's identity, since at least 1776 these identities have been defined, at least in part, by antagonism. Hence George Bernard Shaw's observation that Britain and America are two cultures separated by a common language. Adam Gopnik recently identified two Englishmen—C. S. Lewis and Winston Churchill—"whose reputation in Britain is so different from their reputation in America that we might as well be talking about two (or is that four?) different men."[2] Bloomsbury multiplies this phenomenon.

Some of this difference derives from chronology. Bloomsbury first claimed the attention of British audiences as a contingent of the art world avant-garde. Its artists and critics were well known for their roles in the controversial Post-Impressionist exhibitions of 1910 and 1912, and the Omega Workshops. A few Americans knew Bloomsbury in this context. A memoir by the cofounder of the Sunwise Turn, an avant-garde New York bookstore and gallery founded in 1916, is dedicated to "Mr. Clive Bell, who, though I have never seen him, and he has never heard my name, founded this bookshop because he wrote a book." The book that was so exciting a bookstore opened to sell it was Bell's 1914 *Art*, and the founders of the Sunwise Turn hoped to sell Omega products, as well.[3] For the most part, however, American awareness of Bloomsbury began after World War I and focused not on art but on the writings of Lytton Strachey, Virginia Woolf, and John Maynard Keynes. American interest in figures on Bloomsbury's near-periphery—novelists E. M. Forster and David Garnett, or the poet Julian Bell—also contributed to a text-based sense of the group. Even Roger Fry was known in America for his writings on art, rather than for his painting. In contrast to American familiarity with Bloomsbury texts, Bloomsbury art remained almost unknown in North America for most of the twentieth century.

When, in the last third of the century, American collectors came to Roger Fry, Vanessa Bell, Duncan Grant, and Dora Carrington, their appreciation of the Bloomsbury artists was rooted in their love of the group's writers. This is emphatically not to deny the aesthetic response and emo-

tional attachment Americans experience in relation to the art they collect, but those aesthetic and emotional responses both reflect and inflect the "taxonomies and systems of knowledge," as the scholars put it, that collectors bring to these experiences. Put more simply, Bloomsbury means different things to different audiences. These differences distinguish Americans from Britons, and reflect generational changes as well. Our ideas of what "Bloomsbury" means are inseparable from our responses to the art the group produced. The current exhibition is evidence of the many American pleasures in Bloomsbury, and provides an occasion to consider the history of Bloomsbury collecting on this side of the Atlantic.[4]

There is great variety among American collections of Bloomsbury art and among the collectors. The smallest collections comprise a few drawings; the largest includes almost one hundred paintings, drawings, and works of decorative art. Some of the collectors—the academics—are professionally engaged with Bloomsbury; others came to know Bloomsbury through their attraction to the art. The variety among the collectors is evident in their approaches to collecting. Some collect Bloomsbury art exclusively. Some see their Bloomsbury art as secondary to collections of Bloomsbury books. For others, works by the Bloomsbury painters are part of broader collections, usually of British art.[5] Donald and Patricia Oresman have amassed over two thousand images of people reading, of which a small percentage come from Bloomsbury; these vie for space with their ten thousand books. With no such plan in mind, author Wendy Gimbel and her husband Doug Liebhafsky were delighted when a publisher visiting their home characterized their Pre-Raphaelite and early-twentieth century British art as "a literary collection of drawings and paintings" created by "people who are essentially readers." As these examples suggest, an examination of

Bloomsbury's American collectors reveals patterns and commonalities within the variety of methods and means. Taken together, these collections reflect and develop specifically American modes of approach to and appreciation of Bloomsbury and its art.

"One may as well begin."[6]

THE FIRST COLLECTIONS

Approaching Bloomsbury through Strachey, Keynes, and Woolf, North American collectors were drawn first to the artists closest to those writers. Roger Fry's absence from this history is sadly ironic, for, within Bloomsbury, he had the closest ties to North America. Fry was the only Bloomsbury member to spend significant time here, this during 1906–07 when he was Curator of Paintings at the Metropolitan Museum of Art in New York (he remained associated with the Met as European Advisor, working from London, until 1909). During the first decade of the twentieth century, Fry played a crucial role in shaping the collection at the Metropolitan and also, through his friend John G. Johnson, at the Philadelphia Museum of Art.[7] Despite—or because of—Fry's reputation as a connoisseur and critic, Americans hardly knew him as an artist, however. With the apparently unique exception of the purchase by the anglophile director of the Worcester Art Museum of Fry's 1919 still life *The Blue Bowl* (cat. 54) in 1924,[8] during his lifetime American museums ignored the art created by the man whose formalist aesthetic theory became central to the development of modern art in the twentieth century.

Fry's American sojourn predated his turn to formalism. Among the few examples of Fry's painting from his American period is a 1905 watercolor

depicting the façade of Chartres cathedral and inscribed "To E. Robinson from R. E. Fry 1905" (fig. 1). Robinson, whom Fry described as "the real director of the Museum," was officially the Met's assistant director during Fry's tenure, and often mediated Fry's antagonistic relationship with the nominal director (and fellow Brit), Sir Casper Purdon Clark.[9] Fry's letters from this period invoke Charles Dickens's caricature of the drunken busybody to describe "Sir Purdon" as "like a Mrs Gamp," in contrast to "Robinson of Boston…a real brick, a man of solid sense and capacity."[10] Robinson went on to serve for two decades as the museum's director, and Fry's little watercolor is now in the Met's collection, a bequest in 1952 from Robinson's widow.[11]

The Metropolitan added a second Fry to its collection in 1959, when Pamela Diamand—Fry's daughter, who cared for her father's legacy with "a devotion more often found in artists' widows," as Frances Spalding put it—donated his 1919 oil portrait of Gabrielle Soëne to the museum (fig. 2).[12] At this period, Diamand also donated one of Fry's Provençal landscapes and fifteen lithographs to the Art Gallery of Ontario, which had purchased one of Fry's British landscapes in the 1930s.[13] Despite Diamand's best efforts, however, Bloomsbury's low profile among American arts professionals is evidenced by the fact that these gifts failed to spark further interest among the North American museums that received them.[14]

Throughout this period of institutional neglect, a major collection of Fry's art was in North America, hanging in the home of Julian Fry, the artist's son. After studying agriculture at Cambridge University, Julian Fry immigrated to British Columbia in 1923, where he became a rancher, and eventually the secretary of the British Columbia Cattle Growers Association. Insisting that he did not inherit his father's credentials to judge or discuss art, Julian simply said of his collection, "I like his pictures, many of them, very much."[15] Among his approxi-

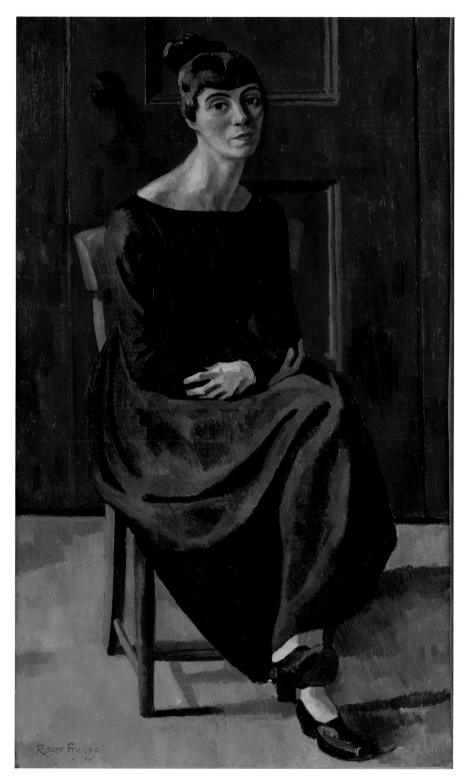

FIG. 2
Roger Fry, *Gabrielle Soëne*,
1919. Oil on canvas,
50 × 30 inches. Collection
of the Metropolitan
Museum of Art. Gift of
Mrs. Pamela Diamand,
1959. (59.132)

mately seventy-five works were images of personal significance, such as the pencil portrait of Julian (fig. 3) that became the basis for Fry's woodcut *The Novel* (cat. 181), published by the Woolfs at the Hogarth Press in 1921.[16] The overall emphasis of Julian's collection, however, was rural landscapes. While this theme may have reflected Julian's interests, family lore has it that his sister shaped her brother's collection according to the criterion of which of Fry's paintings she felt "could be sent to the colonies."[17] Although both Fry's children lent his art to Canadian exhibitions in the 1970s, the bulk of Julian's collection was returned to London for sale in 2005.[18]

For most of the twentieth century, North American audiences knew even less of Duncan Grant and Vanessa Bell than they did of Fry. As late as 1981, when the Metropolitan acquired Grant's still life, *The Coffee Pot* (fig. 4), a document justifying the purchase noted, "No other painting by Grant is owned in New York."[19] This reference is to public collections, for by the 1980s there were Grants—and Bells and Frys, too—in private collections in New York and throughout America. Grant's art was first featured by a New York commercial gallery in 1975 and Bell's, by the same gallery, in 1980.[20] Public collections, however, came to Bloomsbury slowly. Even with its focus on Britain, the Yale Center for British Art purchased its first significant Bloomsbury paintings—one each by Fry, Bell, and Grant—only in 1982.[21] Establishing a pattern that continues to the present day, American interest in collecting Bloomsbury art arose outside the institutions of art history, primarily among academics in other fields. Changing values in American academia—and American culture more broadly—however, have rendered scholars' early perceptions of Bloomsbury almost unrecognizable today.

For the first of these collectors, Charles Richard Sanders, an English professor at Duke University, Bloomsbury sustained a venerable tradition of

FIG. 3
Roger Fry, *Portrait of Julian Fry*. Pencil study for "The Novel" in *Twelve Original Woodcuts* (see cat. 181), Hogarth Press, 1921. Private collection. Courtesy Tony Bradshaw, The Bloomsbury Workshop.

British groups, "such as that around John Locke, that around Carlyle," that "combined the best that liberalism could give with the best that traditions could offer." These phrases come at the end of Sanders's 1953 history of three and a half centuries of the Strachey family's "writings and literary associations."[22] A second book, devoted to Lytton Strachey, followed in 1957. Both books were begun in the 1940s, when Sanders, a specialist in Samuel Coleridge and Thomas Carlyle, sought what he called "relief in research" from the exigencies of the Second World War, and found in Strachey's writings "a subject which would be 'light' and amusing." Acknowledging that he had "very little of the icono-

FIG. 4
Duncan Grant, *The Coffee Pot*, ca. 1916. Oil on canvas, 24 × 20 inches.
Collection of the Metropolitan Museum of Art. Purchase, Mr. and Mrs. Milton Petrie Gift, 1981.
(1981.197)

clast or the satirist in my temperament," Sanders was nevertheless taken with Strachey, finding him "a true classic of English prose" whose

> writings will be highly valued in the future as they have been in the past for the steadfast love of art and beauty which they reflect; for the ideal of order which they embody in an age of confusion; for the marked respect for literature underlying them and for the guidance and increased delight which they give to others who wish to read the best books; for a superb style equally effective in biography and criticism; for an unshakable conviction concerning the incalculable value of friendship, an intense interest in people as individuals, an unusual insight into their lives, and a deep power of sympathy for them; for the complete faith which he consistently shows in the free mind; for a constant loyalty to truth, both scientific and humane; and for an unfailing sense of humor of both laughter and sanity.[23]

During his researches in England, Sanders visited various Stracheys and their friends, forging friendships with James Strachey, Barbara Bagenal, Janey Bussy, and Frances Partridge. Partridge's diary records a visit from "Professor Dick Sanders of Duke University, who is writing about Lytton and all the Stracheys." Delighted by "the intensely human, emotional being that lies underneath the donnish exterior and American pursuit of culture," Partridge enjoyed walks during which they talked of Shakespeare and death: "'I only believe in total extinction,' he announced, 'but if I were to be offered the chance of existing forever, in a bodily as well as a spiritual form, *I should jump at it*. I love life.'"[24] Like so many others, Sanders was charmed by Duncan Grant, a Strachey cousin. They traveled together to Grant's birthplace, Rothiemurchus, in the Scottish highlands. Sanders purchased from Grant thirteen works of art by both Grant and Vanessa Bell, among them pen sketches of Strachey and Keynes.[25] And Grant inscribed to Sanders a drawing of Thomas Carlyle based on a photograph by the pioneering Victorian photographer Julia Margaret Cameron, who was Vanessa Bell and Virginia Woolf's great-aunt (fig. 5). Sanders was also the happy recipient of one of Grant's Christmas cards, a whimsical image of a jug decorated with a boy holding a jug (fig. 6).

Around 1965, after his daughter Nancy married a young economics professor at Duke, Sanders arranged for Grant to sell the young couple Vanessa Bell's 1934 painting titled *A Garden Walk* (cat. 19). This was the start of Nancy and Craufurd Goodwin's extraordinary collection of Bloomsbury art, which was a primary inspiration for this exhibition. The Goodwins' collection developed after 1990, at a later moment in the history of American interest in Bloomsbury art, but its origins in Sanders's professional engagement with Lytton Strachey and the history of British letters exemplifies how Americans approached Bloomsbury through the group's writers.

FIG. 5
Dr. Sanders looking at a drawing by Duncan Grant made for him of Thomas Carlyle based on a photograph by Julia Margaret Cameron.

A second pioneering American collection of Bloomsbury art was the project of another prominent academic, Philip Rieff, for decades the Benjamin Franklin Professor of Sociology at the University of Pennsylvania. Begun in the 1960s, Rieff's collection focused not on Bloomsbury but on British art from the eighteenth to the mid-twentieth centuries.[26] Coincidentally, both Rieff and Sanders completed their graduate training at the University of Chicago, where both specialized in Coleridge's ideas about religion and religious authority[27]—only Rieff, however, married the very young Susan Sontag, who was one of his students. Philip Rieff, in the words of one of his admirers, "adopted 'Old England' and its high culture as a 'cultural homeland'…adopting an 'Oxfordish' accent and a very idiosyncratic way of dressing himself."[28] Rieff's "three-piece pin-stripe suit and well polished English brogues" made an "unforgettable" impression on Frances Spalding when she visited Rieff's Philadelphia townhouse in the late 1970s, while researching her biography of Roger Fry.[29] By the time I made the same pilgrimage in the mid-1990s, he had added a silver-topped cane to this ensemble. Rieff's art collection reflected his veneration for English high culture, a tradition in which he saw Roger Fry as what he called one of the "major judgers of artistic value."[30] Rieff owned a score of Fry's paintings as well as Marie-Mela Mutter's portrait of Fry, which Spalding chose for the dust jacket of her 1980 biography, *Roger Fry: Art and Life*.

Rieff's attitudes distinguish him from other American collectors, for he was not interested in Bloomsbury. Indeed, Rieff's writings from the 1970s onward comprise a jeremiad against the open-mindedness and skepticism of political and intellectual authority we now associate with the group. "Our culture is in crisis today precisely because no creed, no symbol, no militant truth, is installed deeply enough now to help men constrain

FIG. 6
Duncan Grant, *Christmas Card*, 1950s. Watercolor and ballpoint pen, 7½ × 4½ inches. Private collection.

their capacity for expressing everything," Rieff complained in a 1977 essay. "It is culture, deeply installed as authority, that generates depth of character, and character must involve the capacity to say No."[31] For Rieff, Fry's art criticism exemplified this ethos of control. He praised Fry's writings on Cézanne for demonstrating the "inhibiting" effect of the "supreme subtleties" of great art against the younger academics' preference for "direct action."[32] With such attitudes, it's no wonder Rieff disdained Bloomsbury; his references to the group are few and more grandiose than accurate.[33]

Rieff's collection, which has been partially dispersed since his death in 2006, may be best understood as a last vestige of an older American perception of Bloomsbury based upon a few of the most widely circulated publications by the group's most prominent members. Beginning in the late 1960s, however, American perceptions of the group began to shift as ideological trends associated with the resurgence of feminism and the sexual revolution dovetailed with new kinds of Bloomsbury publications: letters, journals, and biographies of the group's members.

"It would be a thousand pities if women wrote like men, or lived like men, or looked like men."[34]

GENDER AND COLLECTING

Michael Holroyd's biography of Lytton Strachey—two volumes published in 1967 and 1968—is widely credited (or blamed) for revolutionizing perceptions of Bloomsbury by acknowledging the group's rejection of conventional sexual norms. Holroyd recalled, "I remember I plunked down an enormous typescript in front of [Duncan Grant] with revelations about his homosexual affairs…. After some time he gave me the go-ahead to use the material about him. He

smiled and said 'Will I be arrested?' It was an act of courage for someone born in the Victorian age."[35] Read today, the treatment of homosexuality in Holroyd's biography can seem flat-footed. Even at the time, Leonard Woolf's review suggested that a certain "pomposity" and lack of humor undercut the "conscientious industry" Holroyd had devoted to understanding the irreverent and funny man who was his subject.[36] Holroyd's tone of the earnest clinician who casts homosexuality as the cause of a wide range of behaviors he understands but does not approve of is exemplified by the way Strachey's romantic infatuations, which were generally more emotional than physical, are indexed as symptoms under "Strachey, Lytton, *Homosexuality*," and in his condemnation of the campier aspects of Strachey's Wildean writings and mannerisms: "In both cases their homosexuality was tied to an exaggerated self-preoccupation which, with its accompanying passion for the applause of others, acted as the limiting factor on their creative output."[37] Despite the biography's deficiencies, however, the material it brought before the public—how many readers made use of that index entry?—attracted new audiences to Bloomsbury. Pioneering this new generation of scholarly admirers was another American professor, Carolyn Heilbrun.

Heilbrun's early scholarly career offered few indications of the rebel she would become. Her 1959 dissertation, published in 1961 as a book, followed a pattern similar to Sanders's book on the Stracheys, examining the Garnetts, another prominent family in English letters. Like Sanders, Heilbrun came to Bloomsbury through the youngest member of the literary dynasty she studied, striking up a warm friendship with the novelist David Garnett, who was on what might be called Bloomsbury's near fringe.[38]

Having discovered Bloomsbury with pleasure, Heilbrun, like many Americans, was surprised to encounter the hostility Bloomsbury aroused among British academics. In one of her literature courses at Columbia University, she reported, "A very bright

young Englishman accused them all of being shrill, arty, escapist, aristocratic, and insufficiently talented …he finally attacked them, with passion, for being, many of them, homosexual." This account opens Heilbrun's 1968 article, "The Bloomsbury Group," where it introduces her passionate defense of the group. Heilbrun's argument, powerfully inflected by recent feminist critiques of conventional gender roles, contends, "The ascendancy of reason which excludes violence but not passion was possible to the Bloomsbury group, I believe, because within it, perhaps for the first time, masculinity was infused, actually merged, with femininity.… Bloomsbury insisted on rejecting the Victorian stereotypes of masculine and feminine in favor of an androgynous ideal."[39]

Heilbrun's essay, published in an out-of-the-way venue, in retrospect stands as a milestone in American scholarship on Bloomsbury.[40] Heilbrun was among the first feminist scholars who explicitly acknowledged their identification with Woolf: "As a woman, I know that Virginia Woolf has uniquely presented some part of the female sensibility: its pain, its impotent awareness, its struggle to be free of the littleness of life, its deep distrust of political parties and the state."[41] Her manifesto seems to be the first to reassess Bloomsbury in relation to the social and intellectual ferment of the 1960s, and was certainly the first to use the revelations in Holroyd's Strachey biography. "It is tempting to begin by pointing out how like they were, when young, to the rebellious youth of today," is the first line of Heilbrun's essay. An asterisked citation (the only citation in the essay) at the bottom of the first page acknowledges her "use of Michael Holroyd's recent monumental biography of Lytton Strachey."

When Heilbrun revisited the themes of this essay in her 1973 book *Toward a Recognition of Androgyny*—a pioneering feminist text published the year after she gained tenure at Columbia—her passion was undimmed, although the anecdotes redolent of the enthusiasm of discovery in her short 1968 article were replaced by sustained scholarly readings of Bloomsbury texts.[42] One such anecdote, which appeared in the article but not in the book, described Heilbrun's recent visit to Charleston, the farmhouse Duncan Grant had shared with the Bells: "The sense of life being lived rather than endured still clung about it. Can one describe Charleston by saying that it had been created not copied, and that no thought had been taken of propriety?"[43] Heilbrun's article explains that what brought her to Charleston in the first flush of her new enthusiasm for Bloomsbury was a desire "to buy a self-portrait of Duncan Grant." Years later, she recalled the visit she made with her husband, the economist James Heilbrun:

> In (I believe) 1967 Jim and I visited David Garnett in his houseboat by Battersea Bridge. He told us that poor Duncan was feeling low; no one was paying attention to his paintings. Garnett suggested that maybe we would buy one. We didn't have much money in those days, but we trundled down to Charleston where I asked Grant for a self-portrait. He sold us the one we have for five hundred dollars, a huge sum to us in those days [cat. 89]. He was so pleased that he threw in a painted sketch he had made of his grand-daughter Amaryllis that afternoon, and a painting of Hampstead Heath.[44]

This small collection was augmented in the early 1980s when Heilbrun bought a self-portrait by Vanessa Bell from the London dealer Anthony d'Offay[45] (cat. 15). She delighted in showing visitors the two self-portraits, which were hung so that Grant seemed to be gazing at Bell, who had the position of honor over the fireplace. Together the paintings evoked in Heilbrun's living room what she loved about Charleston: the sense of an environment defiant of conventional proprieties, a place

where life could be "lived rather than endured."
It is fitting, therefore, that her Grant self-portrait
has a bit of domestic decoration on the back (fig. 7).

Heilbrun's enjoyment of her small collection
of Bloomsbury paintings finds echoes among many
American collectors, academic and otherwise.
Unsurprisingly, many scholars who specialize in
Woolf and Bloomsbury have acquired a much-loved
drawing or print. Mary Ann Caws's 1990 book,
Women of Bloomsbury, analyzes her powerful and
various identifications with Virginia Woolf, Vanessa
Bell, and Carrington in a project of "personal criti-
cism" she describes as "writing *along with*, rather
than on or about." Describing the "charm" and
"apparently childlike sense of life" evident in
Carrington's paintings, Caws analyzes a flower
piece, *Begonias* (cat. 39), that

> has haunted me since the time I first saw
> it. Everything in it: its angles, its colors, its
> presentation, all are odd. In it there predomi-
> nate, almost clashing, the colors orange and
> pink and green. Not only are those not my
> favorite colors, by a long shot, but I could
> not have conceived of their fitting together:
> perhaps indeed they do not fit, any more than
> Carrington herself.

Caws concludes by speculating that *Begonias*
was "painted by someone who saw the world in a
different way, but who was perhaps unaware of that:
the effect on the viewer is startling, as I see it." Caws,
in fact, sees this painting in her own home, reliving
her pleasurable shock of recognizing another woman
who did not always fit in. Her small collection of
Grant's drawings (cats. 71, 80, 102) emphasizes his
bonds with the women around him, especially with
Vanessa Bell, whose love for Grant Caws seeks to
"cherish" against "the accusations of society against
forms of living that seem…to be already at risk
because abnormal…and not strictly categorizable."[46]

FIG. 7
Duncan Grant, verso of *Self-Portrait* (cat. 89).
Collection of Mills College Art Museum.

Feminist perspectives are not unique to the academics among Bloomsbury's collectors. Second-wave feminism—that is, the feminism that followed what Heilbrun called the "dark years" of antifeminist backlash during the mid-twentieth century[47]—provided a powerful impetus for recent interest in Bloomsbury, primarily through the figure of Virginia Woolf. Mona Pierpaoli, laughing over her insistence on using the term "feminist" to characterize her generation of female college students in the 1970s, describes her entrance to Bloomsbury "by way of Virginia Woolf" and her adoption of certain talismans of Woolf's life: "any woman—feminist—woman who went to college in the '70s would naturally read Woolf and be inspired by it. And Woolf leads you to other Bloomsbury figures. You start reading the poets and you start reading the critics and you start looking at who else was in her life. She's a giant! My dog is named Pinker. That's Virginia Woolf's dog, the dog on the cover of *Flush*." Pierpaoli's account of her engagement with Bloomsbury art is echoed by Wendy Gimbel: "I think I started collecting because I loved Virginia Woolf.... I remember the joy with which I first read *Mrs. Dalloway*. I remember the first page, and I remember thinking, 'Oh, this is unbelievable! "What a lark! What a plunge!"'" Asked if her Bloomsbury collection had a feminist impulse, Susan Chaires responded, "Sure! Absolutely. I went to law school at a time when there were twelve women in my graduating class of six hundred.... So I became very interested in what women artists were doing because they were encountering a lot of the same things—in fact still are—in their careers." Although Chaires no longer collects only women artists, she says, "I think I was really drawn to Bell because she was such a revolutionary *woman* in everything that she did."

American women's interest in Bloomsbury, often inspired by Virginia Woolf, is not always so

overtly feminist. Patricia Oresman describes herself laughingly as part of an "old-fashioned generation" "already set in my ways when Gloria Steinem came along" (although she acknowledges attending a couple of feminist marches at the behest of her daughter). For her, too, however, Woolf became a central figure when she read *A Room of One's Own* and *Mrs. Dalloway* at her small Swedish Lutheran college in New Jersey: "It was during Word War II, and the guys were mostly gone, so we girls had a good time reading this stuff.... *A Room of One's Own* has stuck in my mind for a long time. You do need, I think, a place of your own, and especially women need a place of their own." Oresman's sense of Woolf as a personal guide is echoed by women who do identify as feminists. Wendy Gimbel roots her passion for Woolf in "the way she talks about her mother, the way she talks about Mrs. Dalloway, the way she talks about Mrs. Ramsay in *To the Lighthouse*. Woolf is exploring the connections between art and regular life. How does a woman find the proper balance? Mrs. Ramsay's family feeds on her essential substance; what happens to her art? Mrs. Dalloway gives a party that is the work of an artist, but doesn't that take the place of her art? Woolf seems to say that a woman should not give herself over to the demands of either state of being."

Less feminist, and more conventionally feminine, is another American response to Bloomsbury's artists, exemplified by the *Reader's Digest*'s embrace of the group in the 1980s. Although inspired, when it was founded in 1922, by a small-d democratic ambition to bring the best in journalism to a wide range of readers, including newly enfranchised women, the *Digest* was always allied with capital-R Republicans, and by the 1960s frankly championed Richard Nixon. By the 1970s, articles and editorials ghostwritten in the Nixon White House attacked those who protested American involvement in Vietnam, while closer to home a group of the

Digest's female employees won a $1.5 million settlement when they sued for sex-based discrimination.[48] Throughout this period, the profile of the magazine's female cofounder matched its conservative social politics. Lila Acheson Wallace, always visible as her husband's helpmeet, was central to the image of the Digest as a family. She decorated the magazine's Neo-Georgian corporate headquarters in a residential suburb of New York with Impressionist and Post-Impressionist art emphasizing female figures, flower pieces, landscapes, and gardens. Wallace was also an enthusiastic gardener and a generous patron of charities that related to art, gardens, historic houses, and especially to causes that blended these interests. She donated millions of dollars for renovations and expansions at the Metropolitan Museum of Art in New York, including an endowment in 1970 for the weekly creation of spectacular floral arrangements in the Great Hall. The Metropolitan's 1990 purchase of Grant's portrait of Virginia Woolf (cat. 61) was made from another endowment given by Wallace. Looking

abroad in the 1970s, Wallace funded the restoration of Bernard Berenson's garden at the villa I Tatti outside Florence and Monet's garden at Giverny.[49]

In the early 1980s, at the instigation of the Wallaces' longtime lawyer Barnabas "Barney" McHenry, the Digest turned its attention to Bloomsbury art, acquiring twenty-two paintings—mainly by Vanessa Bell, but with Duncan Grant, Roger Fry, and Dora Carrington represented—for the corporation's London offices. McHenry, who, with his wife, the art historian Bannon McHenry, himself collected modern British art and assembled a collection of Woolf's first editions that is now in the library of Duke University, recalls that he was drawn to Bloomsbury paintings because of the group's "combination of art and literature," laughing that he might have chosen the illustrated poems of William Blake if his budget had been larger. After the Digest's Bloomsbury paintings were transferred to the company's headquarters in suburban New York, they were shown at a local museum in 1987, an exhibition that was billed as the largest col-

FIG. 8
Plaque at Charleston Farmhouse in honor of Lila Acheson Wallace.

lection of Bloomsbury paintings then in the United States.[50] Following a corporate restructuring in 1998, however, the *Reader's Digest* began to sell off its art collections, and its Bloomsbury holdings were auctioned in London in 2004.

A more lasting influence of the *Reader's Digest*'s interest in Bloomsbury may be seen at Charleston, the Sussex home of Duncan Grant and Vanessa Bell. Starting in 1984, the year of Wallace's death, the fund she endowed became the major benefactor of the restoration of the gardens. Today, a plaque in the garden attests to this happy consequence of a more conservative construction of American femininity on Bloomsbury's heritage (fig. 8). Although Wallace was undoubtedly the wealthiest American contributor to the restorations at Charleston, her interest is reflected in the large majority of women among the American "Friends of Charleston," who offer financial support for the restoration and maintenance of the house and garden.

"Distortion is like sodomy.
People are simply blindly prejudiced
against it because they think it abnormal."[51]

SEXUAL IDENTITY AND COLLECTING

Concurrent with—and in many ways analogous to—American women's interest in Bloomsbury's attitudes toward gender has been gay men's interest in the group as a key site in the history of modern homosexual identity. Where feminist interest in Bloomsbury is vectored through Woolf, however, Bloomsbury's gay collectors do not evince a parallel interest in Forster's or Strachey's writings, despite the role of Holroyd's Strachey biography in attracting attention to the group. This might seem surprising, for the posthumous publication of Forster's novel *Maurice*—an exploration of options for homosexual

identity in early-twentieth-century Britain—caused a stir in 1971.[52] By the 1970s, however, these options —personified by the dandyism of Oscar Wilde and the earnest socialism of Edward Carpenter (or Carpenter's better-known American analogue, Walt Whitman)—were outdated. That Strachey and Forster seemed to fall on this spectrum—Strachey at the Wildean end, Forster at the Carpenterian— rendered them outdated, too. Though not everyone went as far as the 1974 manifesto on "Homosexual Self-Oppression" that characterized Forster as the "Closet Queen of the Century," who "betrayed other gay people by posing as a heterosexual and thus identifying with our oppressors," neither he nor Strachey could compete with the apparent cheerful self-acceptance modeled by Duncan Grant, who was still very much alive.[53] One American doctor, alerted to Bloomsbury by the Holroyd biography, delighted in recounting how he traveled to Charleston to get Grant to sign one of the two paintings he purchased from Anthony d'Offay, the artist's London dealer. Lingering over lunch, drinks, and more drinks, he finally had to retreat upstairs for a nap before finding his way back to the train.

Another of Grant's American acquaintances was Douglas Turnbaugh, who became preeminent among the artist's American advocates. Turnbaugh retained a formative memory of seeing, in college in the 1950s, a reproduction of Grant's 1933 painting *Bathers* (owned by the National Gallery of Victoria, in Australia) in a book about modern art (figs. 9a, b):

> When I was growing up and there weren't any pictures of naked men except Catholic saints being skewered and Tarzan in the comics. I was always looking for some clue to find my own sexuality. The quest for the child who doesn't know anything was, for me, looking in pictures. And so when I saw Grant's *Bathers* picture it was an epiphany! I thought, I've found somebody who confirmed and illumi-

FIG. 9a
Duncan Grant, *The Bathers*, ca. 1926–33.
Oil on paper on plywood, 54½ × 60¼ inches.
Courtesy of the National Gallery of Victoria,
Melbourne, Felton Bequest, 1948.

DUNCAN GRANT.—The Bathers. Australia, Gallery of Victoria.
Influenced through his friend Roger Fry along the line of Cézanne's experiments, Grant was preoccupied by rhythm and the relation of forms, eventually earning secondary laurels as a decorative artist.

Gwen John, Augustus John's sister, was of an opposite nature to her brother and this is apparent in her painting. Sensitive, retiring, quiet, her pictures pitched in a low key, have all the delicate sensibility inherent in her personality. Her drawing is free and Impressionistic in quality. Her paintings are few and on a small scale, but her *Lady Reading a Book*, in the Tate Gallery, is not readily forgotten.

Between 1900 and 1920, the art critic Roger Fry exerted a great influence in England, bringing to the attention of the public the importance of the

[266]

FIG. 9b
Duncan Grant, *The Bathers*,
as reproduced in Germain
Bazin, *History of Modern
Painting* (New York:
Hyperion), 1951.

nated who I was. I was no longer alone. There was somebody else out there. And I knew from that painting what I needed to know to go ahead with my life.

Turnbaugh recalled this moment a quarter century later, when he was introduced to the poet Paul Roche in a room hung with Grant's paintings at the home of David Read, a Scot who became a prominent Presbyterian minister in New York, and his wife, the actress Pat Gilbert-Read. Roche, who in the late 1970s had taken the elderly Grant into his home, invited Turnbaugh to meet the artist, who, although confined to a wheelchair, remained devoted to two of his favorite activities: sketching and gossiping about sex.[54] "That's when I really fell in love," says Turnbaugh. Having trained in ballet and writing dance criticism at the time, Turnbaugh was fascinated by Grant as a living connection to Nijinsky. He bought a number of Grant's drawings of Nijinsky and what he describes as academic nudes, "which are fabulous, I wasn't disappointed," but recalls that "one of the last times I saw him, [Grant] just couldn't stand it, and he said, 'What you want is under the bed,'" in the London studio in the basement of a house on Regents Park, "and he gave me the keys." Turnbaugh continues the story:

> So I went there all alone with the keys…and it was like finding Ali Baba's cave. It was packed with paintings, stacked on the floor and covering the walls. It was just staggering. That's where I saw the basketball painting, which I fell in love with at once (fig. 10). But he'd said 'what you want is under the bed,' and there was a cardboard box, the kind a department store would put a suit in, all mouse-chewed and ratty. I pulled it out and opened it and there was this collection of erotic drawings.

Thinking back to the connection he had felt decades earlier when he first saw the reproduction of Grant's *Bathers*, Turnbaugh says, "I was not

FIG. 10
Duncan Grant, *Basketball Players*, 1960. Oil on canvas, 28½ × 20½ inches. Collection of Douglas Blair Turnbaugh.

wrong a bit. That's why it was especially gratifying to actually find erotica. I knew there would be."

Turnbaugh reports that when he suggested Grant should publish his erotic pictures, "he laughed and laughed. He lived his long life, under British law, as a sex criminal. These pictures were illicit to do, to have—you were practically condemned by seeing them. He did not believe these illicit images could ever be shown with impunity. I knew it was my task to save them." In 1989, Turnbaugh published *Private: The Erotic Art of Duncan Grant* through the Gay Men's Press in London, having paved the way for this with a biography of Grant two years before.[55] "Duncan had died," Turnbaugh says, "but I felt I had done something for his real reputation."

Turnbaugh's determination to "proselytize," as he puts it, concerning Grant's homosexuality led him to organize a number of New York exhibitions and to lecture about the artist. One man, who ultimately bought two erotic Grants, describes the effect of a lecture Turnbaugh gave at the Gay Community Center in New York in 1992: "The slides turned my head, the erotic stuff, some of them were just breathtaking. I remember in particular seeing one of two guys leaning back in bed, and the nipples were just so exquisite." Turnbaugh is delighted when he can "communicate my own enthusiasm." "That means a lot to me," Turnbaugh says. "I think of Duncan all the time, and his sense of humor, and how he would have loved the route it took, which began with the erotic pictures." Against conventional accounts of Grant's life and art, which Turnbaugh says downplay the importance of Grant's homosexuality, his insistence on Grant's erotic imagination— both his imagery and in his relationships—reflects a perception of Grant as a beacon for an ideal of homosexuality integrated into other aspects of life and art. "What's marvelous in gay terms is his triumph as a man to have this rich, rich life.... He had a fabulous life and people loved him, and he was a

happy person who radiated, even to the end of his life, just sparkling with humor and wit."

Other gay collectors attest to a similar admiration for Grant. In contrast to early–twentieth century paradigms of the "repressed and depressed and suicidal" homosexual, says Rick Purvis, "by all accounts the man was an incredibly resilient, robust character.... And that's pretty remarkable in today's world, let alone post-Victorian England." Purvis and his partner Dean Malone were introduced to the Bloomsbury artists by an older gay friend, Robert Smith, who, Purvis says, felt "a real kinship" with

> the idea that these were people who, on the cusp of post-Victorian culture, were throwing off very rigid strictures and that at such an early time, when it was still quite illegal, people like Duncan Grant were not trying to cover up their homosexuality. That certainly had resonance for Bob. He was a man in his late seventies when he initially discovered them, and he had grown up at a time when, you know, you were taught not to be clear about that. And even for us who are now in our late forties, there was something very inspiring about the openness with which those people lived their lives.

Another collector, Mitch Bobkin, recalls the first two Bloomsbury pieces he purchased, a drawing of Angus Davidson and an ink painting of two wrestlers, both by Grant. Although he knew nothing of the artist's biography at the time, he responded, he says, to the "tenderness" in these pieces:

> The emotional quality Duncan brings to his work was very clear to me in those first two pieces, particularly the Angus Davidson (cat. 86). You can tell there is a relationship between these two people.... Now, I have a lot of Duncan drawings of friends and lovers and I love the emotion that's evident in them.... I think you can see that level of con-

nection—let's not call it emotion, let's call it connection—in the pieces. At least I can.

For Purvis, Malone, and Bobkin, their sense of what Malone calls a shared "experiential awareness" with Grant as a gay man is not focused on erotic imagery, but on Grant's place in Bloomsbury, and their admiration extends beyond Grant to encompass the art and ideas of Bloomsbury as a whole. The sense of freedom associated with casting off Victorian strictures "involved everybody" in Bloomsbury, Malone points out, and is visible in the post-Victorian aesthetic of all the group's artists, not just Grant. Purvis finds himself drawn to portraits from the Bloomsbury milieu because they "capture something about the personality, what they stand for and how they think and interact with the world." Bobkin echoes their comments, saying of Bloomsbury, "They were precursors of modern life. They were among those farsighted individuals who around 1907 decided the twentieth century was going to be different from the nineteenth." Bobkin responds, he says, to the "sense of personal connection and community" in the art he collects by Bell and Fry as well as his Grants: "they found a way to create a secondary family and I think that there is something emotionally rich about that that I respond to."

"Arrange whatever pieces come your way."[56]

ATTITUDES TOWARD COLLECTING

Gay collectors, who approached Bloomsbury through Duncan Grant, describe very similar pleasures to those voiced by women collectors, who approached the group through Virginia Woolf and Vanessa Bell. "I loved the whole idea of moving from the rigidities of the Victorian era into the light of the Bloomsbury world," says Wendy Gimbel.

Explaining her focus on portraiture, Mona Pierpaoli explains, "That's what they did so well, because they knew each other and the portraits are about what they felt." Speaking about Woolf and Bell, Patricia Oresman says, "I feel like they're part of my family, because it's so human and yet they were so much more intellectual than most people. But they felt the same things, they grappled with the same problems that all of us have." Gimbel returns to the idea of family, suggesting that, because of the availability of so much biographical information and the biographical references in so much of the group's creative output, Bloomsbury "is really a family story, and what happens when you collect is that you are admitted to that family for a moment."

That collectors acknowledge such identification with artists whose work they collect—especially when that bond is premised on academically unfashionable identity categories of sexuality and gender —might seem to invite charges of grandiosity or naiveté. Roger Fry may be partly to blame. His influential *Vision and Design* opens with an anecdote about the wrong kind of collector:

> A fussy, feeble little being, who had cut no great figure in life…but he had a dream, the dream of himself as an exquisite and refined intellectual dandy living in a society of elegant frivolity. To realize this dream he had spent large sums in buying up every scrap of eighteenth-century French furniture which he could lay hands on. These he stored in an immense upper floor in his house, which was always locked except when he went up to indulge in his dream and to become for a time a courtier at Versailles…. For this old gentleman, as for many an American millionaire, art was merely a help to an imagined dream life.

Fry's not very veiled allusion to Pierpont Morgan, with whom he was frequently at odds dur-

ing his tenure at the Met, introduces an argument for a purely formal approach to art, one that "cuts out all the romantic overtones of life" and "appeals only to the aesthetic sensibility."[57] This claim for art's independence from what Fry calls "life"—an argument, ironically, strongly inflected by the life issues of its wartime context, as he struggled to exempt art from the collapse of the culture around him—was not one that he sustained throughout his career.[58] But even by the terms of this polemic, Bloomsbury's collectors distinguish themselves sharply from Fry's caricature.

For starters, Bloomsbury's collectors insist on the primacy of their visual response to the art they collect. Describing how she came to include a few Bloomsbury pieces in her collection emphasizing art from later in the twentieth-century, Janice Oresman insists her first response to Bloomsbury's art when she saw it at Anthony d'Offay's 1984 *Omega Workshops* show "was aesthetic":

> I don't think I've ever looked at something and said, "Oh, George Washington slept here—I have to have it." That isn't how I collect. I collect for the visual content of it. I just loved it. I loved the color. It appealed to me. And then the idea of this funny group of people— and they were really funny—gathering out at Charleston, where they were busy decorating nearly every inch of it…. But that had nothing to do with why I bought this art. I had no idea how quirky they were. That was just fun to find out later. I just thought these were wonderful works of art.

Collectors' aesthetic pleasure in Bloomsbury art, however, is often allied to a skepticism toward convention, which makes Bloomsbury biographies appealing, too. Janice Oresman (who is Donald and Patricia Oresman's sister-in-law) was first struck by the modernity of Bloomsbury's art from the second decade of the twentieth century.

It's real Cubist work, and as beautiful as any of that time…. You know, they were really pretty sophisticated! I was also interested in who they were and the odd things they did. They devoted themselves to taking care of each other and to making art. And that doesn't happen so much anymore…. It's really pretty spicy stuff, don't you think—the literature and the way they lived?

Other collectors vehemently defend their taste for art they know many arts professionals belittle. Citing disparaging comments about the "muddy" color of some Bloomsbury paintings, Rick Purvis insists this was what first attracted him to Bloomsbury painting: "Grays and browns: they're not bright, striking colors…I like that sense of how color is handled." Similarly, Susan Chaires acknowledges that "a lot of critics don't like Bloomsbury art; I am aware that a lot of people refer to them as 'dreary little paintings.'" But she, too, responds to the "gray, which I love," especially in Bell's paintings. These muted tones, she says, work well "in dialogue" with a domestic environment, where the paintings are displayed against patterned walls. "You could put virtually any Vanessa Bell up on wallpaper, and it would just be fabulous. I love that tension between the colors and the highly decorative background where the colors talk to each other. That's the way it is at Charleston."

This insistence on the primacy of domesticity in general—and the paradigm of Charleston in particular—runs strongly through American Bloomsbury collections. In the early 1980s, Bannon McHenry and her husband traded in the Pop Art they had acquired during the 1960s for Bloomsbury paintings, because their "domestic scale, color, and light" made them "particularly suitable to hang on the wall of an apartment," she explains. Jasper Johns collects Omega furniture and ceramics; other collectors emphasize designs for decorative objects. Museums, too, have been attracted to the Blooms-

Kerry Olson's kitchen, with cupboards painted by
Deborah Bryant.

ming, has been crucial to attracting American
attention to Bloomsbury's aesthetic. Kerry Olson's
interest in Bloomsbury art, she says, derives from
"the context of Charleston as a community of art-
ists with all their personal stuff, but with a true
commitment to this aesthetic, to making the func-
tional space beautiful." Years before she acquired
any Bloomsbury art, Olson had a friend paint her
kitchen cabinets to reproduce the effect she admired
in a book about Charleston (fig. II). "You can have
a Bloomsbury-inspired space on a budget," she
says, "because that's a lot of what they did. Before
I could buy anything I was creating a space that
was inspired by that space. That's probably more
true to the heart of Bloomsbury than buying the
art is!" Although Dean Malone says, laughing, that
"Charleston is a great place to visit but I wouldn't
want to live there," what he takes from his many
pilgrimages (with Rick Purvis and Bob Smith) is
"how important it is for these paintings to hang in
a very intimate setting," rather than in the museum
context of "a huge wall, probably white." He con-
tinues, "I like that here our collection is in a very
intimate setting. It's in a very small home. It's well
loved. There's not a day that goes by that we don't
attend to what's on our walls."

 Not only do Bloomsbury's American collectors
insist upon their aesthetic response to the art they
own, their identification with Bloomsbury is less
fanciful and more self-conscious than one might
expect from Fry's caricature of the collector. Some
American Bloomsbury collections developed out
of—or in tandem with—friendships with those on
Bloomsbury's edge. Historian Peter Stansky first
discovered Bloomsbury as an undergraduate in the
early 1950s when, inspired by his childhood fond-
ness for a record of songs of the Spanish Civil War,
he wrote his senior essay on British writers who
volunteered for the *republicanos*, among them Julian
Bell, Vanessa and Clive's son, a poet who was killed

bury artists' domestic designs. The first acquisition
of Duncan Grant's work by an American museum
came in 1938 when the Cleveland Museum of
Art purchased two of the commercial fabrics he
designed[59] (cats. 148, 153). When in 1986 the
Wolfsonian museum (now the Wolfsonian–Florida
International University Museum) was founded to
preserve and display Mitchell Wolfson Jr.'s collec-
tion of "decorative and propaganda arts," its collec-
tion included twenty-five of the Omega's printed
linens (cats. III, 130, 131, 134, 135) as well as lamp-
shade designs by Wyndham Lewis (cats. 156–158)
and a couple of Grant's hand-painted wooden boxes
for the Workshops (cats. 133, 137).

 The preservation of Charleston farmhouse,
along with attendant publications and program-

driving an ambulance in Spain in 1937.[60] When, after college in America, Stansky applied to study at King's College, Cambridge, he mentioned his interest in Bloomsbury. "Noel Annan later told me that they were amused that someone would want to study Bloomsbury because, for people at King's they were friends, not an academic subject!" Although Stansky did not, in fact, study Bloomsbury at King's at this time, he met Forster, who "lived in the College, lunched with students, and was a member of the Ten Club, a play-reading group, in which I participated. As he enjoyed meeting people, I brought my mother to meet him when she came to see me get my degree." Other scholars, as Gretchen Gerzina's introduction attests, became friends with Frances Partridge, the longest-living Bloomsbury intimate, and many collectors spoke warmly of meeting Quentin Bell (Julian's brother) and his wife Olivier. Pauline Metcalf was present the day that Charleston opened to the public due to her friendship with Deborah Gage, an art historian whose family owned Charleston (yes, all that wall painting was done by renters!) and who was crucial to the campaign to preserve the house.

Such personal connections ground some collectors' identification with the artists. For collectors who do not claim acquaintance with "Bloomsberries," although they may identify with challenges Bloomsbury's members faced and admire the group in its historical context, they do not attempt to re-create Charleston ("a great place to visit, but....") or imagine themselves as insiders. "There is a kind of irony for all the collectors and people who like Bloomsbury," says Susan Chaires:

> They were great friends to each other, but they tended not to like to bring a lot of new people or outsiders into their circle, especially after they got a little bit older. And so I think, as much as I love their work, I'm a person that they would, if they were alive today, never want to meet, never want to see, they wouldn't

find me at all interesting. So the way I handle that is—and this gets to what's your style of collecting—I try very much *not* to be a Bloomsbury groupie. I want to do the things that I feel really honor them, but without treating them like celebrities.

For her, this includes learning about Bloomsbury and its artists, but not, as a busy practicing lawyer, attempting to emulate them.

"Americans have swallowed their dinner by the time it takes us to decide whether the widow of a general takes precedence of the wife of a knight commander of the Star of India."[61]

BLOOMSBURY FOR AMERICANS

The history outlined to this point suggests some distinctive elements in American perceptions of Bloomsbury, most notably the trajectory from perceiving the group as an embodiment of British literary and philosophical tradition to seeing it as a precursor of modern attitudes, often specifically feminist and gay sensibilities. This second view of Bloomsbury did not so much supplant as augment the first, however. This trajectory characterized journalists Charles Whaley and Carol Sutton Whaley, who first read *To the Lighthouse* when they vacationed in the Hebrides in the early 1970s. Their interest quickly expanded to embrace Woolf's other writings and then her Bloomsbury circle.

After buying a drawing of Vanessa Bell by Duncan Grant, they were invited to Charleston to meet the artist in 1973. "We sat outside that famous room with the decorated fireplace and drank wine," Charles Whaley recalls, as Grant charmed them with stories of his recent trip to Turkey with Paul Roche.[62] In a letter to Whaley shortly thereafter, Grant wrote, "I rather agree with you that it would

be pleasant if Charleston could be preserved as it is." At Charleston, the Whaleys purchased Grant's drawing of a ballerina in a very short tutu, a sketch for a painting invoked in Quentin Bell's memoirs, when he recalled that Keynes distressed his wife (the ballerina Lydia Lopokova) by describing it as "a large naked Lydia"[63] (fig. 12). By this time, the Whaleys were interested in the sexual dynamics of the group, having learned from the 1971 publication of Carrington's letters about her affair with Henrietta Bingham. The glamorous 1920s socialite who played "exquisite songs with a mandoline" and "mixed such wonderful cocktails," as Carrington described her, was an heiress from the family that owned the Louisville, Kentucky, newspaper for which the Whaleys worked. The couple subsequently acquired a drawing by Carrington (of Strachey and Boris Anrep) (cat. 40) and a drawing of Carrington (by Henry Lamb). Whaley now displays a more recent acquisition—an erotic Duncan

Grant drawing of Paul Roche nude and erect—in his living room, "which," he says, "sometimes shocks people…. But I am not going to hide a Duncan Grant!" One suspects he enjoys the shock value. He and his wife, who, as the first female managing editor of a major American newspaper, oversaw prize-winning coverage of the racial desegregation of Louisville schools and integrated the newspaper's staff, prided themselves on taking progressive stands. Bloomsbury's "shedding of inhibitions" about sexuality, Whaley says, "paved the way for freeing people from narrow, harmful constraints" and was part of his attraction to the group.[64]

As with the Whaleys, virtually every Bloomsbury collector acknowledges being an Anglophile, but it seems a particularly American form of Anglophilia comprised of both affection and rebelliousness. "The thing I love about the British and the visual arts is that they were always steps behind the Continent. You know, they were so insular, and always so reactive really. Bloomsbury art is the last gasp of Post-Impressionism—the thing is that it happened thirty years later! I think there is something kind of charming about that," says Mona Pierpaoli. If Americans' view of Britain is steeped in images and anecdotes from the stately homes and "upstairs, downstairs" dramas favored by the culture industry, Bloomsbury provides a perspective on that culture that is uniquely skewed to suit American sensibilities. Although "they still had servants and cooks and gardeners," says Rick Purvis, "in many ways Bloomsbury was the antithesis of all that—the aristocracy and the great country houses." Similarly, Susan Chaires asserts, "I admire the fact that they were not dilettantes, that they were just amazingly productive. They were all working all the time…. I don't know if this is a uniquely American perspective, but a lot of Americans tend to be real workaholics. We can't rely on being a duchess to get ahead in life, we have to work. I think that a lot of Americans admire that. I certainly do."

FIG. 12
Duncan Grant, *Ballerina*. Pen and ink.
Collection of Charles E. Whaley.

Americans find in Bloomsbury, in short, a relationship toward Britain that reflects our own attitudes. Deeply rooted in British literature and culture, we nevertheless join Bloomsbury in mocking Victorian social formalities, preferring Continental cuisine, and, more fundamentally, placing a premium on individual self-realization, especially when it is cast in a narrative of overcoming social convention. "Just as a lot of Europeans romanticize the American West, I think a lot of Americans romanticize England and particular movements in England, and Bloomsbury is one of them," says Kerry Olson. "But I think it's worthy of our admiration. I think there were social rules that were being pushed against, and it was complicated, and people suffered."

"Their iconoclasm has an American quality to it," says Mitch Bobkin. "There is something about that American willingness to rethink things that they were similar to." Another collector, describing Bloomsbury as a group of "social entrepreneurs," sees them as an inspiration for her own political and philanthropic activism: "I think there is a real statement about the need for change in the Bloomsbury movement and certainly in our lives right now," she says. For Wendy Gimbel, it is "separation from the world of father and mother, that is quintessentially American, and quintessentially not European. When Woolf said that if her father had been ninety-six when he died there would have been no work—nothing—I think that is very American. The Bloomsbury artists had a capacity for self-invention that is quintessentially American and decidedly not European."

American attitudes contrast sharply with British perceptions of Bloomsbury, which—to generalize from the critical reactions to the 1999 Tate Gallery exhibition *The Art of Bloomsbury*—often remain locked in the perceptions reported by Carolyn Heilbrun in 1968. The tendency of contemporary British journalists and academics to go on dismissing Bloomsbury as "shrill, arty, escapist, aristocratic, and insufficiently talented" surprises me as much as it surprised Heilbrun forty years ago, for it seems a textbook case of scapegoating. When journalists and academics denounce Bloomsbury as "the chattering classes," you've got to wonder about the proverbial pot calling the kettle black, especially in light of the vast body of evidence documenting a level of political engagement and artistic influence in Bloomsbury that might put most academics and journalists to shame. Yet denunciations of Bloomsbury in Britain—often grounded in progressive ideologies similar to those that motivate appreciation of Bloomsbury in America—seem to grow shriller and more illogical.[65] But that is undoubtedly my own American perspective.

My bemusement is shared, however, by other Americans currently engaged with Bloomsbury. Craufurd Goodwin, the Duke University economic historian whose collection of Bloomsbury art and artifacts is the most comprehensive in North America, says, "I think Americans are often puzzled by the British hostility to Bloomsbury. It certainly amazed me." Goodwin describes his first public lecture on Roger Fry, which took place in the late 1990s, when "I was asked to present to a meeting of economists in Bristol. When I was introduced, the chairman said, 'This is a paper on Roger Fry,' and there was this great hiss from the audience—'Hisssss!' And I said, 'What in the world is going on? I'm amazed you've even heard of him, let alone dislike him so much!'" On that same trip, Goodwin recalls, he applied unsuccessfully for help from the local art museum in finding Fry's parents' country house, which was nearby. "When I finally found Failand and the wonderful iron gate Roger had designed (fig. 13) I knocked on the door and the woman who answered said, 'Who is Roger Fry?'" British attitudes toward Bloomsbury, Goodwin concludes, are "quite startling to Americans."

In contrast, Americans are attracted to Bloomsbury for both cultural and structural reasons, Goodwin believes. Like other collectors, Goodwin cites the American attraction to iconoclasm as key to our appreciation of Bloomsbury. "I think Americans have been more open to iconoclasm in general than people in Britain or in the Empire. I grew up in Canada where there was much less openness to this. I'm struck by my students, who really just love Bloomsbury…. I think Americans are very much open to all kinds of experimentation, and they saw the 'Bloomsberries' as big experimenters."

Goodwin's training in economics leads him to ground such observations of cultural difference in analysis of institutional structures. He looks to the history of American higher education to explain that "Americans have been much more receptive both to the general spirit of liberal education and to interdisciplinarity," in contrast to the United Kingdom, where academic training stresses early professionalization within relatively narrow disciplinary bounds: "There's virtually no place you can get a liberal education there."

Goodwin's insights reflect his own approach to Bloomsbury. Although (as described earlier) Goodwin's father-in-law first introduced him to Lytton Strachey's circle in the 1960s, his own attention turned to the group thirty years later, when he was asked to develop an interdisciplinary Freshman Seminar at Duke in 1995. Roger Fry, he says, was "just a name" when he began developing the course. "I dove into *Vision and Design* with no preconceptions. I was startled to discover that Fry thought at least as much like a social scientist as like an artist or humanist and that one of his major interests was the art market," Goodwin recalled in the preface to his 1998 anthology of sixteen of Fry's essays on the economics of art. [66] Expanding on this history, Goodwin explains, "I have always been interested in intellectuals who understand economic principles… but are professionals somewhere else…. So Roger

FIG. 13
Roger Fry, designer, wrought iron gates with his parents' initials.

was red meat. He had all the instincts of a micro-economist." Such analysis challenges conventional conceptions of the "father of formalism" as a refined aesthete, emphasizing instead the plain-speaking social critic who divided consumers of art into "Philistines, snobbists, classicists, and true aesthetes," divisions, Goodwin says, that "clarify the picture still, no matter how offensive the terms may be to modern ears." [67] Acknowledging the influence on Fry of John Ruskin and William Morris, Goodwin also draws attention to the impact on Fry of American thinkers, such as Denman Ross and especially Thorstein Veblen, the founder of institutional economics, whose cynical tone and concept of "conspicuous consumption" find echoes in Fry's writings. [68]

Goodwin illustrated his argument in *Art and the Market* with two portraits emphasizing Fry's connection to Bloomsbury: a chalk drawing of Fry by Duncan Grant (cat. 73) and an ink drawing of Keynes by Fry (cat. 50). Both were recent acquisitions that related to Goodwin's new-found schol-

arly interest in Fry and complemented the portrait sketches Richard Sanders had acquired from Grant a half century before. The Goodwins' collection of Bloomsbury art, however, quickly expanded beyond its initial focus on Fry and its status as aid to—or souvenir of—scholarship. Like many other recent collectors, the Goodwins were guided by gallerist Tony Bradshaw, whose Bloomsbury Workshop, near the British Library, became a regular port of call for American Bloomsbury-philes in London.[69] "Through him I guess we have one of the largest collections of Roger Fry pieces around," Goodwin says today.

This modest description of the collection is echoed in Goodwin's description of what he insists is their "informal" method of collecting: "We buy things when we like them and we can afford them, and then we stick them on the wall." In fact, the Goodwins' extraordinary collection includes works in a wide variety of media, including furniture, fabrics, and ceramics, as well as paintings and works on paper, by Bell, Fry, Grant, and Carrington. Although the collection clearly has its own integrity, it remains tied to the Goodwins' personal interests. A preponderance of garden imagery speaks to Nancy's career as a gardener. Several works with mythological imagery reflect Craufurd's scholarly interest in the way Bloomsbury used myth to debunk authority. When he writes about how the group interpreted the story of Daphne and Apollo as "the story of a pompous and frustrated war hero (Apollo) tricked by a clever child (Cupid) so that in the end the warrior is cursed to chase a beautiful but uninterested maiden (Daphne) until at last she is placed beyond reach and turned into a laurel bush," and notes that "Duncan Grant won the Medal of Merit at the Paris International Exhibition in 1937 for a design that pictured Apollo chasing Daphne unendingly in diagonals across a gleaming satin fabric," Goodwin's evident admiration for Bloomsbury's attitude enhances his pleasure in sharing his domes-

tic space with Grant's overscale studies of the two figures on this textile[70] (cats. 146, 147).

Goodwin's insights into Bloomsbury's art and ideas develop perspectives articulated by other American collectors. Although he notes that he "grew up in Canada, where there was much less openness" to the iconoclasm Bloomsbury represents for many Americans, Goodwin's relish of the group's approach to classical myth suggests that he has adapted to the sensibilities of his adopted compatriots. More fundamentally, Goodwin shares the American appreciation of Bloomsbury as a force for change. The economic activism of John Maynard Keynes "appealed to the American sense of solving a problem," Goodwin explains, "The people who were active in the New Deal picked up Keynes at the end of the thirties and it became the new wave of thinking. And I don't think there was the receptivity in Britain." Goodwin emphasizes the links between Keynes and others in Bloomsbury, pointing out "fascinating parallels between the ways in which Fry and Keynes described the markets that interested them most" and citing Fry's influence on Keynes's contributions to the development of arts organizations in Britain.[71] His interest in the history of institutions leads Goodwin to describe Bloomsbury as a "think tank":

> Even though the term "think tank" did not gain currency until after World War II the institution appeared early in the twentieth century, sometimes centered around a discipline like philosophy or economics (e.g. the Vienna Circle in Austria or the National Bureau of Economic Research in the United States), or a new political ideology like socialism (e.g. The Fabian Society, with which Leonard and Virginia Woolf were involved), sometimes around a single problem like foreign policy (e.g. the Carnegie Endowment for International Peace and The Royal Institute for International Affairs, Chatham House)....Typically

early think tanks were multidisciplinary, experimental, and ephemeral. Bloomsbury qualifies on all these counts.

Goodwin analyzes early Bloomsbury novels—Forster's 1910 *Howards End* and Woolf's 1915 *The Voyage Out* and 1919 *Night and Day*—as "analytical tools" that functioned much like the "open-ended first stage of inquiry" carried out by think tanks, in contrast to writings by "other novelists writing about policy issues such as H. G. Wells or Charles Dickens" that functioned as a "means of propagating a settled program of reform." Always attentive to the connections between art and policy in Bloomsbury, Goodwin sees Woolf's *Three Guineas* as following Keynes's (and Fry's) shift from the conditions of production to "the demand side of the market" for art and ideas.[72]

To see Virginia Woolf as, in Goodwin words, a "policy analyst" may be a uniquely American perspective on Bloomsbury: both admiring and a bit iconoclastic, with an emphasis on the activist. While this perspective challenges a tendency among literature scholars to read. Woolf only in relation to other novelists, Goodwin's current scholarship on Keynes challenges his own discipline, economic history, on Bloomsbury's terms:

> I've grown increasingly intrigued by the reluctance of most of my friends who were Keynesian specialists to go beyond the myth of how he had four or five economics students who worked with him and those were his intellectual inspiration. Increasingly I found that unlikely, and it's fun to find out, in fact, how much came out of Bloomsbury…. Keynes's life story is an embarrassment to Keynesians. What I find intriguing in his case is how they construct a much more conventional picture of an academic, which appears in the biographies, and leave out all the other stuff.

American collectors, it seems clear, manifest great affection for "all the other stuff"—not only the painting, drawings, pottery, and fabrics produced by Bloomsbury, but, more fundamentally, for the group itself, for the idea of a community of aesthetic and social innovators. This is our Bloomsbury, and American collections, with their emphases on the portraits and decorative arts, reflect our intellectual interests and emotional investments. The objects in American collections serve as palpable links to our ideal of Bloomsbury. Jasper Johns speaks for other American collectors when he describes his surprise, upon seeing Omega objects for the first time, "It had perhaps never before occurred to me that these things still existed in real time and space." At the same time that American ideas about Bloomsbury have inspired the acquisition of Bloomsbury art, American collectors, to return to the claims that opened this essay, are contributing actively "to the ways meaning and quality are seen" in this art—and in Bloomsbury as a whole. In 1938, Virginia Woolf wrote for an American magazine:

> The world is a very large object, buzzing and humming on every inch of its surface with interesting things. But if we compress and epitomize, this essence and abstract of the world and its interesting things reduces itself undoubtedly to the United States of America. *America is the most interesting thing in the world today.*[73]

If, one suspects, Woolf's tongue was near, if not firmly in, her cheek when she penned those words for an American audience, the values she points to in her fanciful essay—"Americans are much freer, wilder, more generous, more adventurous, more spontaneous than we are"—are nonetheless those that now attract many Americans to Bloomsbury. It might even be fair to say that American perspectives have made Bloomsbury among the most interesting things in the world today.

NOTES

1 "Introduction," in *The Cultures of Collecting*, eds. John Elsner and Roger Cardinal (London: Reaktion, 1994), 2.

2 Adam Gopnik, "Prisoner of Narnia," *New Yorker*, November 21, 2005, 88.

3 Madge Jenison, *Sunwise Turn: A Human Comedy of Bookselling* (New York: E. P. Dutton, 1923), 2–3. Correspondence between Mary Mowbray-Clarke and Roger Fry documents her efforts to bring Omega products to the Sunwise Turn, leading one historian to speculate that "she aspired to create her own American Bloomsbury… and an Omega Workshop at the Sunwise Turn" (M. Sue Kendell, "Serendipity at the Sunwise Turn: Mary Mowbray-Clarke and the Early Patronage of Charles Burchfield" in *The Paintings of Charles Burchfield: North By Midwest*, eds. Nannette V. Maciejunes and Michael D Hall [New York: Harry Abrams, Inc. in association with the Columbus Museum of Art, 1997], 94). The Sunwise Turn was linked to the Omega through the Workshops' American artist, Edward McKnight Kauffer (Kendell, 95). Thanks to Allan Antliff and Kim Croswell for alerting me to this connection.

4 I have drawn on written records (augmented by a few oral anecdotes) to understand the generation of Bloomsbury collectors active between the 1950s and the 1970s. Interviews conducted between 2005 and 2008 form the basis of my account of the motivations and experiences of Americans who collected Bloomsbury art in the 1980s and after. These interviews were not a comprehensive poll of American collectors, but were determined by who was able and willing to meet with me. The interviews were transcribed, and sometimes supplemented through e-mail correspondence. I am very grateful to all the collectors for their time and their thoughtful interest.

5 Small collections of modern British art, including works by the Bloomsbury artists, were created by two professors of English and left to their alma maters: the Professor Robert Gordon '50 Bequest at Colgate University and the Kenneth Curry collection at Rollins College.

6 These are the opening words of E. M. Forster's *Howards End* (London: Edward Arnold, 1910).

7 On Fry's impact on American museums, see Chapter 5 of *A Roger Fry Reader*, ed. Christopher Reed (Chicago: University of Chicago Press, 1996).

8 Raymond Wyer, who changed his name to Raymond Henniker-Heaton, was acquainted with Fry, although the painting was acquired from a London dealer, Percy Moore Turner of the Independent Gallery. Also purchased from Turner at this time was an oil on canvas, *Scene in Morocco*, by the French artist Charles Georges Dufresne (information generously supplied by Kate Dalton of the Worcester Art Museum). Fry discussed *The Blue Bowl* in a 1918 letter to Vanessa Bell (*Letters of Roger Fry*, ed. Denys Sutton [London: Chatto and Windus, 1972], 440).

9 Roger Fry to his mother, August 6, 1907, *Letters of Roger Fry*, 288.

10 Roger Fry to his wife, February 11, 1906, *Letters of Roger Fry*, 249.

11 Fry's watercolor was included with a drawing by John Flaxman and ten other works by American artists in Mrs. Robinson's bequest ("Additions to the Collections," *The Metropolitan Museum of Art Bulletin*, new series, vol. 12, no. 1 [Summer, 1953], 15, 18).

12 Frances Spalding, "Pamela Diamand, 1902–1985: A Personal Appreciation," *Charleston Newsletter* 12 (September 1985), 16.

13 Diamand's donation was the 1927 *Le Mas de Berne près de St. Rémy, Provence*; the Art Gallery of Ontario in 1935 had purchased Fry's *The River Ordwell, Near Ipswich*, ca. 1934, through the Lefevre Galleries from Fry's estate. Also in the 1930s, the Vancouver Art Gallery bought Fry's 1931 *Spring in Provence* from Agnew's.

14 In 1987, the Art Gallery of Ontario purchased Fry's only known sculpture (cat. 46), along with some related sketches by Duncan Grant; see Richard Shone, "'Group' (1913): a sculpture by Roger Fry," *Burlington Magazine*, December 1988, 924–27.

15 S. P. Rosenbaum, *Conversation with Julian Fry* (London: Cecil Woolf, 2005), 19.

16 Roger Fry, *Twelve Original Woodcuts* (Hogarth Press, 1921).

17 This family story was recounted to Tony Bradshaw.

18 An exhibition of work from Julian Fry's estate was staged by the Bloomsbury Workshop at the Woburn Gallery, London, under the direction of Tony Bradshaw (November 22–26, 2005). Works from Julian Fry's collection were lent to the 1976 exhibition, *Roger Fry: Artist & Critic*, originated by the Edmonton Art Gallery. Pamela Fry lent to the 1977 exhibition *Bloomsbury Painters and their Circle*, originated by the Beaverbrook Art Gallery, Fredericton, New Brunswick.

19 Untitled document, object file, Metropolitan Museum of Art.

20 In partnership with Grant's London gallery, Anthony d'Offay, the New York gallery Davis & Long

gave Duncan Grant his first American exhibition in 1975, and did the same for Vanessa Bell in 1980 (in the year it changed to Davis and Langdale).

21 These were Vanessa Bell's ca. 1915 *Self-Portrait* (cat. 10), Roger Fry's 1917 *The Artist's Garden at Durbins* (cat. 49), and Duncan Grant's 1915 *At Eleanor: Vanessa Bell* (cat. 72).

22 Charles Richard Sanders, *The Strachey family, 1588–1932: their writings and literary associations* (Durham: Duke University Press, 1953), 294–95.

23 Charles Richard Sanders, *Lytton Strachey: His Mind and Art* (New Haven: Yale University Press, 1957), 352–53.

24 Frances Partridge, *Everything to Lose: Diaries 1945–1960* (Boston: Little Brown, 1986), 355–56.

25 Information provided by Craufurd Goodwin, personal communication, 2008.

26 Information provided by David Rieff, personal communication, 2008.

27 Charles Richard Sanders's 1934 doctoral dissertation was titled *The Relation of Frederick Denison Maurice to Coleridge*. Rieff's master's thesis, completed in the mid–1940s, was on Coleridge's theory of the clerisy.

28 Antonius A.W. Zondervan, *Sociology and the Sacred: An Introduction to Philip Rieff's Theory of Culture* (Toronto: University of Toronto Press, 2005), 145.

29 Personal communication, 2008.

30 Philip Rieff, untitled review of Jakob Rosenberg's *On Quality in Art: Criteria of Excellence, Annals of the American Academy of Political and Social Science*, vol. 379 (September 1968), 189.

31 Philip Rieff, "Culture in Crisis: American Society Void of Principles" (1977) in *The Challenge of the Future: Visions and Versions*, ed. William A. Conboy (Lawrence: Division of Continuing Education, University of Kansas, 1979), 147–48.

32 Philip Rieff, *Fellow Teachers: of culture and its second death* (1973, repr., Chicago: University of Chicago Press, 1985), 52.

33 Rieff wrote, for example, "Better than any sociologist or psychologist, Forster described in *Howard's End* [sic] the function of high culture. Leonard Bast goes to a concert, listens to Beethoven's *Ninth* [sic], and, in its resonance, catches the silence around which every culture gulls every man into producing an appropriate insulation of experience" ("Cooley's *Human Nature and the Social Order*" in *The Feeling Intellect: Selected Writings*, ed. Jonathan B. Imber,

[Chicago: University of Chicago Press, 1990], 305). Inasmuch as the garbled second sentence can be said to make sense in the context of Rieff's defenses of the social function of high culture, "insulation of experience" is the opposite of the effect when Leonard Bast hears Beethoven's Fifth Symphony in *Howards End*.

34 Virginia Woolf, *A Room of One's Own*, rev. ed. (1929, repr., New York: Harcourt Brace Jovanovich, 1957), 91.

35 Quoted in "Passing Bloomsbury," *Evening Standard*, May 10, 1978, 18.

36 Leonard Woolf, "Dying of Love," *New Statesman*, October 6, 1967, 438.

37 Michael Holroyd, *Lytton Strachey: A Critical Biography*, vol. I (New York: Holt, Rinehart and Winston, 1967), 201; see also 136. Holroyd's attitudes enact the tolerant extreme of elite opinion concerning homosexuality at the time: accepting individuals with same-sex erotic impulses but censorious toward subcultural manifestations of homosexuality as an identity. In sometimes criticizing Strachey's writing, Holroyd was also asserting his distance from Sanders, whom he belittled as "a hagiographer" (xv).

38 Carolyn G. Heilbrun, *The Garnett Family* (London: Allen and Unwin, 1961). David Garnett came into Bloomsbury in the

1910s, when he lived at Charleston with Duncan Grant and Vanessa Bell; he later married their daughter. Garnett was a crucial link between "Old Bloomsbury" and a younger generation of men in the 1920s (on this generational succession, see Christopher Reed, *Bloomsbury Rooms: Modernism, subculture, and domesticity* [London: Yale, 2004], 232).

39 Carolyn Heilbrun, "The Bloomsbury Group," *Midway* 9, August 1968, 72.

40 *Midway*, a self-described "magazine of discovery in the arts and sciences," was published by the University of Chicago between 1960 and 1970.

41 Heilbrun, 83.

42 On *Toward a Recognition of Androgyny*, see Regina Marler, *Bloomsbury Pie: The Making of the Bloomsbury Boom* (New York: Henry Holt, 1997), 130–33. On Heilbrun's importance to American debates about Woolf more generally, see, in addition to Marler, Brenda Silver, *Virginia Woolf Icon* (Chicago: University of Chicago Press, 1999).

43 Heilbrun, 78.

44 Personal communication, 2003.

45 Information kindly provided by James and Margaret Heilbrun, personal communication, 2008.

46 Mary Ann Caws, *Women of Bloomsbury:*

Virginia, Vanessa, and Carrington (New York: Routledge, 1990), 2, 3, 137, 153.

47 Carolyn Heilbrun, *Toward a Recognition of Androgyny* (New York: Alfred A. Knopf, 1973), 152.

48 Peter Canning, *American Dreamers, The Wallaces and Reader's Digest: An Insider's Story* (New York: Simon and Schuster, 1996), 138–42.

49 Although Canning criticizes what he sees as the deflection, during the 1980s, of Lila Wallace's bequests from populist initiatives to high culture, his own account shows her to have been strongly attracted to high-culture enterprises throughout her career as a benefactor.

50 Frances N. Chaves, "The Reader's Digest Collection of Bloomsbury Paintings" in *Bloomsbury Artists at Charleston: Paintings from the Reader's Digest Collection* (Katonah, NY: The Katonah Gallery, 1987), n.p.

51 Vanessa Bell, *Selected Letters of Vanessa Bell*, ed. Regina Marler (New York: Pantheon, 1993), 153–4.

52 On the reception of *Maurice*, see Marler, 94–100; and Christopher Reed, "The Mouse that Roared: Creating a Queer Forster" in *Queer Forster*, eds. Robert K. Martin and George Piggford (Chicago: University of Chicago Press, 1997), 75–88.

53 Andrew Hodges and David Hutter, *With Downcast Gays: Aspects of Homosexual Self-Oppression* (London: Pomegranet, ca. 1974), 20–21.

54 Turnbaugh's recollection that Grant, over brandies, "wanted to know about my love life" coincides with Simon Watney's account of how, a decade earlier, Grant, as an octogenarian, was fascinated by "the contemporary social life of the still swinging Sixties. He was ever eager to hear of one's amours, keen to meet friends and lovers" (*Art of Duncan Grant* [London: John Murray, 1990], 14).

55 Douglas Blair Turnbaugh, *Duncan Grant and the Bloomsbury Group* (Secaucus: Lyle Stuart, 1987); *Private: The Erotic Art of Duncan Grant* (London: Gay Men's Press, 1989).

56 Virginia Woolf, *The Diary of Virginia Woolf*, vol. 3, ed. Anne Olivier Bell (New York: Harcourt Brace Jovanovich, 1980), 39.

57 Roger Fry, *Vision and Design* (London: Chatto and Windus, 1920), 1, 15.

58 *A Roger Fry Reader*, ed. Christopher Reed (Chicago: University of Chicago Press, 1996), 2, 310–11.

59 Bolts of Grant's 1935–36 "Apollo and Daphne" and 1937–38 "Dove" fabrics (cats. 148, 153), were purchased, along with other textiles and glassware, from an "Exhibition of Modern Glass and Textiles," held at the Cleveland Museum in 1938 (information kindly provided by Robin Hanson, Associate Conservator of Textiles). This seems to be the second purchase by an American museum of work by a Bloomsbury artist (following the Worcester Art Museum's 1924 purchase of Fry's *The Blue Bowl*, cat. 54). On Grant's fabrics of the 1930s, see Richard Shone and Judith Collins, *Duncan Grant Designer* (Liverpool: Bluecoat Gallery, n.d.), 38–30.

60 Peter Stansky, *From William Morris to Sergeant Pepper: Studies in the Radical Domestic* (Palo Alto: SPOSS, 1999), 6–8. His research culminated, years later, in a book coauthored with William Abrahams. *Journey to the frontier: two roads to the Spanish Civil War* (Boston: Little, Brown, 1966), which opens with a respectful discussion of Bloomsbury (3–41), and Stansky subsequently published extensively on the group (see his *On Or About December 1910: Early Bloomsbury And Its Intimate World* [Cambridge, Massachusetts: Harvard University Press, 1996].

61 Virginia Woolf, "America, Which I Have Never Seen" (1938) in *Dublin Review* 5 (Winter 2001–02), 58.

62 Paul Roche published an account of the Turkey trip as *With Duncan Grant in Southern Turkey* (n.p.: Honeyglen, 1982).

63 Quentin Bell, *Elders and Betters* (London: John Murray, 1995), 95.

64 On Carol Sutton Whaley's career, see Patricia Bradley, *Mass Media and the Shaping of American Feminism, 1963–1975* (Jackson: University Press of Mississippi, 2003), 207.

65 I analyzed in some detail the critical responses to *The Art of Bloomsbury* in "A Tale of Two Countries," *Charleston* 22, Autumn/Winter 2000, 35–39, which includes reference to the hypocrisy of art journalists' dismissive characterization of the group as "the chattering classes."

66 *Art and the Market: Roger Fry on commerce in art*, ed. Crauford D. Goodwin (Ann Arbor: University of Michigan Press, 1999), xi.

67 Ibid., 61.

68 Ibid., 15–17 (on Ross), 20–21, 23, 26 (on Veblen); see also Goodwin, "Economic Man in the Garden of Eden," *Journal of the History of Economic Thought*, vol. 22, no. 4 (Fall 2000), 417–18.

69 Gallerists have been crucial to developing many American Bloomsbury collections. In the 1970s, Anthony d'Offay introduced American collectors to Duncan Grant, Pamela Diamand, and Quentin and Olivier Bell, generat-

ing a living connection to Bloomsbury (on d'Offay, see Marler, 65–68, 205–08, 222–23). D'Offay's promotion of the Bloomsbury artists tapered after 1984, however (Marler, 222), and American collectors of Bloomsbury art in the 1980s turned increasingly to Sandra Lummis and Tony Bradshaw (on Bradshaw, see Marler, 264–65). Bradshaw, whose Bloomsbury Workshop opened in 1986, was especially influential in educating American buyers and helping them shape collections that respond to their interests. "He's become much more than an art dealer, he's a very close friend," says Goodwin, and this sentiment is echoed by others. "He's been a good guide, listening to what you like," says another collector: "For people who might be intimidated, or didn't know much about it, he managed to make it a very safe and inviting undertaking to venture into the world of collecting." When I asked another collector if she thought of the Bloomsbury art in her house as a collection, she said that she did not, "but I know Tony thinks of it like that."

70 Goodwin, "Economic Man," 408; "Bloomsbury and the Destructive Power of Myth" in *Still More Adventures with Britannia*, ed. William Roger Louis (Austin: Harry Ransom Humanities Research Center, 2002), 109.

71 *Art and the Market*, 52, 54.

72 Craufurd D. Goodwin, "Virginia Woolf as Policy Analyst" in *Virginia Woolf's Bloomsbury* (London: Palgrave Macmillan, forthcoming).

73 Woolf, "America, Which I Have Never Seen."

Lightness Visible: An Appreciation of Bloomsbury's Books and Blocks

Benjamin Harvey

"WOOD is a pleasant thing to think about." This thought, taken from Virginia Woolf's 1917 experimental short story "The Mark on the Wall," assumed a new importance when it was later excerpted and printed on a single sheet, about thirteen inches high and seven wide (fig. 1). The sentence in question, which originally fell toward the end of the story, now rose to the top of a paragraph of text, surrounded above and below by woodcut prints. All the letters of the leading word—"wood"—are capitalized and spaced generously, as though to distinguish it from the words that follow and to recommend it as a subject for our consideration. A similar pattern occurs in the letters of the first word, with the leading element, the letter "W," accented not merely by virtue of its primacy but through its typographical elements: it is outsized, bolded, and italicized. As though to connect text and image, the slanting wedges of the "W" find analogues in some of the forms above it: in a female figure's nose and eyebrows, the descending neckline of her garment, and in the interval between her shoulder and the back of a chair. A three-line ascription at the foot of the page, below the smaller of the two prints, clearly identifies the authors of these words and these prints: "From THE MARK ON THE WALL by VIRGINIA WOOLF / BLOCKS by VANESSA BELL / *The Chelsea Book Club Broadside No. 1 ptd. at* 43 BELSIZE PARK GDNS."

Woolf's books offered an important avenue through which American audiences were exposed to aspects of Bloomsbury's art. Most of her major works appeared with dust jackets designed by Bell,[1]

W OOD is a pleasant thing to think about. It comes from a tree; and trees grow, and we don't know how they grow. For years and years they grow, without paying any attention to us, in meadows, in forests and by the side of rivers - all things one likes to think about. The cows swish their tails beneath them on hot afternoons; they paint rivers so green that when a moor-hen dives one expects to see its feathers all green when it comes up again. I like to think of the fish balanced against the stream like flags blown out; and of water-beetles slowly raising domes of mud upon the bed of the river. I like to think of the tree itself; first the close dry sensation of being wood; then there is the grinding of the storm; then the slow, delicious ooze of sap. I like to think if it, too ,on winter's nights standing in the empty field with all leaves close-furled, nothing tender exposed to the iron bullets of the moon, a naked mast upon an earth that goes tumbling, tumbling, all night long. The song of birds must sound very loud and strange in June; and how cold the feet of insects must feel upon it, as they make laborious progresses up the creases of the bark or sun themselves upon the thin green awning of the leaves, and look straight in front of them with huge diamond-cut red eyes ... One by one the fibres snap beneath the immense cold pressure of the earth; then the last storm comes and, falling, the highest branches drive deep into the ground again. Even so, life is'nt done with; there are a million patient, watchful, lives still for a tree, all over the world, in bedrooms, in ships, on the pavement, lining rooms where men and women sit after tea, smoking their cigarettes.

From THE MARK ON THE WALL by VIRGINIA WOOLF BLOCKS by VANESSA BELL
The Chelsea Book Club Broadside No. 1 ptd. at 43 BELSIZE PARK GDNS.

FIG. 1
Vanessa Bell, designer, broadside for *The Mark on the Wall*. Courtesy of the Mortimer Rare Book Room, Neilson Library, Smith College, Northampton, Massachusetts.

and these images helped to stamp the Woolfs' Hogarth Press with a distinctive modern aesthetic.[2] Bell's book designs and illustrations are of a uniformly high quality and, considered as a group, represent a major contribution to twentieth-century book design. They include covers for well-known texts (*Jacob's Room, Mrs. Dalloway* [cat. 171], *To the Lighthouse* [fig. 2], *A Room of One's Own* [cat. 174], and *The Waves*) but, equally, Bell produced fascinating designs for slighter texts, such as Woolf's 1930 *On Being Ill.*

Though the illustrated excerpt from "The Mark on the Wall" was among the most ephemeral of Bell and Woolf's collaborations, it embodies important aspects of the Bloomsbury's ventures into the "book arts" and raises issues this essay will explore. These include the appropriate balance between image and text; the question of what illustration is, or can be; and how it relates to an ornamental function, or the "decorated" text. Attending to these pictorial elements should also encourage us to consider some of the more easily ignored physical and visual properties of texts: bindings, covers, margins, typographical elements, and so forth. From the perspective of the history of the book these elements, far from being secondary elements of a text, literally constitute it (there is no text without them), and, if they are altered, so are the possible meanings of the text.

Woolf's publications and especially her early experimental fiction provide some interesting test cases for these claims. "The Mark on the Wall" and "Kew Gardens" (cat. 186) both appeared in multiple versions in the first decade of the Hogarth Press's life, in publications both with and without illustrations. The year 1927 marked both the climax of Woolf and Bell's joint ventures and a shift in the nature of their collaboration. That year saw the publication of a "decorated" version of *Kew Gardens*, Bell's most extensive project involving the woodcut, and a contribution that radically reorients the read-

FIG. 2
Vanessa Bell, designer, dust jacket for *To the Lighthouse*, 1927. Courtesy of Washington State University Libraries, Manuscripts, Archives, and Special Collections.

er's relationship to Woolf's prose. *To the Lighthouse*, perhaps Woolf's best-loved novel, was also published in 1927. Although, with the important exception of Bell's dust jacket, it contains no illustrations, Woolf's text strongly stimulates the reader's desire to imagine the pictures that exist in the world of the text's narrative. *To the Lighthouse*, thus, suggests that the reader him- or herself might be viewed as the ultimate illustrator of a text, albeit an inherently "unreliable" one.

At the center of these considerations is the modernist woodcut. Not itself an innovation of Bloomsbury, it was adopted and adapted in the books the group produced. The woodcut looked beguilingly simple and was relatively easy to make, yet it offered rich perceptual and aesthetic experiences when brought into dialogue with texts.

Virginia Woolf's story "The Mark on the Wall" has a special place in the history of the Hogarth Press; initially bound in a single volume together with Leonard Woolf's story "Three Jews," its 1917 appearance as one of the Woolfs' *Two Stories* marked the inauguration of the press. In "The Mark on the Wall," the identity of the titular object, which provokes the narrator's reflections—including those on the nature of wood—is revealed, with a touch of bathos, at the very end of the story: "Ah, the mark on the wall! It was a snail."[3] *Two Stories* included four small woodcuts by Dora Carrington, two for each of the stories; the first of the images accompanying Virginia's story precedes the text and shows a woman warming herself in front of a blazing fireplace (fig. 3); she cranes her neck upward and over the mantelpiece, looking toward, one assumes, the mark in question. The second image follows the end of the story and, like a cinematic point-of-view shot or a visual punch line, reveals what she has been looking at all along: a snail (fig. 4).

Woolf and Bell's broadside excerpt from "The Mark" is even more ambiguous than the original story. Although it is often dated to 1921, its exact date of publication is unknown, as is the size of the edition, and unlike Woolf and Bell's other collaborations, it was not published by the Hogarth Press.[4] Perhaps part of the difficulty of interpreting the sheet of paper originates in its unclear function. Cut adrift from the confines of a book, it might be held and read, framed and looked at, or some combination of the two. Or it could be nothing more than a fugitive advertisement for the Chelsea Book Club and a teaser to prompt people to buy similar products offered by the Hogarth Press. The sheet evokes the maturing "house style" of the Woolfs' publishing house, which in its first decade favored the simple, bold aesthetic of the woodcut in the pages and (increasingly) on the covers of its books.

FIG. 3
Dora Carrington, designer, illustration for *The Mark on the Wall*, London, 1921. Courtesy of Cornell University Library, Division of Rare and Manuscript Collections.

FIG. 4
Dora Carrington, designer, illustration for *The Mark on the Wall*, London, 1921. Courtesy of Cornell University Library, Division of Rare and Manuscript Collections.

The two prints Bell made to accompany the excerpt from "The Mark on the Wall" reflect Bloomsbury's dialogue with continental Modernism, and share the avant-garde enthusiasm for the "primitive" (and thus, apparently, folksy and authentic) printing procedure of the woodcut (figs. 5, 6). The woodcut had been recently revived by Paris-based artists and, given Bloomsbury's Francophilia, it seems likely that the influence exerted by these artists outweighed that of the German Expressionist artists now most strongly associated with the medium. Gauguin had favored the woodcut and younger artists, such as Derain, Dufy, Maillol, Matisse, Picasso, and Vlaminck, also used this printing process, and often produced illustrations for texts.[5] Many of these artists were mainstays in Roger Fry's two Post-Impressionist shows (1910–11 and 1912–13). As Tony Bradshaw points out, Fry's interest in the woodcut was further stimulated by the more proximate examples provided by the work of William Morris, Eric Gill, Edward Wadsworth, and by Roald Kristian, who in 1915 had a selection of his woodcuts on display in the Omega's Fitzroy Square space.[6] The Workshops offered a congenial environment for Fry to develop and share his interest in books and printing; the last of the four books that came out under the Omega's sign featured, as the title put it, *Original Woodcuts by Various Artists*

FIG. 5
Vanessa Bell, illustration for *Kew Gardens*, London, 1919. Courtesy of the Mortimer Rare Book Room, Neilson Library, Smith College, Northampton, Massachusetts.

FIG. 6
Vanessa Bell, illustration for *Kew Gardens*, London, 1919. Courtesy of the Mortimer Rare Book Room, Neilson Library, Smith College, Northampton, Massachusetts.

(1919) and consisted of a selection of prints by Fry, along with many other of his Bloomsbury friends and artistic associates: Vanessa Bell, Simon Bussy, Mark Gertler, Duncan Grant, McKnight Kauffer, Roald Kristian, and Edward Wolfe. This publication marked the moment when the chief venue for woodcut experiments passed from the Omega Workshops to the Hogarth Press,[7] which would later publish Fry's *Twelve Original Woodcuts* in 1921 (fig. 7; see also cat. 181).

Fry's 1926 essay "Book Illustration and a Modern Example," Bloomsbury's most extensive discussion of this topic, demonstrates the group's preference for simple and playful-looking illustrations.[8] Revealingly, none of the examples Fry cites employs tonal gradations. For their aesthetic impact, they all rely (like type) on the binary relationship between marked and unmarked surface, exploiting different line weights, a variety of hatching effects, and a careful balance of ink (sometimes applied in solid areas) against blank page. Fry's discussion begins with his "modern example," the Nonesuch Press's *Burton's Anatomy of Melancholy*, illustrated by Edward McKnight Kauffer (fig. 8), an American living and working in England who had significant contact with Bloomsbury and contributed to *Original Woodcuts by Various Artists*.[9] Later, he designed an ingenious device for the Hogarth Press; fusing a wolf's head and an off-kilter printing press,

the animal's mouth unfurls a paper-thin tongue (fig. 9). Kauffer used modern "zincotype line blocks" for his illustrations, but they reminded Fry of "early Italian illustrators," who, in works such as the woodcuts from *The Dream of Poliphilus*, "find almost the

exactly right kind of rhythm for the printed page."[10] The art historical comparison recalls Fry's earlier account of Post-Impressionism, when "vital" currents in recent art were routinely connected to the spirit of early Italian art. In Kauffer's most successful illustrations, writes Fry, "Poliphilus and Picasso seem to shake hands across the centuries."[11]

The links with Post-Impressionism are reinforced by Fry's final example, Derain's work for Guillaume Apollinaire's poem "L'Enchanteur Pourrissant"; "few modern book illustrations," he reveals, "have seemed to me hitherto so stimulating."[12] Fry is surely acknowledging a debt[13] (figs. 10, 11). Executed in 1909, Derain's woodcuts offer the closest stylistic comparison to the prints made by Bloomsbury artists. (Fry himself, in his *Twelve Original Woodcuts*, produced prints that might easily be mistaken for Derain's.) At once assertive and dynamic,

FIG. 11
André Derain (French, 1880–1954), animals from *L'Enchanteur Pourissant*, as reproduced in Roger Fry's *Transformations*, 1926.

FIG. 10
André Derain (French, 1880–1954), floral still life from *L'Enchanteur Pourissant*, as reproduced in Roger Fry's *Transformations*, 1926.

yet whimsical and ornamental, such prints would have appealed to Bloomsbury as models worthy of emulation. Derain achieves a complicated chiaroscuro, a balance between marked and plain areas of his designs, concentrating "first of all on the decorative disposition of his blocks of white and black, their enrichment of the page."[14] He uses the visual weight of the ink to activate the surrounding spaces and often exploits figure/ground reversals, so that in the same print figurative elements can be black against white, white against black, or white figures delineated with a black outline. This strong activation of figure/ground dynamics evokes other Post-Impressionist artists, like Matisse and Gauguin, who favored strong lines, often delineating or separating zones of solid color. Frances Spalding's biography of Fry relates an amusing anecdote involving precisely this aesthetic and perceptual issue. Showing "Lady Bonham-Carter" around the Second Post-Impressionist exhibition, Fry stopped in front of Matisse's *The Dance* (fig. 12) and, "when she objected to the shape of the legs, he urged her

instead to study the spaces created in between the legs, shifting her attention from the representational subject to the formal content."[15] Following this exercise, the viewer discovers that usually overlooked areas gain new importance, seeming to loom forward and gain solidity as we attend to them; more radically still, we become aware of our activity as viewers—that, to a large extent, we can animate and "change" the visual object merely by shifting the way we perceive it.

Fry concludes his praise of Derain by criticizing the book of Apollinaire's poems in which his illustrations appeared:

> The illustrations might, in fact, lead one to anticipate more from Guillaume Apollinaire than he was able to provide…. With so remarkable and original and also so dominating an illustrator as Derain the typography should have been adjusted to the colour and weight of the artist's woodcuts. In that case the text alone would have been left to play an agreeable but secondary *rôle*.[16]

FIG. 12
Henri Matisse
(French, 1869–1954),
The Dance.
Oil on canvas.
Courtesy of The State
Hermitage Museum,
St. Petersburg.

Here Fry acknowledges the potential antagonism between author and illustrator: "Book illustration is a battle ground, a no-man's land raked by alternate fires from the artist and the writer."[17] Noting the puniness of the book's printed letters, Fry suggests that the mismatch between author and artist might have been resolved in the book's design. Fry treats the book not as a mere vehicle for language, but as an aesthetic structure that, ideally, will strike a satisfactory balance between semantic, visual, and physical elements. In his discussion of Kauffer, he praises the artist for the way his illustrations relate to other aspects of the book. Noting the work's admirable typography, its "general effect of an ancient folio," and the fact that it is "well planned and admirably printed on very good paper," Fry concludes that "Mr. Kauffer has clearly appreciated these qualities in his drawings."[18]

Perhaps in an attempt to avoid the charge of cliquishness, Fry opted not to discuss Woolf and Bell's collaborations, but his holistic approach to book design and illustration was certainly shared by his Bloomsbury peers. In the case of Woolf and Bell's broadside (see fig. 1), one is struck by the decorative qualities of the prints on the page, the way the bolder lines of the woodcut surround the text above and below with pleasingly intricate and wayward patterns. The eye is encouraged to meander over the surface of the page, rather (or in addition to) following a strict sequence from left to right, top to bottom, beginning to end. The prints have the effect of making us aware of the physical properties of the text, turning the block of text into just that, a rectangular block—one that contrasts vividly with the small oval beneath, while echoing the rectangles of the print above and the page itself. The text is not simply illustrated with images; rather, text and images together combine to decorate the page.

When it comes to how the illustrator may respond to the content of a text, a fascinating passage from Fry's essay helps to establish a sense of the range of possibilities open to Bell. "There is no doubt," Fry asserts,

> that a book may be decorated—initials, borders, *culs-de-lampe*—these may be always admitted if they are good of their kind; they do not provoke any question with the writer. It is only when the artist's forms have a further significance, suggest ideas or feelings by what they represent or by symbolical or expressionist methods, that they impinge on the text. It is only then that the question arises, first, can it be done at all? and secondly, has the artist in question done it? It seems to me that real illustration in the sense of reinforcing the author's verbal expression by an identical graphic expression is quite impossible. But it may be possible to embroider the author's ideas or rather to execute variations on the author's theme which will not pretend to be one with the text, but rather, as it were, a running commentary, like marginal notes written by a reader…. And of all such marginal commentators the draughtsman [like Kauffer] is the most discreet, for he is inaudible, he never puts an actual word into your head which might get confused with the words of the author. He merely starts a vague train of thought by the image which he puts before you in one of those pauses which the author's discursiveness allows.[19]

Rejecting a commonplace notion of illustration, the possibility of an equivalence between text and image, Fry directs our attention to what the latter might add to the former. Fry's illustrator occupies a paradoxical position, however, both there and not there, inaudible yet commenting, weaving in and out of the reader's consciousness. Bell's prints cut across the main distinction Fry makes. Providing strong borders to the page, they fulfill a role he associates with decoration, but they surely have an

illustrative function, too, and provide the kind of running commentary Fry describes.

But what exactly do Bell's prints depict? In general terms, Fry's theory denies that they provide an "identical graphic expression" to Woolf's words. Bell's use of visual ambiguity ensures that this is the case. The smaller of Bell's two prints shows pieces of fruit resting on an oval dish or platter. The two white zones on either side of the central pear can be read as other pieces of fruit lying behind the foreground fruit (making five pieces in total) or as the bottom of the tray itself (reducing the number to just three). The larger and more complicated of Bell's images, an elongated rectangle, depicts a seated woman; heavy-lidded, she seems lost in thought or even asleep. Objects to the right of her are rendered in startlingly different scales, as if to suggest a scrambling of near and far. To the right, we see a portion of tree trunk, presumably the same tree that has produced a couple of dappled fruits and some startlingly large leaves; these hang above a cup and saucer placed on top of a round table (we see only the arc of its top portion); at the top center of the image, we detect the familiar shape of two trees—familiar forms rendered strange by their diminutive size in relationship to the objects immediately around them. They appear to spring from a leaf, rather than vice versa. Do these objects define the kind of space that the woman occupies— perhaps a garden or bower? Or, since she seems lost in reverie—enjoying, in Andrew Marvell's phrase, "a green Thought in a green Shade"—could they rather relate to her thoughts, providing not a literal description of place so much as a catalogue of the kind of things that might pass through the woman's mind as she thinks about wood? Since the larger context of the story tentatively places the story in "the middle of January" and locates it in a living room, could the entire scene be imagined—a mid-winter's fantasy of distant delights?[20]

The possibilities multiply and, while the prints respond to the content of the passage, they do not do so in any simple way. Instead of replicating Woolf's verbal imagery, Bell contributes to and extends the author's task, this thinking about wood. As with Woolf's narrator, Bell's allusions include the living tree, seasonal associations, and the products of trees. For, Woolf's prose reminds us, even after the tree is chopped down, "life is'nt [sic] done with; there are a million patient, watchful, lives still for a tree, all over the world, in bedrooms, in ships, on the pavement, lining rooms where men and women sit after tea, smoking their cigarettes." Some of these products, Bell's print suggests, are immediate and obvious (leaves and fruit); others are often made of wood and thus their relationship to wood may be inferred (a chair, a table, a tray, or dish). Fruits on a platter combine these two categories and suggest a further and more obscure role, another "life still" for wood—the provision of a suitable subject for a still life. Tracing this "vague train of thought" to one possible destination, one recalls that the prints themselves are products of trees. Like the finer paper of Woolf's "cigarettes," the sheet is made of pulped wood. Furthermore, the style of the prints, their refined crudity, is a vivid reminder of the wood block that created the image. Woolf's subject matter is explicitly wood, and the prints were created by the coming together of two wooden products, paper and block, each manipulated in very different ways; after the pressure had been exerted, what was left behind on the paper were the likenesses of trees, leaves, and fruit that we see.

From the early days of the Hogarth Press and the production of *Two Stories* in 1917, Woolf collaborated in this printing process. First, the artist made his or her design and then placed or transferred it onto a block of wood; next, those parts of the block that were to remain free of ink in the final print were carved away; finally (and here is where

the Hogarth Press became directly involved), the resulting raised surface was inked and run through a press. But even a relatively simple printing technique presented challenges, especially to relative novices. One of Woolf's letters to Dora Carrington describes her participation in printing the illustrations for *Two Stories*:

> We like the wood cuts immensely. It was very good of you to bring them yourself—We have printed them off, and they make the book much more interesting than it would have been without. The ones I like best are the servant girl and the plates, and the Snail.
>
> Our difficulty was that the margins would mark; we bought a chisel, and chopped away, I am afraid rather spoiling one edge, but we came to the conclusion at last that the rollers scrape up the wood as they pass, as sometimes the impression would be clean to start with, and end with smudges.[21]

Such experiences provided Woolf with insights into the kind of practical and visual demands that accompany the fashioning of a woodcut. If printing with metal type generally stresses the addition of elements to a blank page, printing a woodcut draws attention to a kind of negative mark-making. Cutting into the surface of the wood, tool marks leave absences in the final print and, when they are surrounded by inked areas, these become visible as marks, as for example, in the complicated patterns in Carrington's snail print for "The Mark on the Wall." In Bell's broadside illustrating the same story, the marks she added to the tree trunk at the far right of her larger print provide a sense of texture, of a rough bark surface, but they can also be read as signs of a tool cutting into a surface, in what often seems to be a single action.

Despite being the product of a multistep process, the woodcut can also convey a sense of direct-

ness and simplicity. This aspect of Derain's prints strongly appealed to Fry:

> Instead of taking the pen drawing as the point of departure, which has been the method of procedure almost from the beginnings of the art, he has regarded the gouge as the essential instrument of expression. He shows, I think, a wonderful instinct for conceiving forms directly in terms of the gouge-stroke on the wood block, with the result that his sensibility comes through to us unchecked. It is like having an original poem instead of a translation.[22]

Fry's distinction between drawing and gouging hints at a conventional division of labor in printmaking, where an "artist" usually provided the design but a "craftsman" performed the more technical and laborious work of actually turning wood into a carved surface ready to receive ink. Like Derain and other modernists, however, Bloomsbury's artists carved their own woodcuts, allowing each work to be read as directly expressing its maker's sensibility.[23] In letters dating from November 1918, Bell writes about cutting and altering blocks, and mentions that she and Duncan Grant are "both waiting for a fine tool with which to finish" the woodblocks on which they are working.[24] Dora Carrington informed Virginia Woolf she had heard that Fry was "cutting wood all over the carpets of Gordon Square."[25] Woolf witnessed this activity herself a couple of years later; her diary entry for April 12, 1921, records Fry working on his *Twelve Original Woodcuts*: "Roger again last night, scraping at his woodcuts while I sewed; the sound like that of a large pertinacious rat."[26] It's an apt acoustic and behavioral description, evoking both the repetitive and persistent sound of a tool working away on wood and a class of mammals known to gnaw and chew; in addition, one wonders whether it may also have been inspired by the look of one of Fry's works.

FIG. 13
Roger Fry, *Self-Portrait* from
Twelve Original Woodcuts, 1922.
Collection of the Herbert
F. Johnson Museum of Art,
Cornell University. Ruth and
Meyer Abrams Fund.

In the self-portrait he contributed to the volume (fig. 13), Fry stressed the ratty qualities of his own features—the long tapering face and slightly bared teeth. Could this be a self-portrait of the artist as a worrier of wood?

Such a dialogue between subject matter and printing process seems still more pronounced in Bell's woodcuts for the "Wood" extract from "A Mark on the Wall." Bell's prints participate in this physical language of wood in a way that Woolf's text, which was printed using metal type, cannot. One can look at the prints, concentrate on the blank areas, and imagine the chiseling and cutting of a wooden surface, imagine the resistance of the wood against tool. To say, then, that the prints are "illustrations," in any narrow sense, seems wholly inadequate. We might, in fact, prefer to *reverse* this relationship. The expectation that the end product of this collaborative effort would be a single sheet of paper, a shared space for text and woodcuts, presumably dictated the choice of this particularly apt excerpt from "The Mark on the Wall." The narrator's thoughts about wood serve to illustrate (elucidate, embellish, set off) Bell's woodcuts, just as much as the other way round. Text and images work on one another in a complicated way that is both reciprocal and suggestive. The word "illustration" shares roots with "illumination," the sense of lighting up, of kindling, of adding luster. Text and image illuminate one another, just as—through the force of proximity and simultaneous contrast—the white of the page seems brighter when it is seen in proximity to the generously inked areas of Bell's designs.

The snail, that symbol of slow, tentative, and patient progress;[27] of domesticity and domestic retreat (its house on its back); and even of mark-making (its silvery trail recording its incremental movement) makes an appropriate emblem of the Hogarth Press and the often tedious business of printing. In Carrington's print for the first publication of Woolf's story (see fig. 4), the creature might be leaving a trail behind it—note the hatching directly beneath the rear of its muscular foot; moreover, the space around the snail, outside of its halo of light, is filled by patterned parallel lines, and these surely evoke that most rudimentary producer of prints, the human fingertip. Set up in and named after Hogarth House, the Woolfs' Richmond home, the press was initially installed on a kitchen table and for years shared the spaces and rhythms of their domestic life. By naming the press after their house, the Woolfs also invoked the memory of one of England's greatest artists and printmakers, William Hogarth. The prospect of printing images as well as texts seems to have been part of the allure of the press from the beginning. When the Woolfs considered buying a replacement printing press in 1917, Virginia noted in letters to Fry and Carrington that the new model was particularly good at reproducing pictures, "and we see that we must make a practice of always having pictures."[28]

The Hogarth Press put writing and book production in intimate proximity for Virginia Woolf. Bookbinding had long been a hobby of hers, but now she was also involved with the selection and editing of texts, with typesetting and printing, with binding books together and distributing them. It is often remarked that controlling her own press allowed Woolf more creative options as a writer. Equally importantly, it allowed the Woolfs to print and reprint texts in a number of contrasting physical contexts. As we have seen, "The Mark on the Wall" appeared in *Two Stories* (illustrated by Carrington)

and the excerpt from it featured in the Chelsea Bookclub broadside (illustrated by Bell). It also appeared in a separate, text-only edition of 1919, and in *Monday or Tuesday* in 1921 (fig. 14), the only collection of Woolf's short stories published during her lifetime, which appeared "With woodcuts by VANESSA BELL," as the title page put it. Bell provided five full-page woodcuts and although none relates directly to "The Mark on the Wall," the book's final story, the woodcuts powerfully impact the aesthetic "ecology" of the book as a whole. They prepare the reader to attend to the interplay between Woolf's words and the book's other material characteristics.

Bell's five prints for *Monday or Tuesday* can be subdivided between the cover and the individual illustrations for four of the book's eight pieces. This

FIG. 14
Vanessa Bell, designer, cover for Virginia Woolf's *Monday or Tuesday*, Hogarth Press. Courtesy of Cornell University Library, Division of Rare and Manuscript Collections.

four-plus-one scheme is anticipated by the bold cover design, which consists of four curling members branching off from a central circular form, like lazy volutes or aspiring spirals. The center of the design—a circle of black surrounded by a cream corona—amplifies aspects of the lettering at the top and bottom of the cover, in particular the repetitions of "Os" found in "Monday," "Or," "Woolf," and "Woodcuts." Simple mathematical patterns seem to relate Bell's cover and illustrations. The four-plus-one scheme of both the cover's design and the cover's relationship to the four other prints (see cat. 168), repeats in cognate elements within these illustrations. A string quartet is four different instruments which, together, create a separate "larger" entity—the quartet itself; but taken as discrete elements, the anthropomorphic objects found in two of the prints divide into a group of four (the quartet) plus the chair. The human figures in the other two prints divide into groups of two and three, but (if we focus on gender, rather than on discrete prints) into four women plus a man. We might observe a final numerical pattern: each of Bell's quartet of woodcuts presents a figure, or figurative equivalent, for each of the first four cardinal numbers, although they are not presented in sequence: one chair ("A Haunted House"), three women ("A Society"), two passengers ("An Unwritten Novel") and, finally, four instruments ("The String Quartet"). Each of the four illustrations inside the book is opposite the title and first page of its related story. Accordingly, the four interior prints serve multiple purposes: they reiterate major divisions in the text, and encapsulate the mood and themes of the upcoming story. They also have a particularly intimate relationship to the facing text—the text they will come in contact with when the book is closed.

In terms of their subjects, the four prints subdivide into two groups of two, according to whether they show human figures or anthropomorphized objects. Like the cover, the image paired with "A Haunted House," the volume's first story, uses a white figure on an emphatically black ground, but here the dominance of the ink establishes a nocturnal mood. Carving broad, expressive lines into the block, Bell delineates the interior of a room, complete with a large window and a curtain (tied back, as though to let in more darkness). The room is furnished with an alarmingly animate chair whose rounded forms and curling arm briefly remind us of the forms found in the book's cover. The chair both suggests the presence (and absence) of a human body and, rather uncannily, begins to resemble one.[29] This, after all, is a ghost story. Formally, the print is an exercise in negative mark-making, its qualities furthering our sense of how an absence might become a presence, and vice versa. Bell inverts normal figure/ground relationships. Usually, a dark medium delineates figures against a white ground, but here it is the lack of ink that allows us to identify the objects. The block is gouged sparingly, but through the process of printing, this modest amount of activity generates bold white lines. In contrast, the inked areas seem almost excessively bold, and become an invasive force. The black ground turns into something more than just a foil to the white figurative elements. Night becomes palpable here and, to borrow Milton's phrase, darkness visible.

The potential slippage between objects and humans, which animates Bell's illustration for "A Haunted House," also characterizes the last of her four illustrations. Accompanying Woolf's "The String Quartet," and in lieu of the musicians who play them, the image presents four instruments colliding in a tangle of wooden curves, strings, fingerboards and f-holes. At the peripheries of the print, raggedy-edged patches of black and white expressively connect the instruments to the space around them. The acoustic analogy is clear: violin, violin, viola, and cello converge to create a larger object—the quartet itself. Four instruments become one. What initially seems chaotic becomes an ensemble:

fingerboards elide in the center of the composition, around which the rounded ends of four instruments can be discerned, two up and two down. The whole work is a clever variation (played *a presto*) on the theme we have already seen stated on the book's cover, only this time, the composition is configured around an "X" rather than an "O."

The first and last of Bell's four illustrations present objects that, through shape and metonymic contact, evoke the human figure, while avoiding its direct presentation. These figurative surrogates are complemented in the other two illustrations by depictions of actual figures. The heads of three women engaged in intense conversation appear in Bell's illustration for "A Society." Slightly harder to discern than her two companions, the figure at the bottom left of the composition bears a stack of books—an action appropriate to a story singularly concerned with how textual production and consumption relate to gender: "While we have borne the children, they, we supposed, have borne the books and the pictures.... So we made ourselves into a society for asking questions."[30]

Our point of view in the print for "An Unwritten Novel" echoes that of Woolf's narrator at the start of the story, who is taking a journey on a train; while casually pretending to do something else, this narrator tries to read in the "[f]ive faces opposite" her "the knowledge in each face." Four of these passengers conceal this knowledge behind "[m]arks of reticence" and behind a variety of activities: they smoke, read, check "entries in a pocket book" and stare "at the map of the line framed opposite." But "the terrible thing about the fifth is she does nothing at all. She looks at life. Ah, but my poor, unfortunate woman, do play the game—for all our sakes, conceal it!...Such an expression of unhappiness was enough by itself to make one's eyes slide above the paper's edge to the poor woman's face."[31]

In the figure of the cropped man, Bell's print economically conflates the reading and smoking Woolf's prose associates with two different passengers. Bell hints at a peculiar quality of silence, a speechlessness that seems sustained by both public convention and personal effort, as though dialogue could (and perhaps should) break out at any time in the anonymous public spaces of mass transportation. In Woolf's story, the presence of other passengers seems to guarantee the silence between the narrator and this inscrutable woman. But soon the narrator realizes that

> the other passengers had left, one by one, till, save for the man who read, we were alone together. Here was Three Bridges station. We drew slowly down the platform and stopped. Was he going to leave us? I prayed both ways— I prayed last that he might stay. At that instant he roused himself, crumpled his paper contemptuously, like a thing done with, burst open the door and left us alone.[32]

And so their conversation can now begin. Bell's illustration stands out from the others in the way it seems to illustrate the narrative in a more conventional way, not only summarizing important aspects of the narrative, but including a specific detail (the presence of the man) that keys it into the story's opening paragraphs.

Bell's emphasis on the beginning of the story's complicated and temporary silence attunes us to her interest in Woolf's theme of various modes of communication and noncommunication. The silences of "An Unwritten Novel" are familiar and social; but the quietude in Bell's print for "A Haunted House," with its large expanses of nocturnal ink and its sparing but dramatic use of white, comes across as a dead silence. Here, the interest is in extreme forms of communication: the possibility of communing with the dead, of overhearing conversations held between the dead, and of detecting the "pulse" of the haunted house itself. In contrast, "A Society" presents an obviously conversational and social sce-

MONDAY OR TUESDAY.

Lazy and indifferent, shaking space easily from his wings, knowing his way, the heron passes over the church beneath the sky. White and distant, absorbed in itself, endlessly the sky covers and uncovers, moves and remains. A lake? Blot the shores of it out! A mountain? Oh, perfect—the sun gold on its slopes. Down that falls. Ferns then, or white feathers, for ever and ever——

Desiring truth, awaiting it, laboriously distilling a few words, for ever desiring—(a cry starts to the left, another to the right. Wheels strike divergently. Omnibuses conglomerate in conflict)—for ever desiring—(the clock asseverates with twelve distinct strokes that it is mid-day; light sheds gold scales; children swarm)—for ever desiring truth. Red is the dome; coins hang on the trees; smoke trails from the chimneys; bark, shout, cry 'Iron for sale'—and truth?

Radiating to a point men's feet and women's feet, black or gold-encrusted—(This foggy weather—Sugar? No, thank you—The commonwealth of the future)—the firelight darting and making the room red, save for the black

36

figures and their bright eyes, while outside a van discharges, Miss Thingummy drinks tea at her desk, and plate-glass preserves fur coats——

Flaunted, leaf-light, drifting at corners, blown across the wheels, silver-splashed, home or not home, gathered, scattered, squandered in separate scales, swept up, down, torn, sunk, assembled—and truth?

Now to recollect by the fireside on the white square of marble. From ivory depths words rising shed their blackness, blossom and penetrate. Fallen the book; in the flame, in the smoke, in the momentary sparks—or now voyaging, the marble square pendant, minarets beneath and the Indian seas, while space rushes blue and stars glint—truth? or now, content with closeness?

Lazy and indifferent the heron returns; the sky veils her stars; then bares them.

37

BLUE & GREEN.

GREEN.

The pointed fingers of glass hang downwards. The light slides down the glass, and drops a pool of green. All day long the ten fingers of the lustre drop green upon the marble. The feathers of parakeets—their harsh cries—sharp blades of palm trees—green too; green needles glittering in the sun. But the hard glass drips on to the marble; the pools hover above the desert sand; the camels lurch through them; the pools settle on the marble; rushes edge them; weeds clog them; here and there a white blossom; the frog flops over; at night the stars are set there unbroken. Evening comes, and the shadow sweeps the green over the mantelpiece; the ruffled surface of ocean. No ships come; the aimless waves sway beneath the empty sky. It's night; the needles drip blots of blue. The green's out.

66

BLUE.

The snub-nosed monster rises to the surface and spouts through his blunt nostrils two columns of water, which, fiery-white in the centre, spray off into a fringe of blue beads. Strokes of blue line the black tarpaulin of his hide. Slushing the water through mouth and nostrils he sinks, heavy with water, and the blue closes over him dowsing the polished pebbles of his eyes. Thrown upon the beach he lies, blunt, obtuse, shedding dry blue scales. Their metallic blue stains the rusty iron on the beach. Blue are the ribs of the wrecked rowing boat. A wave rolls beneath the blue bells. But the cathedral's different, cold, incense laden, faint blue with the veils of madonnas.

67

nario, while the human voice has an obvious musical counterpart in "The String Quartet." The latter work is surely the "noisiest" of Bell's prints visually, and Woolf's text provides us with a range of voices: the narrator's thoughts and interior monologue ("The tongue is but a clapper"); polite social banter ("'That's an early Mozart, of course—'"); the "voice" of the quartet itself ("Flourish, spring, burgeon, burst!"); and the beginnings and ends of conversations ("'Good night, good night. You go this way?' 'Alas. I go that.'").[33]

The prints help to establish the physical structure, or architecture, of the book, introducing half of the stories and stressing the transitions between them. But they are not the only element of the book to do so. The scale, titles, and prose style of two of Woolf's "stories" (or prose poems) relate them as structuring elements. Both "Monday or Tuesday" (the title story, fig. 15) and "Blue & Green" (fig. 16) occupy just two facing pages of text, and together they divide the remaining six longer stories into three groups of two.[34] "Monday or Tuesday" is the third story, "Blue & Green" the sixth (in relationship to the book's other stories, their positions are comparable to the bold numbers in the following sequence: 1, 2, **3**, 4, 5, **6**, 7, 8). Although neither work is illustrated, both are highly descriptive and imagistic. Their logic is deliberately evasive, their stream of images associational, but both pieces seem to come from the point of view of a narrator whose flights of fancy and memory are, at least in part, responses to a living room or fireside environment. Furthermore, both titles reference adjacent elements within a larger series, elements that might be confounded, substituted or combined.

In these pendent pieces, Woolf's evocative prose seems to carry its own illustrations with it. At one moment of "Monday or Tuesday," the vivid images generated by the text blend with the physical image of text itself, of type on paper: "Now to recollect by the fireside on the white square of marble. From ivory depths words rising shed their blackness, blossom and penetrate."[35] The contrast between the blackness of printed words and their transformation in the mind of the reader, where they bloom like colorful flowers, resonates strongly with "Blue & Green." The scenario of this piece seems more straightforward. The marble we are looking at belongs, not to a domestic hearth, but to the elevated ledge of a mantelpiece. Green and blue are invoked repeatedly in their respective portions of the piece, as are various objects associated with them. Consider the opening lines of "Green"—"The pointed fingers of glass hang downwards. The light slides down the glass, and drops a pool of green." Or the end of "Blue"—"Blue are the ribs of the wrecked rowing boat. A wave rolls beneath the blue bells. But the cathedral's different, cold, incense laden, faint blue with the veils of madonnas."[36] The saturated colors of Woolf's imagery are at odds with the black and white of print on paper. We are presented with the gulf between signified and signifier, a gulf that can be bridged only as the words take root in the imagination. Alternatively, we might focus on the piece's concern for light (summarized in the opening image of light hitting glass), and reflect that the light that makes reading possible, the light that illuminates the text and bounces off the white of the page, must necessarily contain the colors of the spectrum within it. It's a forceful antinomy. Here there is no color: here there is color.

In *Monday or Tuesday*, "Blue & Green" is printed in just two short paragraphs of roughly equal length, one per page, each headed with one of the titular colors. But these titles, and the paragraphs that correspond with them, surprisingly reverse the order indicated in the title, while bringing them back in alignment with the customary order of the spectrum. "GREEN" falls on the left side of the open book, "BLUE" on the right, as though Woolf is suggesting that the sequence of her two paragraphs is potentially reversible. The paragraphs' balanced,

counterweighted presence, one falling on either side of the book's binding, is crucial to the piece's impact. Aligned to the rough symmetry of the human face, the piece has a curious, almost stereoscopic feel. When open, the mechanism of the book separates the paragraphs but, when closed, the same device traps "Green" and "Blue" together again, placing one on top of the other in an intimate embrace. The reference to madonnas in the last line of "Blue" reminds us that the book has a close cousin in the diptych, where a donor, saint, or Christ may balance the Virgin opposite.[37] The placement of "Monday or Tuesday" and "Blue & Green" within the book's sequence presents us with a final (and more abstract) type of symmetry. They are counterparts and counterweights of one another. *Monday or Tuesday* explores text/image relationships in two related ways: most obviously, through the presence of Bell's distinctive illustrations; but even in their absence, most obviously in "Blue & Green," Woolf directs our attention to how her writing might engage with *other* material and visual aspects of the book.

Monday or Tuesday is a book concerned with symmetry and balance, and so it is somewhat surprising that "The String Quartet," the fifth of its eight stories, is also the last to feature an illustration by Bell (on page 58 of 91). This results in a somewhat "front-loaded" feel to the book's balance. One partial explanation is that, in contrast to the four stories accompanied by woodcuts, illustrated versions of the last two stories in the volume ("Kew Gardens" and "The Mark on the Wall") had recently been published by Hogarth Press.[38] In fact, Bell's print for "An Unwritten Novel" is adapted from an earlier illustration she had made for "Kew Gardens" (1919). Bell's interest in "Kew Gardens" spanned almost a decade, and prompted her to reflect upon one of the central themes of this essay: how, in certain situations, words (even spoken words) resist their usual transparency, and take on a physical presence or look.

KEW VARIETALS

"It's a relief to turn to your story," Vanessa Bell wrote her sister in a letter dated July 3, 1918, "though some of the conversation—she says, I says, sugar—I know too well! But it's fascinating and a great success, I think." Bell was referring to "Kew Gardens," which she had just read in manuscript. "I wonder," she continues:

> if I could do a drawing for it. It would be fun to try, but you must tell me the size. It might not have very much to do with the text, but that wouldn't matter. But I might feel inclined to do the two people holding the sugar conversation. Do you remember a picture I showed at the Omega of 3 women talking with a flower bed seen out of the window behind? It might almost but not quite do as an illustration.[39]

Bell ended up contributing two woodcuts to the first edition of *Kew Gardens* (cat. 186), which was initially published in a limited edition of around one hundred and seventy copies. The prints follow the structure of the story, which crosscuts between the insect and human inhabitants of the gardens. One print serves as the book's frontispiece and depicts a parklike setting containing two figures. The other functions as a tailpiece and shows a large striped caterpillar and a butterfly. Although the most prominently featured creature in the story is a snail progressing toward an unspecified "goal," the caterpillar and butterfly pairing evokes the possibility of transformation, of change over time. In the story, the erratic flight of the butterfly connects the inhabitants of the ground to the humans above: "The figures of these men and women straggled past the flower-bed with a curiously irregular movement not unlike that of the white and blue butterflies who crossed the turf in zigzag flights from bed to bed."[40]

In the first and larger print, the figure on the left reads what looks like a newspaper, while her

companion looks across at her and in the direction of her reading material. A profusion of flowers and plants fills the space between and above them, but refuses to function "properly" as a backdrop to the figures; its floral forms compete for our attention, particularly in the space immediately between their faces. Seeming to attach themselves to the figures' hats, some of the flowers separate from this background and become sartorial ornamentation, becoming temporary visitors to Kew rather than residents.[41] Where in Bell's *A Conversation* (fig. 17), the painting that "might almost but not quite do as an illustration" for *Kew Gardens*, the burst of flowers between the figures reads as a punchy visual analogue for intense conversation,[42] in the print they seem almost excessive, an ironic counterpart to the couple's more equivocal and guarded body language.

The two figures in Bell's illustration (reduced from three in the painting) correspond most closely to the characters associated with the "she says, I says" dialogue of Woolf's text, those "two elderly women of the lower middle class, one stout and ponderous, the other rosy-cheeked and nimble."[43] Initially, the women are associated with collaborative activities. They both scrutinize "an old man's back" or else piece together "their very complicated dialogue." Bell's illustration, however, evokes their separateness as much as their sociability, and relates more closely to the next paragraph of Woolf's text, when the "heavy woman" has "ceased even to pre-

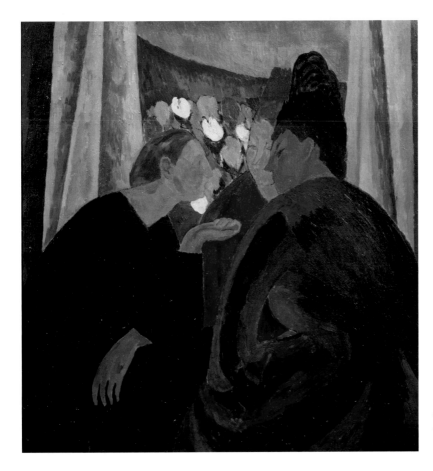

FIG. 17
Vanessa Bell, *Conversation*, 1913–16. Oil on canvas. The Samuel Courtauld Trust, Courtauld Institute of Art Gallery, London.

tend to listen to what the other woman was saying." Instead she looks "through the pattern of falling words at the flowers" and lets the words of their fading conversation "fall over her." The elusive idea of being able to see speech perhaps prompted Bell to introduce something Woolf's text doesn't mention. The newspaper, and our sense of how it might be read, substitute for the "pattern of falling words." This print, of course, strongly resembles the later illustration for "An Unwritten Novel," where additional adjustments to the image fit a different location and articulate a further disconnect between the two figures. Bell's woodcut for "A Society" shows an even more obvious debt to Bell's *A Conversation*,

stressing the status of that painting as a kind of ur-picture in Bell's thinking about illustration, and confirming the importance of conversation to the prints she made for *Monday or Tuesday*.[44]

Bell's contributions to Woolf's texts shifted in the early 1920s, after the completion of *Monday or Tuesday*. Increasingly, her energies were directed toward designing covers and dust jackets for her sister's work (and for other Hogarth Press publications). There are two major exceptions to this focus on cover art. Bell produced four line drawings for *Flush* (cats. 175–177); relatively conventional in style—or, put another way, in dialogue with nineteenth-century illustrative traditions—these were transferred into the text using the photomechanical collotype process. The other example is the third edition of *Kew Gardens*. Published in 1927 in a limited edition of five hundred, the book is Bell's most extensive exercise in book design and in the woodcut process; she designed the cover (printed in three colors of ink), a title page, and decorative borders for each of the twenty-one pages of text. There is a feeling of restrained luxury to the book, a feeling of the collectible (like a print, each copy of the book is individually numbered). The book has larger than standard dimensions and the type is generously spaced and surrounded by the space necessary for Bell's borders, which often penetrate into areas of the page usually reserved for text. Bell had been irritated by some of the technical shortcomings of *Monday or Tuesday*, and rightly so. Heavily inked and printed on rather thin paper, the prints often bled through the page, sometimes also leaving residual marks on the leaf opposite. Here, in contrast, the paper was of thicker stock and the pages only received ink on one side.

This third edition of *Kew Gardens* (fourth, if one counts the story's appearance in *Monday or Tuesday*) offers an entirely different text/image relationship from the earlier versions.[45] Although, as we have seen, Bell had earlier adapted compositions

FIGS. 18
Vanessa Bell, designer, first page of the 1927 edition of *Kew Gardens*. Courtesy of Washington State University Libraries, Manuscripts, Archives, and Special Collections.

for new contexts, she had avoided illustrating any story that she had treated previously. *Kew Gardens* was the exception to this rule—if, that is, the word "illustration" even applies to the 1927 edition (fig. 18). Bell preferred a different term. The work features "Decorations by Vanessa Bell" (according to her cover) or, alternatively, it was "decorated by Vanessa Bell" (according to the title page). The woodcut remained the chosen medium, but the style has radically changed, moving away from expressionistic chiaroscuro and toward a lighter, more linear playfulness. Gone are the humans and the insects of her previous images for the story, replaced by patterns of all sorts: zigzags, braids, spirals, meshes, loops, concentric circles, spirals, curlicues, and various organic forms—flowers, leaves, clouds, and water droplets. These elements create decorative borders for Woolf's text, usually surrounding it on all sides, but they are not mere adjuncts to the text. Although the prose remains the same, the text is altered in fundamental ways so as to accommodate the borders and respond to them. In this environment, the text only sometimes conforms to regular "blocks." Departures from the norm include staggered margins, centered text, uneven spaces between words, and uneven line lengths. The look of the text becomes, in this respect, just one decorative element among many. This version of *Kew Gardens* puts the page—rather than, say, the paragraph—at the heart of the book's organization. Settling on exactly how to distribute the text between the twenty-one pages was crucial to planning the book. The pages vary dramatically in length, from the short (just sixty odd words) to the long (around three times that number).[46] Sometimes the end of a page corresponds with a paragraph break, but sometimes it does not: each of the lengthy paragraphs that begins and ends the story, for example, is distributed among three consecutive pages.

Turning the page, therefore, becomes a crucial break in the text. There is an appealing diversity to

FIG. 19
Vanessa Bell, designer, page from the 1927 edition of *Kew Gardens.* Courtesy of Washington State University Libraries, Manuscripts, Archives, and Special Collections.

the book and, as one leafs through the pages, each consecutive page presents something different, some new interplay of text and image. Bell exploits the feeling of surprise that can accompany the page turn as we rapidly take in the different visual conditions of the new leaf. At the moment we meet the text's only pair of men, for example, they are first glimpsed from the perspective of a snail, as feet passing the flower bed. Upon turning the page, the arching and spreading lines of one sheet are abruptly replaced by far more orderly forms, lines suggesting not nature, but the vocabulary of classical architecture—two flanking columns supporting a flattened arch (fig. 19). "This time," the top line of text reads, "they were both men."[47] The transi-

"Fifteen years ago I came here with Lily," he thought. "We sat somewhere over there by a lake, and I begged her to marry me all through the hot afternoon. How the dragon-fly kept circling round us; how clearly I see the dragon-fly and her shoe with the square silver buckle at the toe. All the time I spoke I saw her shoe and when it moved impatiently I knew without looking up what she was going to say: the whole of her seemed to be in her shoe. And my love, my desire, were in the dragon-fly; for some reason I thought that if it settled there, on that leaf, the broad one with the red flower in the middle of it, if the dragon-fly settled on the leaf she would say 'Yes' at once.

But the dragon-fly went round and round: it never settled anywhere—of course not, happily not, or I shouldn't be walking here with Eleanor and the children—Tell me, Eleanor. D'you ever think of the past?"
"Why do you ask, Simon?"
"Because I've been thinking of the past. I've been thinking of Lily, the woman I might have married . . . Well, why are you silent? Do you mind my thinking of the past?"
"Why should I mind, Simon? Doesn't one always think of the past, in a garden with men and women lying under the trees? Aren't they one's past, all that remains of it, those men and women, those ghosts lying under the trees, . . . one's happiness, one's reality?"
"For me, a square silver shoe-buckle and a dragon-fly—"

FIGS. 20, 21

Vanessa Bell, designer, pages from the 1927 edition of *Kew Gardens.* Courtesy of Washington State University Libraries, Manuscripts, Archives, and Special Collections.

tion has an unmistakable note of humor, as though the text explains (and genders) the stiff and upright forms our eyes are in the process of absorbing.[48]

Or, to choose an earlier example, consider the three pages dealing with Simon and Eleanor, the first human couple we encounter on our tour of Kew (fig. 20). Simon is thinking about a visit he made to the gardens "[f]ifteen years ago," when he proposed to his girlfriend, Lily.[49] Nervously waiting for her response, Simon fixated on her shoe and on the flight of a dragonfly. "And my love, my desire," he remembers, "were in the dragon-fly; for some reason I thought that if it settled there, on that leaf, the broad one with the red flower in the middle of it, if the dragon-fly settled on the leaf she would say

'Yes' at once." Elements of the page's decorations correspond to his thoughts. There is a spiral and generously spaced curves, which run into a large floral motif at the bottom right; a line around the flower, spaced at a generous interval, implies that it is located on a leaf. The curves hint at the organic forms of plants, perhaps, but may also describe the erratic path of the dragonfly, the path Simon wishes it would take.

Alas, we turn the page and find out this is not to be (fig. 21). The curves are replaced by straighter lines, and our point of view retreats, revealing larger and more recognizable forms bracketing the page: the trunk, canopy and branch of a stiff tree, like a capital "F"; and beneath this, emphatic horizontal

lines of different lengths suggest the ground receding away from us. The visual shift, from one page to the next, is abrupt, like a cinematic cut from close-up to long shot, and seems to pull Simon abruptly out of his memories; we feel this before Simon's words confirm it in the text: "But the dragon-fly went round and round: it never settled anywhere—of course not, happily not, or I shouldn't be walking here with Eleanor and the children—Tell me, Eleanor. D'you ever think of the past?" "Doesn't one always think of the past," Eleanor responds:

> in a garden with men and women lying under the trees? Aren't they one's past, all that remains of it, those men and women, those ghosts lying under the trees…. one's happiness, one's reality?"
>
> "For me, a square silver shoe-buckle and a dragon-fly—"
>
> "For me, a kiss."

Their conversation is now cooperative, and one partner echoes the speech patterns of the other. But in the 1927 edition of the story, a page break falls between the last two lines of dialogue, leaving Simon stranded on another page, and freeing Eleanor to recall a less traumatic moment from her past, a moment of erotic (and homoerotic) awakening (fig. 22). Placed twenty years ago, the recollection involves a painting excursion to "the side of a lake," where the young Eleanor received "suddenly a kiss, there on the back of my neck. And my hand shook all the afternoon so that I couldn't paint." Administered, as in a fairy tale, by "an old grey-haired woman with a wart on her nose," it was the "mother of all my kisses all my life." Bell's simple decorations for this page consist of a border of parallel lines, wavy at the sides, braided at the top, and looped at the bottom. They generate a feeling of liquidity, as though we are looking into a watery surface (a memory pool) or even as though these are the kinds of lines that a recently kissed artist might make, with hand shaking.

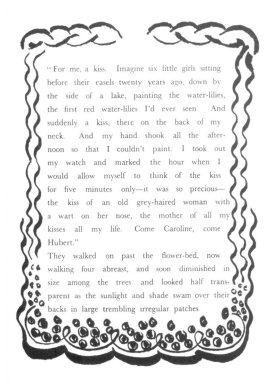

FIG. 22
Vanessa Bell, designer, page from the 1927 edition of *Kew Gardens*. Courtesy of Washington State University Libraries, Manuscripts, Archives, and Special Collections.

Bell's decorations have been compared to those of William Blake,[50] but the way Bell exploits the page-turn more closely recalls another genre with a history of exploiting decorative elements to amusing ends: children's literature. Bell often read to her own children, and Angelica, the youngest of them (born 1918), would have ensured her mother's continued familiarity with this literature.[51] Bell's decorations presumably drew on her immediate environment, the gardens of Charleston; and around the same time, another part of Sussex inspired Ernest Shepard's illustrations for what is now a much more famous book, A. A. Milne's *Winnie-the-Pooh* of 1926 (fig. 23).

FIG. 23
Page from *Winnie-the-Pooh* by A. A. Milne, illustrated by E. H. Shepard (London: Methuen & Co., Ltd.), 1926.

The differences between these visual texts are obvious, but a comparison points to some surprising kinships in the playful relationship between typographic and illustrative elements, and in the treatment of the page as a kind of physical and gravitational field. Bell does not turn *Kew Gardens*—which is after all as much a song of experience as of innocence—into a children's book. Rather, her decorations foreground the qualities of Woolf's story more commonly associated with children's literature rather than with supposedly off-putting or "difficult" modernist texts: its steady sense of pace and interest in pattern, its pleasure in sensation and language, its relative simplicity. To borrow a phrase from the last paragraph of the story, Bell's illustrations underline a quality Woolf associates with "the voices of children"—namely, "such freshness of surprise."[52]

One such surprise provided by the turn of the page in *Kew Gardens* is the incursion of image into text, and vice versa. Though Bell's bordering elements generally keep a respectful distance from the text they surround, at certain points, Bell's marks are allowed to encroach upon Woolf's words. This possibility is announced on the very first page, where Bell's print overwhelms the scanty nine lines of text. Springing from the ground level of the bottom of the page, flowers and foliage climb up the leaf and surround the text on all sides, the organic forms turning into "hand written" words at the top of the page so as to provide us with the story's title. Woolf's words mention a flower bed, stalks, "heart-shaped or tongue-shaped leaves," and we may search the page, with some success, for images of these objects.[53] Our search climaxes at the end of the page, where we read about the emergence from a flower of "a straight bar, rough with gold dust and slightly clubbed at the end." As if to demonstrate this point, a stamen springs up from a nearby flower, its tip (perhaps even clubbed in shape) falling just below the space between "at" and "the." This first

page alerts us to an important principle and one that informs the rest of the work: these may be "decorations" but that does not make them unrelated to the content of the text. Bell's earlier illustrations for *Kew Gardens* and *Monday or Tuesday* also had a strongly decorative dimension. The converse is the case here: her decorations can also illustrate.

Bell's prints create an alternative climax to the story, one that competes with the conclusion of the text, where Woolf broadens our sense of context and reminds us that idyllic Kew is located within a modern city: "But there was no silence; all the time the motor omnibuses were turning their wheels and changing their gear; like a vast nest of Chinese boxes all of wrought steel."[54] Bell, it seems, was still fascinated by the passage she mentioned to her sister when she first read the story in 1918, the moment of the "two people holding the sugar conversation." In her earlier illustration of this scene, Bell concentrated on the moment *after* the conversation and, by supplying the "stout and ponderous" woman with a newspaper, indicated one way spoken words might become fixed in a visual form. In the 1927 edition of *Kew Gardens*, Bell exploited the two devices I have been discussing: the page turn, and the intrusion of image into text.

The text of the couple's "complicated dialogue" is placed at the bottom of the twelfth page of the text (fig. 24):

> "Nell, Bert, Lot, Cess, Phil, Pa, he says, I says, she says, I says, I says, I says—"
> "My Bert, Sis, Bill, Grandad, the old man, sugar.
> Sugar, flour, kippers, greens,
> Sugar, sugar, sugar."[55]

As the fragmented record of the conversation moves between proper nouns, dialogue markers, back to proper nouns, and finally to a simple list of food stuffs, the language takes on the look of poetry, a

FIG. 24
Vanessa Bell, designer, page from the 1927 edition of *Kew Gardens*. Courtesy of Washington State University Libraries, Manuscripts, Archives, and Special Collections.

shift suggested by the use of two short, indented lines. The look of words on a page, their visual organization, is typically more important in poetry than prose, but as we turn to the next page we immediately notice an entirely new level of complexity, of words becoming pattern. "The ponderous woman," reads the text at the top of the page (fig. 25):

> looked through the pattern of falling words at the flowers standing cool, firm and upright in the earth, with a curious expression. She saw them as a sleeper waking from a heavy sleep sees a brass candlestick reflecting the light in an unfamiliar way, and closes his eyes

At which point our own eyes hit an obstacle—the top portion of a flower, which Bell placed squarely in the center of the page, and which indeed somewhat resembles a candlestick. We continue to read but must negotiate this intrusion as we go, repeatedly searching for the beginning of the next section of related text. The effort gets harder: petal-like forms begin to intrude into the text and divide the two columns of text into three. Finally, on the page's last line, an element (petal or stem) separates each of the four words from its neighbor (and / have / their / tea). One consequence of dividing the page in this way is to make the reader conscious of the (usually ignored) vertical relationships between words. Constantly impeded in our progress across the page, we are tempted to take paths of less resistance by reading down the columns that the flower and petals have created. What emerges from this activity is, of course, largely nonsense and, thus, in a way, we are taken back to the women's dialogue. The page begins to resemble the ponderous woman's perception of her conversation in the moments immediately following it. Like her, we find that as the obvious meaning of language drifts away, we become alert or "awake" to something else—the sensation of being immersed in a "pattern of falling words."

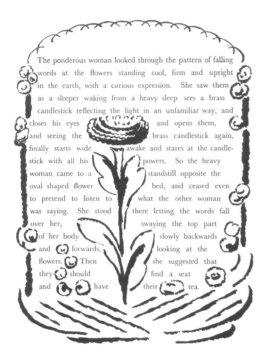

Fry's 1926 essay on book illustration defined some of the features of the decorated text, but also stated that the decorator does "not provoke any question with the writer. It is only when the artist's forms have a further significance, suggest ideas or feelings by what they represent or by symbolical or expressionist methods, that they impinge on the text."[56] That is to say, it is only at this point that the artist ceases to be a decorator and moves into the realm of illustration. Yet in her 1927 woodcuts for *Kew Gardens*, Bell's forms *do* artfully impinge on the text, and the gesture seems to announce a departure from the categories Fry outlined. Or rather, the book occupies the space between them, drawing freely from both.

In terms of text-and-image explorations, 1927 was a remarkable year for Bloomsbury and the Hogarth Press. Apart from Bell's decorated version of *Kew Gardens*, it was the year of Roger Fry's *Cézanne: A Study of His Development*, often considered his most important contribution to art criticism, and also the year of *To the Lighthouse*, which contains Woolf's most prolonged descriptions of the painting process. Fry and Woolf, like Bell, approach the text/image divide from distinctive angles. Fry explores an axiom of his formalism—that the conclusiveness of verbal analysis is inversely related to the visual qualities it seeks to describe. Critical impotence here becomes an index of artistic worth, and to truly appreciate Cézanne's art, we must turn to the reproductions at the end of the book or, better still, go and look at the original works. Fry's aim is to stimulate our desire to see paintings, but *To the Lighthouse* prompts us to want to visualize images that have no existence outside of Woolf's language—Lily Briscoe's paintings. We especially desire to see the painting Lily completes at the end of the novel, when, "as if she saw it clear for a second, she drew a line there, in the centre."[57]

Readers can try to imagine what Lily's paintings might look like (try, so to speak, to provide their own mental illustration) or can look for inspiration—at least in the original editions of the book—at the dust jacket Bell created for the novel, an image of a vertical element surrounded by stylized waves. This vertical reads as a lighthouse, but the light emanating from it seems to solidify, turning it into a rather ambiguous figure—like an upturned brush or a spectral body with arms aloft. Providing an illustration might not, then, eliminate the need to interpret. Moreover, the fate of a dust jacket is typically to be lost, a casualty of the careless reader or of the publishers of subsequent editions. More enduringly (but with no more certainty), the implied "look" of the painting Woolf's text describes could be analogous to the tripartite structure of the novel, with the line in the center of the work corresponding to "Time Passes," the shorter central section of the novel. The (mental) illustration we are looking for might, then, come from our sense of Woolf's literary form, something akin to the "H" schema she drew in her notebook while planning the novel ("Two blocks joined by a corridor").[58]

Since these approaches are necessarily subjective and ambiguous, we might prefer to consider what the novel says about illustrated or picture-filled texts. The first section, "The Window," is particularly rich in this respect. It starts with descriptions of the young James Ramsay cutting out images of commodities from a catalogue. A little later on, his mother reads to him the Grimms' story of "The Fisherman and his Wife." Woolf doesn't specify whether the Ramsays' edition of Grimm's stories was illustrated, but she connects the scene of mother and child to picture making and to illustration. The figures become "the triangular purple shape" or "shadow" in the painting Lily works on throughout the first section of the novel. And they

also become a type of illustration for Mr. Ramsay as he walks past:

> He stopped to light his pipe, looked once at his wife and son in the window, and as one raises one's eyes from a page in an express train and sees a farm, a tree, a cluster of cottages as an illustration, a confirmation of something on the printed page to which one returns, fortified and satisfied....[59]

The scenario of reading on the train takes us back to "An Unwritten Novel," where the narrator intermingles her reading of the *Times* with her observations of fellow passengers, treating both as "great reservoir[s] of life."[60] Bell's 1921 illustration of the scene might even suggest that our point of view, like the narrator's, is "over the paper's rim." Woolf here toys with the intriguing idea that the experience of reading a book invariably involves moments of "going in and out" of the text. Our concentration breaks; we take a rest; we become distracted by things in the peripheries of our vision; we look elsewhere. Since these breaks or interruptions in the act of reading are experienced in relation to the text, it follows that these moments are akin to illustrations. For Mr. Ramsay, these are "good" illustrations and confirm "what is on the printed page," a snug one-on-one correspondence that arouses our suspicions of him. Even if we accept that all texts are illustrated in this phenomenological sense, however, we would surely expect a great deal more friction between the text and the world around it. Tellingly, when his father interrupts his story time, James refuses to return the favor, refuses to let him "illustrate" the book he is sharing with his mother: "By looking fixedly at the page, he hoped to make him move on."[61]

In this fascinating passage Woolf presents the possible relationship between text and illustration in a new way, bringing in material that we usually ignore, overlook, or deem irrelevant. This over-looked material need not be located "beyond" the edges of the text. As in any strong figure/ground relationship, one might follow Fry's instructions about looking at art by reversing the normal order of perception and attend to the way the figure of the text is "grounded" in the physical form of pages bound together as a book. This, I have suggested, was also the case with "Blue & Green," another visually evocative (rather than illustrated) text containing a Madonna or "madonnas." But in *To the Lighthouse*, the visual absences are of an entirely different magnitude and, in the case of Lily's paintings, encompass not only colors ("all its greens and blues"[62]) but also style, composition, subject matter, and so forth.

In an oft-quoted letter to Roger Fry, Woolf rejected ascribing any narrow symbolism to the lighthouse:

> I meant *nothing* by The Lighthouse. One has to have a central line down the middle of the book to hold the design together. I saw that all sorts of feelings would accrue to this, but I refused to think them out, and trusted that people would make it the deposit for their own emotions—which they have done, one thinking it means one thing another another.[63]

Woolf's language, that "central line down the middle of the book," recalls the end of the novel and Lily's completion of her painting, suggesting a connection between the issue of symbolism and her descriptions of Lily's work. Certainly, for the reader, the process of visualizing Lily's work must, like the matter of symbolism, be largely a matter of personal projection. While arguing for broad interpretative possibilities, however, Woolf's language also opens up another, more specific avenue of thought.

The "central line down the middle" suggests a number of aspects of the novel, among them the lighthouse (as reiterated in Bell's dust jacket), Lily Briscoe's painting and its completion, and the text's

tripartite structure. Yet Woolf's language is also the language of book making and book binding, where a line down the middle is a spine, and a spine is necessary for the physical integrity of the larger object. It holds the "design" together. The book as an object, that is, might become a kind of phantom illustration for the text that it contains. It becomes a schema, or mapping device, one that recalls crucial aspects of the novel's organization. The reader responds to the book as a physical object. We look at the book in our hands or possess the sense memory of what a book looks and feels like. As with "Blue & Green," *To the Lighthouse* is a folding structure, a balanced diptych, only this time the connecting hinge, or corridor, is not merely perceived as a line dividing the page into two, into a left and a right. It is written out and becomes its own section, "Time Passes."

A decade of experimenting with book design, of collaborating with artists (most often with her sister), and of thinking about illustration can be felt in *To the Lighthouse.* A crucial part of this visual and physical education was provided by the chiaroscuro of the modernist woodcut, those riveting performances of the relationship between ink and paper, presence and absence. For in these woodcuts, marks can also be absences, and paper itself becomes lightness visible. The modernist woodcut powerfully activated figure/ground reversals, but certainly it was not the only medium to possess this ability. When Woolf encourages us to attend to the way her writing is embodied in a particular type of physical object—one that possesses a cover, a spine, and pages; one that can open and close—she is rather like Fry in front of Matisse's *Dance*. She prompts us, so to speak, not to look exclusively at the legs of her figures, but to consider the easily ignored spaces between and around them. The ability of marks to shape space is, it turns out, precisely where Lily Briscoe's thoughts turn as she begins her painting

in the final section of *To the Lighthouse*. Having made her initial "brown running nervous lines," she immediately contemplates how they "enclosed (she felt it looming out at her) a space. Down in the hollow of one wave she saw the next wave towering higher and higher above her. For what could be more formidable than that space?"[64]

1 In addition to Woolf's two early novels, which were published by Duckworth & Co., the exceptions are *Orlando* and *Flush*. It should be noted, however, that Bell is mentioned in the acknowledgments of *Orlando* and contributed four illustrations to *Flush*. Another partial exception is Woolf's *Roger Fry: A Biography*; this book's cover features not an original design by Bell, but a reproduction of her earlier oil painting of Fry working at his easel. Bell also coauthored (with Duncan Grant) its appendix.

2 From 1921, Harcourt, Brace and Company published the American editions of Woolf's books, also using Bell's cover designs.

3 *The Complete Shorter Fiction of Virginia Woolf*, ed. Susan Dick (Orlando: Harcourt Brace & Company, 1989), 89.

4 It does, however, seem to be associated with the growth in small presses and publishers that sprang up in the interwar years, of which the Hogarth Press was one of the first. B. J. Kirkpatrick and Stuart N. Clarke note that "John Rodker, founder of the Ovid Press and the Imago Press was living at 43 Belsize Gardens, Hampstead, from 1920 to 1923 and may have published the broadsheet.... The Chelsea Book Club records provide no infor-

mation"; see *A Bibliography of Virginia Woolf* (Oxford: Oxford University Press, 1997), 15. On the growth of small presses during this time, see J. H. Willis, *Leonard and Virginia Woolf as Publishers: The Hogarth Press, 1917–41* (Charlottesville: University Press of Virginia, 1992), 35–42.

5 For a convenient summary of the renewed popularity of the woodcut at the beginning of the twentieth century, see Riva Castleman, *Prints of the 20th Century: A History* (London: Thames and Hudson, 1988), 17–36.

6 See *The Bloomsbury Artists: Prints and Book Design* (Aldershot: Scolar Press, 1999), 12.

7 Initially the book was to have been published by the Hogarth Press, but disagreements between Leonard Woolf and Vanessa Bell put an end to this plan. For an account of this project, see Diane Gillespie, *The Sisters' Arts: The Writing and Painting of Virginia Woolf and Vanessa Bell* (Syracuse: Syracuse University Press, 1988), 122–23.

8 Originally published in *The Burlington Magazine* as a review of Kauffer's illustrated version of Burton's book, an expanded version of the essay appeared in Fry's *Transformations: Critical and Speculative Essays on Art* (New York: Brentano's, 1926), 157–72.

9 For more on Kauffer, see Mark Haworth-Booth,

E. McKnight-Kauffer: A Designer and His Public (London: Gordon Fraser, 1979).

10 Fry, *Transformations*, 160–61.

11 Ibid., 168.

12 Ibid., 168–70.

13 For a summary of Fry's relationship to Derain, albeit one that omits to mention illustration, see *Art Made Modern: Roger Fry's Vision of Art*, ed. Christopher Green (London: Merrell Holberton, 1999), 160–61.

14 Ibid., 170–2.

15 *Roger Fry: Art and Life* (Norwich: Black Dog Books, 1999), 150.

16 Ibid., 172.

17 Ibid., 157.

18 Ibid., 160.

19 Ibid., 157–59.

20 Diane Gillespie reads the top print more definitively, seeing the woman, the chair, table and cup as belonging to the interior where the narrator of the story is located, the remaining objects as belonging to a mental realm: "As the natural world fills the narrator's thoughts, so it mingles with the furniture and teacup in the woodcut. Both Woolf and Bell blur the distinction between interior and exterior environments." See Gillespie, 139.

21 Letter 844 (July 13, 1917) in *The Letters of Virginia Woolf. Volume II: 1912–1922*,

eds. Nicolson and Trautmann (New York: Harcourt Brace Jovanovich, 1978), 162.

22 Ibid., 170.

23 "Harliquinade," one of the Omega's *Original Woodcuts by Various Artists*, still follows the traditional division of labor. While Mark Gertler provided the design, Roger Fry actually cut the block.

24 Respectively, letters IV-30 (to Virginia Woolf, November 15, 1918) and IV-29 (to Roger Fry, November 11, 1918) in *Selected Letters of Vanessa Bell*, ed. Regina Marler (Wakefield: Moyer Bell, 1998); the quotation is taken from the letter to Roger Fry (216).

25 Letter of October 1918, in *Carrington: Letters and Extracts from her Diaries*, ed. David Garnett (London: Jonathan Cape, 1970), 106.

26 *The Diary of Virginia Woolf. Volume II: 1920–24*, ed. Anne Olivier Bell (Harmondsworth: Penguin Books, 1981) 109.

27 The snail will also feature in "Kew Gardens" where, like an emblem of Sisyphean futility, it labors "over the crumbs of loose earth which broke away and rolled down as it passed over them. It appeared to have a definite goal in front of it" (Dick, 91).

28 For the quotation, see letter 844 (to Dora Carrington, July 13, 1917),

163; and, for similar sentiments, as well as an intimation of the idea that would later become *Original Woodcuts by Various Artists*, see letter 851 (to Roger Fry, July 22, 1917), 166: "Tomorrow we are going to see a £100 press which we are told is the best made—particularly good at reproducing pictures. This opens up fresh plans, as you will see. Wouldn't it be fun to have books of pictures only, reproductions of new pictures—but we must get you to tell us a little about how one does this."

29 For another image by Bell featuring an armchair and stressing its relationship to the human body, see her cover for Woolf's *The Common Reader, Second Series* (1932).

30 *Monday or Tuesday* (Richmond: The Hogarth Press, 1921), 16.

31 Ibid., 39.

32 Ibid., 41.

33 Ibid., 64, 62, 61, and 65.

34 Unlike many of the other pieces in the volume, and indicating their importance to it, these pieces only appeared in *Monday or Tuesday* during Woolf's lifetime.

35 Ibid., 37.

36 Ibid., 66–67.

37 Such relationships and associations are lost when the two paragraphs are placed together on the same page. See, for example, *The Complete*

Shorter Fiction of Virginia Woolf (142).

38 As we have seen, the remaining two pieces ("Monday or Tuesday" and "Blue & Green") have a distinctively visual quality and, like the illustrations, serve the function of acting as interludes, of dividing up the longer pieces.

39 Letter IV-28, 214–15. Bell refers here to her painting *A Conversation* (1913–16), now at the Courtauld Institute of Art Gallery (see fig. 17).

40 Dick, 90.

41 This interpretation of the flowers follows Gillespie, 119.

42 See Frances Spalding, *Vanessa Bell* (New Haven: Ticknor & Fields, 1983), 153–54.

43 For this, and the other quotations in this paragraph, see Dick, 93. These are the only couple in the story consisting of two women. Woolf refers to the subject of the print as "the women"; see letter 990 (to Vanessa Bell, November 264, 1918), 298–300.

44 Woolf, too, appreciated the significance of this painting, once expressing a desire to "write the Three Women [i.e. *A Conversation*] in prose." See letter 1894 (to Vanessa Bell, May 12, 1928) in *The Letters of Virginia Woolf. Volume III: 1923–1928*, eds. Nicolson and Trautmann (New York: Harcourt Brace Jovanovich, 1980), 497–99.

45 To recap, it had originally been printed in 1919 with Bell's two illustrations; shortly after this, a larger and unillustrated second edition appeared.

46 It is unclear as to who exactly made these decisions. Gillespie suggests that "Virginia, Leonard, or both must have given Vanessa some indication of what part of the text would be on each page since the portions are relatively self-contained" (123). But I find it highly probable that Bell, too, was involved in determining this issue.

47 Dick, 92. (Since the 1927 *Kew Gardens* is unpaginated, all page references are to the text reprinted in *The Complete Shorter Fiction of Virginia Woolf*.)

48 This reading follows Gillespie, who notes that "the general symmetry and rigidity of the design communicates stereotypical masculine characteristics" (126–131).

49 For all quotations in this and the next paragraph, see Dick, 90–91.

50 See, for example, Spalding, *Vanessa Bell*, 221, and Gillespie, 131–32.

51 See Angelica Garnett, *Deceived with Kindness: A Bloomsbury Childhood* (San Diego: Harcourt Brace Jovanovich, 1985), 96 and 166.

52 Ibid., 95.

53 For all quotations in this paragraph, see ibid., 90.

54 Ibid., 95.

55 For all quotations in this paragraph, see ibid., 93.

56 Ibid., 157–58.

57 *To the Lighthouse* (Orlando: Harcourt, Inc., 2005), 211.

58 Ibid., xxxix.

59 Ibid., 36.

60 *Monday or Tuesday*, 40.

61 Ibid., 40.

62 Ibid., 163 and 211.

63 Letter 1764 (May 27, 1927) in *The Letters of Virginia Woolf. Volume III: 1923–1928*, 385–86.

64 Ibid., 161–62.

Works in the Exhibition

2
Vanessa Bell
British, 1879–1961
Sketch for Durbins mural, ca. 1911
Oil and wash on board
18½ × 11¾ inches
Private collection

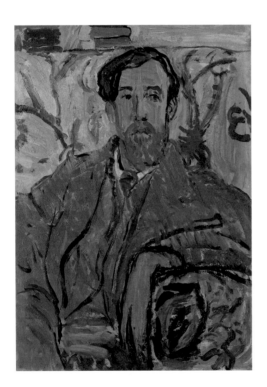

1
Vanessa Bell
British, 1879–1961
Lytton Strachey, 1911
Oil on board
14 × 10 inches
Collection of William Kelly Simpson, New York

3
Vanessa Bell
British, 1879–1961
Landscape with Haystack, Asheham, 1912
Oil on board
23¾ × 25⅞ inches
Collection of the Smith College Museum of Art,
Northampton, Massachusetts. Purchased with
the gift of Anne Holden Keickhefer, class of 1952,
in honor of Ruth Chandler Holden, class of 1926, 1989.

4
Vanessa Bell
British, 1879–1961
Still Life, 1912
Watercolor
14 × 9½ inches
Private collection

5
Vanessa Bell
British, 1879–1961
Virginia Woolf, ca. 1912
Oil on paperboard
14½ × 12 inches
Collection of the Smith College Museum of Art,
Northampton, Massachusetts
Gift of Ann Safford Mandel, class of 1953

6
Vanessa Bell
British, 1879–1961
Pool at Durbins (recto) and
Two figures (verso), 1913
Oil on board
10½ × 8¾ inches
Private collection

7
Vanessa Bell
British, 1879–1961
Composition, ca. 1914
Oil and gouache on cut-and-pasted paper
21¾ × 17¼ inches
Collection of the Museum of Modern Art, New York
The Joan and Lester Avnet Collection, 1978
Shown only at Durham, Ithaca, Evanston, and Northampton

8
Vanessa Bell
British, 1879–1961
Omega Paintpots, 1915
Oil on board
16 × 19 inches
Private collection

9
Vanessa Bell
British, 1879–1961
Portrait of Mary St. John Hutchinson, 1915
Oil on canvas
31 × 21¾ inches
Collection of the Cornell Fine Arts Museum, Rollins College
Gift of Dr. Kenneth Curry, PhD, R. '32

10
Vanessa Bell
British, 1879–1961
Self-Portrait, ca. 1915
Oil on canvas laid on panel
25⅛ × 18¹/₁₆ inches
Collection of the Yale Center for British Art, Paul Mellon Fund
Shown only at University Park

11
Vanessa Bell
British, 1879–1961
The Lesson, 1917
Oil on canvas
24 × 19 inches
Private collection

12
Vanessa Bell
British, 1879–1961
Flowers in a Vase, 1917
Watercolor
18½ × 12½ inches
Private collection

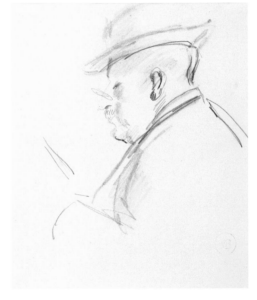

13
Vanessa Bell
British, 1879–1961
Man Reading in a Paris Café, 1920s
Pencil
10½ × 9 inches
Collection of Anne and Allen Dick

14
Vanessa Bell
British, 1879–1961
St. Tropez, 1922
Oil on canvas
15 × 21 inches
Collection of Susan Chaires

15
Vanessa Bell
British, 1879–1961
Self-Portrait, ca. 1926
Oil on canvas
30 × 24 inches
Collection of Mills College
Art Museum
Bequest of
Carolyn G. Heilbrun

Lettice Ramsey, *Vanessa Bell*,
1932. Courtesy of the
Harvard Theatre Collection,
Houghton Library,
Harvard University.

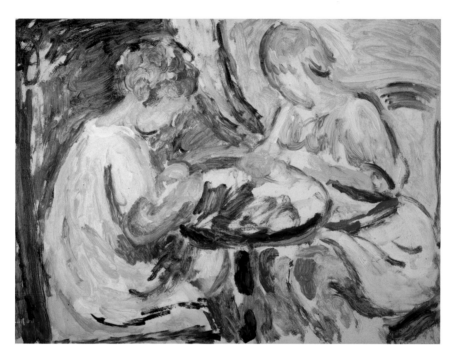

16
Vanessa Bell
British, 1879–1961
Girls Doing Needlework, ca. 1928–30
Oil on board
15¼ × 20½ inches
Private collection

ALFRISTON

SEE BRITAIN FIRST ON SHELL

17
Vanessa Bell
British, 1879–1961
Shell Poster: Alfriston, 1931
Color lithograph
24 × 36 inches
Private collection

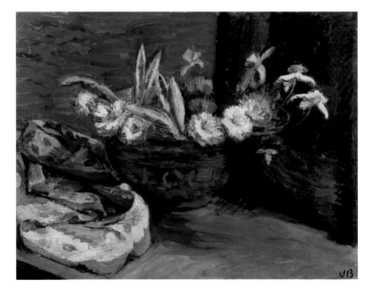

18
Vanessa Bell
British, 1879–1961
Ranunculas in a Bowl, ca. 1930s
Oil on canvas
13 × 17 inches
Collection of Dean Malone and
Dr. Richard Purvis, Louisville, KY

19
Vanessa Bell
British, 1879–1961
A Garden Walk, 1934
Oil on canvas
28¾ × 24 inches
Private collection

20
Vanessa Bell
British, 1879–1961
Angelica at the Loom, 1937
Oil on paper
21½ × 27½ inches
Private collection

21
Vanessa Bell
British, 1879–1961
The Schoolroom, 1931
Color lithograph
18 × 24 inches
Collection of the Herbert F. Johnson
Museum of Art, Cornell University
Purchased with funds from
Janet and Bob Liebowitz

22
Vanessa Bell
British, 1879–1961
*Study for the
Portrait of
Leonard Woolf*, 1938
Oil on paper
26⅜ × 20¾ inches
Collection of the
Victoria University
Library, Toronto

23
Vanessa Bell
British, 1879–1961
Young Boy Reading
Watercolor and red conté crayon
12⅞ × 9⅝ inches
Collection of Patricia and Donald Oresman

24
Vanessa Bell
British, 1879–1961
Young Boy Reading
Color lithograph based on the watercolor
14 × 10½ inches
Collection of Patricia and Donald Oresman

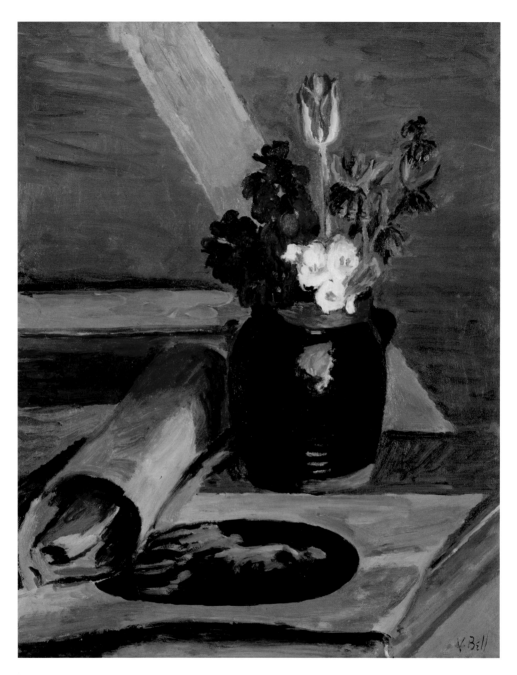

25
Vanessa Bell
British, 1879–1961
Still Life of Flowers in a Jug, 1948–50
Oil on canvas
20 × 16 inches
Collection of Bannon and Barnabas McHenry

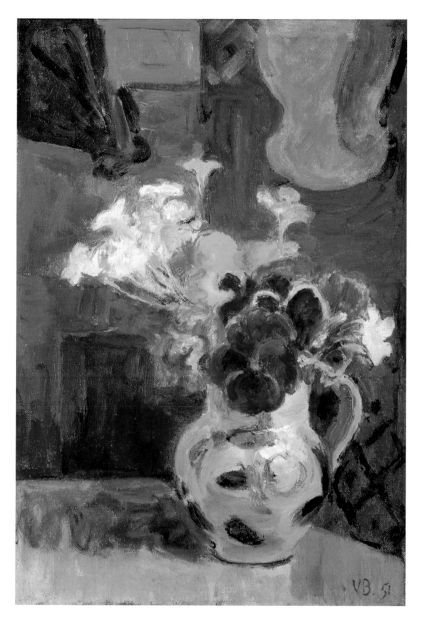

26
Vanessa Bell
British, 1879–1961
Flowers in a Patterned Pot, 1951
Oil on canvas
17 × 12¾ inches
Collection of Anne and Allen Dick

27
Vanessa Bell
British, 1879–1961
Family Group, ca. 1950
Oil on paper
17½ × 15½ inches
Collection of the Herbert F. Johnson
Museum of Art, Cornell University
Purchased with Funds from
the Overton Estate

28
Vanessa Bell
British, 1879–1961
Duncan Grant Painting, ca. 1952
Oil on canvas
18 × 11⅜ inches
Collection of the Cornell
Fine Arts Museum,
Rollins College. Gift of
Dr. Kenneth Curry, PhD, R. '32.

29
Vanessa Bell
British, 1879–1961
Plums in a Dish, ca. 1950s
Oil on board
2 × 8⅝ inches
Private collection

30
Vanessa Bell
British, 1879–1961
Reflections in a Pond, Charleston, 1957
Oil on canvas
21 × 20 inches
Collection of Peter Stansky

31
Dora Carrington
British, 1893–1932
The Garden Slug (recto) and
Three scenes with children (verso), ca. 1901
Watercolor and pencil
10 × 13 inches
Collection of Penelope Franklin

32
Dora Carrington
British, 1893–1932
The Clothesline, ca. 1901
Pencil
10 × 13 inches
Collection of Penelope Franklin

33
Dora Carrington
British, 1893–1932
Teddie in the Garden (recto) and
Enid Hathery (verso), ca. 1901
Pencil
10⅝ × 14⁷⁄₁₆ inches
Collection of Penelope Franklin

34
Dora Carrington
British, 1893–1932
Pink Buildings and Horse
(recto) and *Two Couples*
(verso), ca. 1901
Watercolor and pencil
10 × 13 inches
Collection of
Penelope Franklin

35
Dora Carrington
British, 1893–1932
Village School, ca. 1901
Pen and pencil
8⅞ × 11⅜ inches
Collection of Patricia and Donald Oresman

36
Dora Carrington
British, 1893–1932
Teddy Carrington, 1912
Oil on board
20 × 18 inches
Private collection

37
Dora Carrington
British, 1893–1932
*Maynard Keynes, Lytton
Strachey, and Others,*
ca. 1916
Ink and wash
7¼ × 9¾ inches
Private collection

38
Dora Carrington
British, 1893–1932
Julia Strachey, ca. 1925
Pencil
9¾ × 7¼ inches
Collection of Susan Chaires

39
Dora Carrington
British, 1893–1932
Begonias, 1927
Oil on canvas
27¼ × 20 inches
Collection of Mary Ann Caws, New York

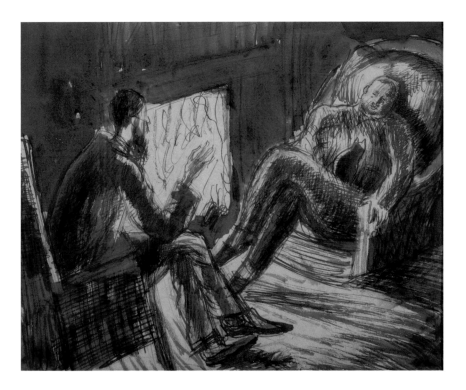

40
Dora Carrington
British, 1893–1932
*Lytton Strachey and Boris Anrep in the
front sitting room at Ham Spray*, ca. 1927
Pen and ink
14 × 13 inches
Collection of Charles E. Whaley

Carrington perfected
her whimsical illustrative
style in letters such
as this one to Mark
Gertler. Collection
of the Harry Ransom
Center, The University
of Texas at Austin.

41
Dora Carrington
British, 1893–1932
Cattle by a Pond, View from Ham Spray, 1930
16½ × 14⅛ inches
Oil on canvas
Private collection

42
Roger Fry
British, 1866–1934
Winifred Gill by the Pool at Durbins, 1912
Oil on board
32 × 25 inches
Private collection

Portrait of Winifred Gill.
Gill Family Papers, Bodleian
Library, Oxford University.

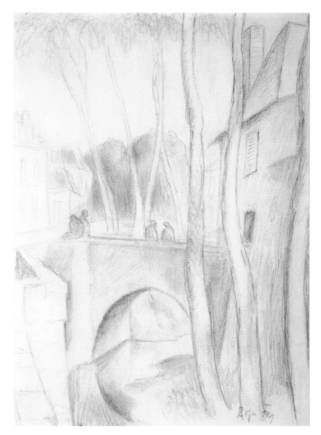

43
Roger Fry
British, 1866–1934
Figures on a Bridge,
Chartres, ca. 1912
Pencil
13 × 10 inches
Collection of Dean Malone
and Dr. Richard Purvis,
Louisville, KY

44
Roger Fry
British, 1866–1934
Winter Landscape, 1912–14
Oil on canvas
mounted on board
20 × 20 inches
Collection of the
Cornell Fine Arts Museum,
Rollins College
Bequest of Kenneth Curry,
PhD, R. '32

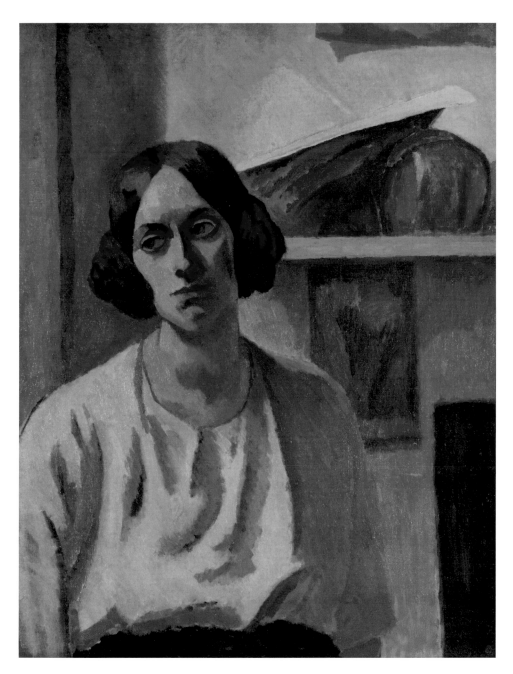

45
Roger Fry
British, 1866–1934
Head of a Model, 1913
Oil on board
34 × 28 inches
Private collection

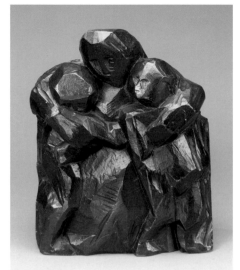

46
Roger Fry
British, 1866–1934
Group: Mother and Children, 1913
Wood
11⅛ × 9¼ × 4⅛ inches
Collection of the Art Gallery of
Ontario, Toronto. Purchase, 1987.

47
Roger Fry
British, 1866–1934
Portrait of Vanessa, ca. 1913
Pencil
19 × 15 inches
Private collection

48
Roger Fry
British, 1866–1934
Still Life, 1915
Watercolor and colored crayon
9½ × 13¾ inches
Collection of Mitch Bobkin

49
Roger Fry
British, 1866–1934
The Artist's Garden at Durbins, ca. 1915
Oil on canvas
18³⁄₈ × 29⁷⁄₈ inches
Collection of the Yale Center for British Art,
Paul Mellon Fund

Shown only at Ithaca and Evanston

50
Roger Fry
British, 1866–1934
Maynard Keynes, ca. 1916
Pen and ink on graph paper
8½ × 6½ inches
Private collection

51
Roger Fry
British, 1866–1934
Portrait of Lytton Strachey, 1917
Oil on canvas
17¾ × 15¾ inches
Collection of the
Harry Ransom Center,
The University of Texas at Austin

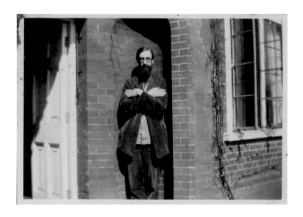

Lytton Strachey.
Courtesy of the Harvard
Theatre Collection,
Houghton Library,
Harvard University.

52
Roger Fry
British, 1866–1934
Clivia, 1917
Oil on canvas
41 × 30 inches
Private collection

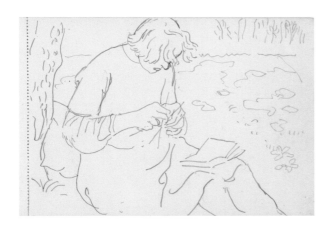

53
Roger Fry
British, 1866–1934
Pamela Knitting and Reading, 1918
Pencil
4½ × 6⅞ inches
Collection of Patricia and Donald Oresman

54
Roger Fry
British, 1866–1934
The Blue Bowl, ca. 1918
Oil on composition board
17⅛ × 22⁷⁄₁₆ inches
Collection of the Worcester Art Museum
Shown only at Evanston, Northampton, and University Park

55
Roger Fry
British, 1866–1934
Paper Flowers on a Mantelpiece, 1919
Oil on canvas on board
16½ × 20 inches
Collection of Bannon and Barnabas McHenry

56
Roger Fry
British, 1866–1934
Landscape and Hills,
ca. 1920
Oil on canvas
21 × 27 inches
Private collection

57
Roger Fry
British, 1866–1934
Lydia Lopokova, 1922
Oil on canvas
24¼ × 18 inches
Private collection

58
Roger Fry
British, 1866–1934
Bridge over River, France, ca. 1925
Oil on panel
12½ × 16 inches
Collection of the Speed Museum, Louisville, Kentucky
Gift from Wayne and Cheryl Smith to Bob Smith

59
Roger Fry
British, 1866–1934
French Market, 1926–29
Oil on canvas
24 × 34 inches
Collection of Anne and Allen Dick

60
Duncan Grant
British, 1885–1978
Sketchbook, ca. 1902
Pen, ink, pencil, and
watercolor
9 × 7 inches
Collection of Douglas
Blair Turnbaugh

61
Duncan Grant
British, 1885–1978
Virginia Woolf, 1911
Oil on millboard
22 × 16 inches
Collection of the
Metropolitan Museum
of Art. Purchase,
Lila Acheson Wallace
Gift, 1990. (1990.236)
Shown only at Ithaca

62
Duncan Grant
British, 1885–1978
Pamela, 1911
Oil on canvas
19½ × 29⁹⁄₁₆ inches
Collection of the Yale Center for
British Art, Paul Mellon Fund
Shown only at Ithaca and Evanston

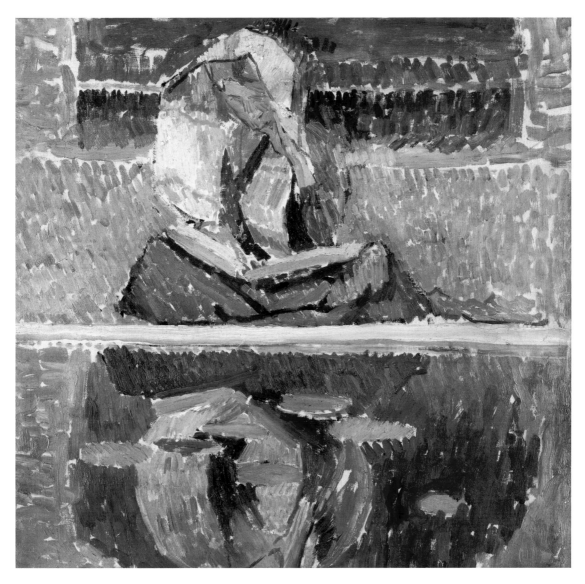

63
Duncan Grant
British, 1885–1978
Winifred Gill, ca. 1911–12
Oil on canvas
24 × 24 inches
Collection of the Fred Jones Jr.
Museum of Art, University of Oklahoma
Gift of Dr. Mark Allen Everett, 2005

64
Duncan Grant
British, 1885–1978
Leonard Woolf, ca. 1912
Oil on board
25⅜ × 20⅝ inches
Private collection

65
Duncan Grant
British, 1885–1978
Vanessa and Henri Doucet, ca. 1912–13
Oil on millboard
30 × 21 inches
Private collection

66
Duncan Grant
British, 1885–1978
Portrait of Vanessa Bell,
1912–14
Black chalk on two joined
sheets of paper
26½ × 23¼ inches
Collection of the Yale
Center for British Art,
Paul Mellon Fund

*Shown only at Northampton and
University Park*

67
Duncan Grant
British, 1885–1978
*Group at Asheham: Adrian Stephen, Virginia Woolf,
Vanessa Bell, and Henri Doucet*, 1913
Oil on board
10⅜ × 25 inches
Collection of Patricia and Donald Oresman

68
Duncan Grant
British, 1885–1978
Still Life at Asheham, 1914
Oil on canvas
24 × 29 inches
Private collection

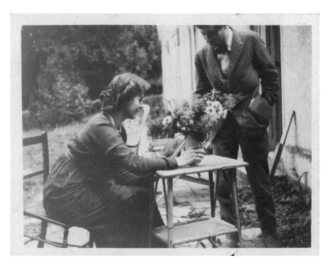

Duncan Grant and Vanessa
Bell arranging a still life at
Asheham, 1913–14. Courtesy
of the Harvard Theatre
Collection, Houghton
Library, Harvard University.

69
Duncan Grant
British, 1885–1978
Still Life with Salt-Glazed Pitcher, 1915
Oil on canvas
28¾ × 24½ inches
Collection of the Cornell Fine Arts Museum, Rollins College
Bequest of Kenneth Curry, PhD, R. '32

70
Duncan Grant
British, 1885–1978
In Memoriam:
Rupert Brooke, 1915
Oil and collage on panel
21 9/16 × 11 3/4 inches
Collection of the Yale
Center for British Art,
Paul Mellon Fund
Shown only at Durham

71
Duncan Grant
British, 1885–1978
Vanessa Bell Drawing
Pencil
13 × 16 inches
Collection of
Mary Ann Caws

72
Duncan Grant
British, 1885–1978
At Eleanor: Vanessa Bell, 1915
Oil on canvas
29 15/16 × 21 7/8 inches
Collection of the
Yale Center for British Art,
Paul Mellon Fund
Shown only at Ithaca

73
Duncan Grant
British, 1885–1978
Roger Fry, ca. 1915
Chalk
11 × 7½ inches
Private collection

74
Duncan Grant
British, 1885–1978
Fairground Figure in the Studio, 1917
Watercolor
18⅝ × 12½ inches
Private collection

75
Duncan Grant
British, 1885–1978
David Garnett Sleeping, 1918
Pencil
7¾ × 9¾ inches
Collection of Mitch Bobkin

76
Duncan Grant
British, 1885–1978
Woman with Ewer, 1918
Watercolor, pencil, and
tempera on printed paper
11¾ × 8¾ inches
Collection of the
Metropolitan Museum of
Art. Bequest of Scofield
Thayer, 1982. (1984.433.10)
Shown only at Ithaca

77
Duncan Grant
British, 1885–1978
Virginia Woolf, 1918
Pencil
11⅜ × 9½ inches
Private collection

78
Duncan Grant
British, 1885–1978
Self-Portrait, ca. 1918
10¾ × 9½ inches
Collection of the Art Gallery
of Ontario, Toronto. Gift of
Gary Michael Dault, 1998.

79
Duncan Grant
British, 1885–1978
Still Life with Decanter and Fruit Dish, ca. 1916–17
Watercolor
10 × 13½ inches
Private collection

80
Duncan Grant
British, 1885–1978
Vanessa Bell and Angelica Feeding Swans, ca. 1920
Pencil
9 × 12½ inches
Collection of Mary Ann Caws

81
Duncan Grant
British, 1885–1978
Cat, ca. 1920
Pencil
10¾ × 7 inches
Private collection

82
Duncan Grant
British, 1885–1978
Maynard in a Cap, ca. 1920
Pastel
12⅛ × 9 inches
Private collection

83
Duncan Grant
British, 1885–1978
Lydia Lopokova, 1920s
Pencil
10 × 8⅛ inches
Private collection

84
Duncan Grant
British, 1885–1978
Landscape Near St. Tropez, 1921–22
Oil on canvas
23½ × 27¾ inches
Private collection

85
Duncan Grant
British, 1885–1978
Female Nude Near Fireplace,
Arms and Legs Crossed, 1923
Pastel over pencil
18 × 11⅛ inches
Collection of the Art
Institute of Chicago
Gift of Robert Atherton,
1923.945
Shown only at Evanston

86
Duncan Grant
British, 1885–1978
Angus Davidson Sleeping, 1923
Charcoal and pencil
10½ × 18 inches
Collection of Mitch Bobkin

87
Duncan Grant
British, 1885–1978
Mina Kirstein Curtiss, ca. 1924
Charcoal and red chalk
24½ × 21⅞ inches
Collection of the Herbert F. Johnson Museum of Art,
Cornell University. Ruth and Meyer Abrams Fund.

David Garnett.

88
Duncan Grant
British, 1885–1978
David Garnett, 1925
Pastel
20 × 12¾ inches
Collection of
Mitch Bobkin

89
Duncan Grant
British, 1885–1978
Self-Portrait
Oil on canvas
29½ × 19¾ inches
Collection of Mills College Art Museum
Bequest of Carolyn G. Heilbrun

90
Duncan Grant
British, 1885–1978
Reclining Nude (recto) and
Standing Woman with Flowers
(verso), 1927
Watercolor, ink, and wash
5¾ × 8⅜ inches
Collection of Susan Chaires

91
Duncan Grant
British, 1885–1978
*The Pond at Charleston, Looking
towards Tilton*, ca. 1920s
Pencil
12 3/8 × 18 7/8 inches
Collection of Susan Chaires

92
Duncan Grant
British, 1885–1978
Two Nudes on a Beach, 1928–32
Oil on panel
42 × 27 inches
Collection of the Yale Center for British Art
Gift of Joseph F. McCrindle

93
Duncan Grant
British, 1885–1978
Lytton Strachey, ca. 1930
Pencil
14 × 10 inches
Private collection

94
Duncan Grant
British, 1885–1978
*Pond and Barns at
Charleston*, ca. 1930
Oil on canvas
20 × 24 inches
Collection of Dean
Malone and Dr. Richard
Purvis, Louisville, KY

95
Duncan Grant
British, 1885–1978
Shell Poster: St. Ives, Huntingdon, 1932
Color lithograph
28 × 42½ inches
Private collection

97
Duncan Grant
British, 1885–1978
The Artist's Cat at Charleston, ca. 1935
Oil and pencil on paper
14 × 18 inches
Private collection

96
Duncan Grant
British, 1885–1978
Farmer in a Field, Near Charleston, 1934
Watercolor
31½ × 17½ inches
Collection of Mitch Bobkin

98
Duncan Grant
British, 1885–1978
Design for "The Sheaf" decoration for the Queen Mary, 1936
Oil on board
95⅝ × 56½ inches
Collection of the Wolfsonian–Florida International University

Shown only at Durham and Ithaca

99
Duncan Grant
British, 1885–1978
Cymbal Player for the Queen Mary, 1937
Oil on canvas
130 × 68 inches
Private collection

100
Duncan Grant
British, 1885–1978
L'atelier du Jardin de Renoir, 1937
Pencil
23 × 19¹³⁄₁₆ inches
Collection of the Herbert F. Johnson
Museum of Art, Cornell University
Gift of Joyce and Robert Evans,
Classes of 1959 and 1958

101
Duncan Grant
British, 1885–1978
Card Player
Watercolor and pencil
11 × 8¾ inches
Collection of the Smith College Museum
of Art, Northampton, Massachusetts
Gift of Mrs. Henry Tomlinson Curtiss
(Mina Kirstein, class of 1918)

102
Duncan Grant
British, 1885–1978
Seated Figure Reading, ca. 1940s
Pencil
16 × 14 inches
Collection of Mary Ann Caws

103
Duncan Grant
British, 1885–1978
Helen Anrep at Charleston, 1942
Oil on canvas
16 × 32 inches
Private collection

104
Duncan Grant
British, 1885–1978
Cat, 1948
Color lithograph
9³⁄₄ × 13 inches
Private collection

105
Duncan Grant
British, 1885–1978
Standing Nude Male, 1950
Watercolor, gouache, and charcoal
22 × 11¹⁄₂ inches
Collection of Douglas Blair Turnbaugh

106
Duncan Grant
British, 1885–1978
*Fanny Garnett Reading in the
Garden at Charleston*, 1950s
Oil on board
28½ × 22 inches
Collection of Anne and
Allen Dick

107
Duncan Grant
British, 1885–1978
Artist's Study at Charleston, 1967
Oil on paper, mounted on masonite
31½ × 23⅜ inches
Collection of the Metropolitan Museum of Art. Gift of Arthur W. Cohen, 1985. (1985.36.2)
Shown only at Ithaca

108
Duncan Grant
British, 1885–1978
The Matisse Poster, 1971
Oil on paper
20 × 14 inches
Private collection
Shown only at Evanston and Northampton

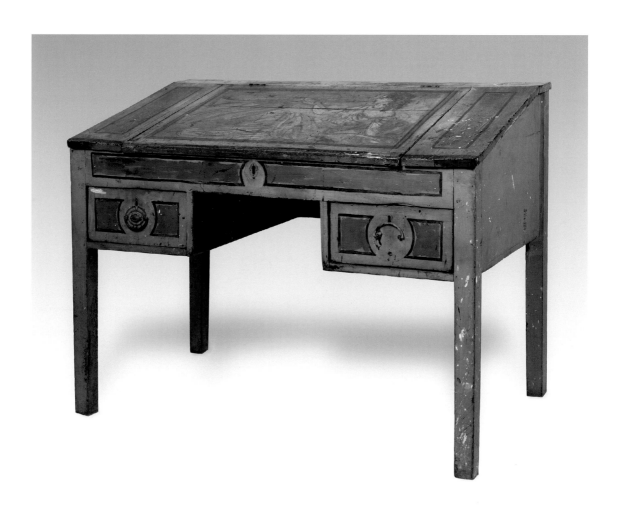

109
Quentin Bell, decorator
1910–1996
Virginia Woolf's Desk, ca. 1911;
painted ca. 1929
Painted wood
26½ × 49½ × 34½ inches
Private collection

Shown only at Ithaca

110
Vanessa Bell
British, 1879–1961
*Design for a screen:
Figures by a Lake*, ca. 1912
Gouache on board
9¾ × 17¼ inches
Collection of BNY Mellon
*Shown only at Northampton and
University Park*

111
Vanessa Bell, designer
British, 1879–1961
*Maud I for the Omega
Workshops*, 1913
Linen
10 × 15 inches
Collection of the
Wolfsonian–Florida
International University
Shown only at Durham and Ithaca

112
Vanessa Bell
British, 1879–1961
Shutters, ca. 1917
Painted wood
51 × 41½ inches, each
Private collection

113
Vanessa Bell, designer
British, 1879–1961
Printed textile, 1931–32
Linen
15 × 72 inches
Private collection

Duncan Grant and
Vanessa Bell, music room
installed at Alex Reid
and Lefevre Gallery, 1932,
as illustrated in Derek
Patmore, *Colour Schemes for
the Modern Home*, 1933

114
Vanessa Bell
British, 1879–1961
Design for chair-seat, 1922
Watercolor
14¾ × 15¾ inches
Collection of Bannon and
Barnabas McHenry

115
Vanessa Bell
British, 1879–1961
Design for an embroidered stool
Gouache
10¾ × 30⅝ inches
Collection of the Yale Center for British Art, Paul Mellon Fund
Shown only at Northampton and University Park

116
Vanessa Bell
British, 1879–1961
*Stage set design for Lytton
Strachey's* A Son of Heaven,
ca. 1925
Gouache
12 × 19½ inches
Collection of the Victoria
University Library, Toronto

117
Vanessa Bell
British, 1879–1961
*Design for an embroidered
mirror surround*, ca. 1928
Gouache
14⅝ × 10 inches
Private collection

118
Vanessa Bell
British, 1879–1961
Design for embroidered chair seat: Flowers, 1930
Oil and charcoal on paper
21⅝ × 25⅞ inches
Private collection

119
Vanessa Bell, designer
British, 1879–1961
*Dinner plate and server
manufactured by
Clarice Cliff*, 1932–34
Painted ceramic
Plate diameter: 10 inches
Server: 12 × 9¾ inch, oval
Private collection

120
Vanessa Bell, designer
British, 1879–1961
Plate, ca. 1930s
Earthenware
Diameter: 6⅜ inches
Collection of the Milwaukee Art Museum
Gift of Daniel Morris and Denis Gallion

121
Vanessa Bell
British, 1879–1961
Two Flowers: Tile design for Ethel Sands, ca. 1930s
Gouache
5¾ × 5⅞ inches
Private collection

122
Vanessa Bell, designer
British, 1879–1961
Duncan Grant, designer
British, 1885–1978
*Table with tiles from Virginia
Woolf's table at Monk's House*,
1930s (tiles), 1990s (table)
Hand-painted ceramic tiles
37¾ × 37¾ × 31 inches
Private collection

123
Vanessa Bell
British, 1879–1961
Decorative design "Cat," 1930s
Gouache on board
Diameter: 22 inches
Private collection

124
Vanessa Bell
British, 1879–1961
Tabletop design, 1930s
Oil on paper
Diameter: 29½ inches
Private collection

125
Vanessa Bell
British, 1879–1961
Decorative design with urn, ca. 1933
Watercolor
23 × 23 inches
Private collection

126
Vanessa Bell
British, 1879–1961
Design for furnishing fabric, ca. 1946
Oil and pencil
15 × 18 inches
Collection of Janice and Roger Oresman
Shown only at Durham, Ithaca, and Northampton

127
Dora Carrington
British, 1893–1932
Design for stationery, Ham Spray House, ca. 1930
3½ × 4½ inches
Private collection

Carrington, Ralph Partridge, and Lytton Strachey at Ham Spray.
Courtesy of the National Portrait Gallery, London.

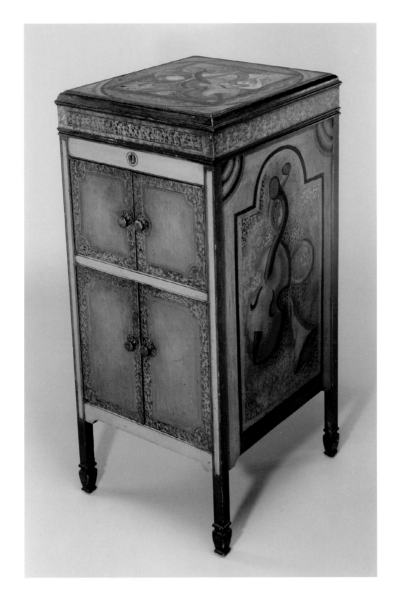

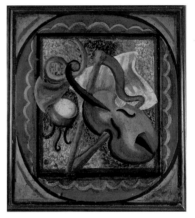

128
Douglas Davidson
British, ca. 1896–1960
Decorated gramophone cabinet, 1930s
Painted wood
20½ × 18½ × 40½ inches
Private collection

Douglas Davidson and his brother
Angus became close friends with
Duncan Grant in the early 1920s,
and remained on the periphery of
Bloomsbury. Douglas's embroidery
and painted furniture were exhibited
and publicized alongside work by
the Bloomsbury artists.

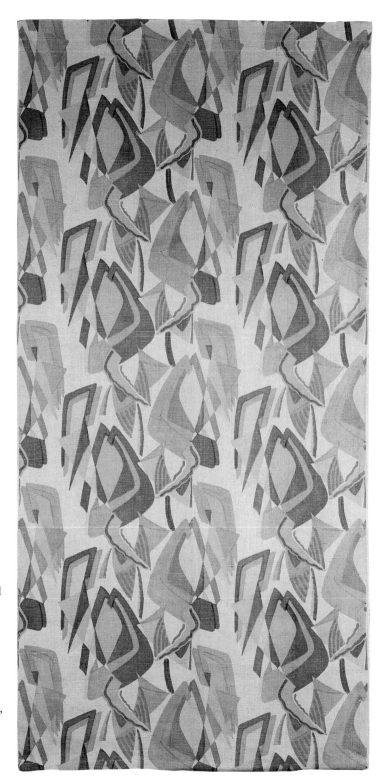

129
Design attributed to
Frederick Etchells
British, 1886–1973
*Curtains for the Omega
Workshops*, ca. 1913
Hand-screened linen
59 × 28½ inches, each panel
Private collection

Etchells participated very
actively in the Omega
Workshops in 1913, before
leaving to join its short-
lived rival, the Rebel Arts
Center. After World War I,
he turned to publishing
and is today best known as
the English translator of
the architect Le Corbusier.

130
Roger Fry, designer
British, 1866–1934
*Amenophis III for the
Omega Workshops*, 1913
Linen
10 × 15 inches
Collection of the
Wolfsonian–Florida
International University
Shown only at Durham and Ithaca

131
Roger Fry, designer
British, 1866–1934
*Mechtilde I for the
Omega Workshops*, 1913
Linen
10 × 15 inches
Collection of the
Wolfsonian–Florida
International University
Shown only at Durham and Ithaca

132
Duncan Grant
British, 1885–1978
Design for a fire screen, 1912
Watercolor and gouache and collage
29 × 23¾ inches
Private collection
Shown only at Ithaca and Northampton

133
Duncan Grant
British, 1885–1978
Box with reclining figure for the Omega Workshops, 1913
Painted wooden box
3¼ × 13¼ × 5¼ inches
Collection of the Wolfsonian–Florida International University
Shown only at Durham and Ithaca

134
Duncan Grant, designer
British, 1885–1978
Margery VI for the Omega Workshops, 1913
Linen
10 × 15 inches
Collection of the Wolfsonian–Florida International University
Shown only at Durham and Ithaca

135
Duncan Grant, designer
British, 1885–1978
Pamela for the Omega Workshops, 1913
Linen
10 × 15 inches
Collection of the Wolfsonian–Florida International University

Shown only at Durham and Ithaca

136
Duncan Grant
British, 1885–1978
Design for an Omega Christmas card, 1913
Pen and ink over pencil
7⅞ × 10 inches
Collection of the Art Gallery of Ontario, Toronto. Purchase, 1987.

137
Duncan Grant
British, 1885–1978
Box with abstract design for the Omega Workshops, ca. 1913
Polychrome painted wooden box
3 × 12½ × 4⅜ inches
Collection of the Wolfsonian–Florida International University

Shown only at Durham and Ithaca

138
Duncan Grant
British, 1885–1978
Design for Lilypond Table, 1913–14
Oil on colored paper
18 × 24¼ inches
Collection of Bannon and Barnabas McHenry

139
Duncan Grant
Decorative Design, 1916–17
Oil on paper
24⅝ × 18⅛ inches
Private collection
Shown only at Ithaca and Northampton

140
Duncan Grant, designer
British, 1885–1978
Embroidered bell pull, 1924–43
Worsted wool on canvas
worked by Ethel Grant,
the artist's mother
73 × 3¾ inches
Collection of Roy and
Cecily Langdale Davis

141
Duncan Grant
British, 1885–1978
Design for Famous Woman
*dinner service: Elizabeth
Tudor*, ca. 1932
Watercolor
Plate diameter: 9½ inches
Private collection

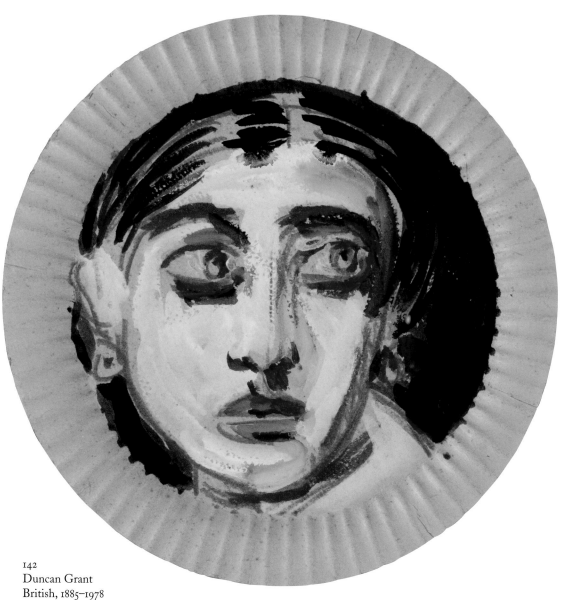

142
Duncan Grant
British, 1885–1978
Plate Design I, ca. 1932
Watercolor on paper plate
Plate diameter: 9½ inches
Private collection

143
Duncan Grant, designer
British, 1885–1978
Plate manufactured by Clarice Cliff, 1932–34
Painted ceramic dinner plate
Diameter: 10⅛ inches
Private collection

144
Duncan Grant
British, 1885–1978
Carpet design, 1930s
Oil on paper
21½ × 26 inches
Private collection

145
Duncan Grant, designer
British, 1885–1978
Floral Carpet, probably manufactured by Wilton,
ca. 1935
Woven wool
124 × 143 inches
Private collection

146
Duncan Grant
British, 1885–1978
Apollo, ca. 1936
Oil on paper
36 × 22 inches
Private collection

147
Duncan Grant
British, 1885–1978
Daphne, ca. 1936
Oil on paper
36 × 22 inches
Private collection

148
Duncan Grant
British, 1885–1978
Panel with Apollo and Daphne *design*, 1935–36
Silkscreen-printed rayon
117 × 48¼ inches
Collection of the Cleveland Museum of Art,
Dudley P. Allen Fund
Shown only at Ithaca and University Park

149
Duncan Grant, designer
British, 1885–1978
Fabric for the
Queen Mary, 1937
Cotton velveteen
76 × 47 inches, framed
Private collection

150
Duncan Grant
British, 1885–1978
Design for a carpet
Gouache
18½ × 22 inches
Private collection

151
Duncan Grant
British, 1885–1978
Design for an embroidery, ca. 1930s
Diameter: 27½ inches
Private collection

152
Duncan Grant
British, 1885–1978
Fabric design
22 × 29 inches
Private collection

153
Duncan Grant, designer
British, 1885–1978
Panel with Dove *design*,
1937–38
Silkscreen-printed rayon
104½ × 49 inches
Collection of the
Cleveland Museum of Art,
Dudley P. Allen Fund, 1938

Shown only at Ithaca and
University Park

154
Duncan Grant
British, 1885–1978
Summer, ca. 1940
Etched glass manufactured by Corning Glass Works,
Steuben Division, New York
Height: 11⅜ inches
Collection of the Metropolitan Museum of Art
Gift of Udo M. Reinach, 1959 (59.136.4)
Shown only at Ithaca

155
Duncan Grant
British, 1885–1978
Scenery design for John Blow's Opera
Venus and Adonis, ca. 1956
Collage and oil on paper
28¾ × 47½ inches
Private collection

156–158
Wyndham Lewis, designer
British, 1882–1957
*Lampshade designs for the
Omega Workshops*, 1913
Pen and ink
Collection of the
Wolfsonian–Florida
International University
Shown only at Durham and Ithaca

Lewis particpated in the
Omega Workshops in 1913
until he led a defection of
some of the artists, who
formed the Rebel Arts
Center. As a leader of the
avant-garde contingent
calling itself the Vorticists,
Lewis promoted himself
and his allies as more
radical than Bloomsbury.

156. "Circus Performers," 5¼ × 11⅛ inches.

157. "Gentlemen in Plaid Suits," 5¼ × 9⅛ inches.

158. "Seated Woman and Dog," 5¼ × 9⅛ inches.

159
Omega Workshops Ltd, artist decorators
London: Omega Workshops, 1914
8½ × 5½ inches
Collection of the Victoria University Library,
Toronto

Roger Fry letter to Mary Hutchinson about the Omega
Club, February 14, 1917. Collection of the Harry Ransom
Center, The University of Texas at Austin.

160
Omega Workshops (1913–19)
Fruit bowl, ca. 1917–18
Earthenware with cobalt blue glaze
Diameter: 8⅛ inches
Collection of Jasper Johns

161
Omega Workshops (1913–19)
Dessert plate, ca. 1914–16
Earthenware with cobalt
blue glaze
Diameter: 10 inches
Collection of Jasper Johns

162
Omega Workshops (1913–19)
Side plate, ca. 1914–16
Earthenware with cobalt
blue glaze
Diameter: 8 inches
Collection of Jasper Johns

163
Omega Workshops (1913–19)
Dinner Plate, ca. 1914–16
Earthenware with white tin glaze
Diameter: 12 inches
Collection of Jasper Johns

164
Omega Workshops (1913–19)
Soup plate, ca. 1914–16
Earthenware with white tin glaze
Diameter: 11½ inches
Collection of Jasper Johns

165
Omega Workshops (1913–19)
Side plate
Earthenware with blue glaze
Diameter: 7¾ inches
Collection of Bannon and
Barnabas McHenry

166
Autumn announcements
with an illustration by
Vanessa Bell, 1924
The Hogarth Press, London
10½ × 8⅜ inches
Collection of the Victoria
University Library, Toronto

167
Vanessa Bell
British, 1879–1961
Figure in a Rocker, 1921
Woodcut
4 × 6¼ inches
Collection of Mitch Bobkin

168
Vanessa Bell
British, 1879–1961
Monday or Tuesday,
1921
Four woodcut illus-
trations: *The String
Quartet*, *A Haunted
House*, *A Society*, and
An Unwritten Novel
5½ × 4 inches, each
Collection of
Mitch Bobkin

169
Vanessa Bell, designer
British, 1879–1961
Cover for *Henry James at Work*
by Theodora Bosanquet, 1924
The Hogarth Press, London
8½ × 5½ inches
Collection of the Victoria University Library,
Toronto

170
Vanessa Bell, designer
British, 1879–1961
Cover for *Mr. Bennett and Mrs. Brown*
by Virginia Woolf, 1924
The Hogarth Press, London
8½ × 5⅜ inches
Collection of the Mortimer Rare Book Room,
Neilson Library, Smith College, Northampton,
Massachusetts. Presented by the Estate of
Frances Hopper, Class of 1914.

171
Vanessa Bell
British, 1879–1961
Dust jacket design for *Mrs. Dalloway*, 1925
Watercolor
13⅜ × 10 inches
Collection of the Victoria University Library, Toronto

172
Vanessa Bell
British, 1879–1961
Dust jacket design for *The Common Reader*, 1925
Watercolor
8 × 5¼ inches
Collection of the Mortimer Rare Book Room,
Neilson Library, Smith College,
Northampton, Massachusetts
Gift of Ann Safford Mandel, class of 1953

173
Vanessa Bell
British, 1879–1961
Illustration for *Emlycaunt* by Julia Stephen
Watercolor, pen, and ink
10 × 8 inches
Collection of the Mortimer Rare Book Room,
Neilson Library, Smith College, Northampton,
Massachusetts. Gift of Elizabeth P. Richardson,
Class of 1943.

174
Vanessa Bell
British, 1879–1961
Dust jacket design for *A Room of One's Own*, 1929
Pencil
8 × 6⅜ inches
Collection of Patricia and Donald Oresman

175
Vanessa Bell
British, 1879–1961
Elizabeth Barrett Browning, drawing for
Flush, ca. 1933
Pencil
7 × 4½ inches
Collection of Patricia and Donald Oresman

176
Vanessa Bell
British, 1879–1961
Drawings for *Flush*,
ca. 1933
Two-page layout:
(left) *Elizabeth
Browning in bed with
view out window*
(right) *Closer up, sitting
up in bed, features
indistinguishable*
(additional sketches
on the reverse)
Pencil
7 × 9 inches
Collection of the
Mortimer Rare
Book Room, Neilson
Library, Smith
College, Northampton,
Massachusetts
McConnell-Bohning &
Richardson Funds

177
Vanessa Bell
British, 1879–1961
Drawings for *Flush*,
ca. 1933
Two-page layout:
(left) *Elizabeth
Browning looking out
a window*
(right) *Sketch of her read-
ing in bed, from behind*
(additional sketches
on the reverse)
Pencil
7 × 9 inches
Collection of the
Mortimer Rare
Book Room, Neilson
Library, Smith
College, Northampton,
Massachusetts
Gift of John Lancaster
in memory of
Ruth Mortimer '53

178
Vanessa Bell
British, 1879–1961
*View of Elizabeth Browning in daybed, in room
interior with sculpture busts over the mantelpiece*,
drawing for *Flush*, ca. 1933
Pencil
7 × 4⅜ inches
Collection of the Mortimer Rare Book
Room, Neilson Library, Smith College,
Northampton, Massachusetts
McConnell-Bohning & Richardson Funds

179
Dora Carrington
British, 1893–1932
Portfolio of Woodcuts for Bookplates, 1915–20
Twenty woodcuts, various dimensions
Collection of the Harry Ransom Center,
The University of Texas at Austin

180
T. S. Eliot
American, 1888–1965
The Waste Land, 1923
The Hogarth Press, London
9 × 5¾ inches
Collection of the Victoria
University Library, Toronto

181
Roger Fry
British, 1866–1934
"The Novel" from *Twelve Original Woodcuts*, 1921
The Hogarth Press, London
9 × 6⅜ inches
Collection of the Wolfsonian–Florida International University
Shown only at Durham and Ithaca

182
Duncan Grant
British, 1885–1978
Cover design for *Fanfare Magazine*, 1921
Crayon and watercolor
17½ × 14 inches
Collection of Peter Stansky

Nurse Lugton was asleep
She had given one great snore
She had dropped her head;
Thrust her spectacles up her
forehead; and there she sat by
the fender with her finger
sticking up and a thimble
on it; and her needle
full of cotton hang
ing down; and
she was
snoring, snoring,
and on her
knees, covering
the whole of
her apron
was a large
piece of
figured blue
stuff.

183
Duncan Grant
British, 1885–1978
Nurse Lugton was asleep
Pen and ink with text
8¹⁵⁄₁₆ × 7 inches
Collection of the Victoria University Library, Toronto

184
The story of the League of Nations: told for young people,
by Kathleen Elizabeth Royds Innes, 1925
The Hogarth Press, London
7¼ × 4⅞ inches
Collection of the Victoria University Library, Toronto

185
E. McKnight Kauffer
American, 1890–1954
Dust jacket for *Quack! Quack!* by Leonard Woolf, 1937
Photo collage
7⅜ × 5¹⁄₁₆ inches
Collection of the Victoria University Library, Toronto

With bookplate for Lytton Strachey
by Carrington, ca. 1925

186
Virginia Woolf
British, 1879–1941
Kew Gardens, 1919, with woodcuts by Vanessa Bell
The Hogarth Press, London
First edition, 150 copies printed
9 × 5¾ inches
Collection of the Mortimer Rare Book Room,
Neilson Library, Smith College, Northampton, Massachusetts
Gift of Ann Safford Mandel, class of 1953

187
Virginia Woolf
British, 1879–1941
The Years, 1937, with dust jacket designed by Vanessa Bell
The Hogarth Press, London
First edition
7⅜ × 5 inches
Collection of Mitch Bobkin

188
Vanessa Bell
British, 1879–1961
Floral design calendar,
1949
Watercolor
8 × 4 inches
The Henry W.
and Albert A. Berg
Collection. The New
York Public Library,
Astor, Lenox, and
Tilden Foundations.

Shown only at Ithaca

JANUARY	·		1950			
Sun.	.	1	8	15	22	29
Mon.	.	2	9	16	23	30
Tues.	.	3	10	17	24	31
Wed.	.	4	11	18	25	..
Thur.	.	5	12	19	26	..
Fri.	.	6	13	20	27	..
Sat.	.	7	14	21	28	..

189
Vanessa Bell
British, 1879–1961
*Kneeling nude design
calendar*, 1950
Watercolor
8½ × 5½ inches
The Henry W.
and Albert A. Berg
Collection. The New
York Public Library,
Astor, Lenox, and
Tilden Foundations.
Shown only at Ithaca

190
Vanessa Bell
British, 1879–1961
Floral design calendar, 1953
5 × 8 inches
The Henry W. and Albert A. Berg Collection.
The New York Public Library, Astor, Lenox,
and Tilden Foundations.

Shown only at Ithaca

191
Vanessa Bell
British, 1879–1961
Curtain design calendar,
1955
8½ × 8½ inches
The Henry W. and
Albert A. Berg Collection.
The New York Public
Library, Astor, Lenox,
and Tilden Foundations.
Shown only at Ithaca

192
Vanessa Bell
British, 1879–1961
Floral design calendar
4 × 6 inches
The Henry W. and Albert A. Berg
Collection. The New York Public
Library, Astor, Lenox, and Tilden
Foundations.
Shown only at Ithaca

194
Dora Carrington
British, 1893–1932
Bookplate for St. John Hutchinson, 1918
3½ × 3 inches
Collection of Bannon and Barnabas McHenry

193
Dora Carrington
British, 1893–1932
Bookplate for F, 1917
4¾ × 3 inches
Collection of Bannon and Barnabas McHenry

195
Dora Carrington
1893–1932
Honey Label Design for David Garnett, 1917
Two-color woodcut
2 × 2⅞ inches
Collection of Bannon and Barnabas McHenry

196
Duncan Grant
British, 1885–1978
Study for a Bookplate for Adrian Stephen, ca. 1911
Pen, ink, and gouache
7⅝ × 4¾ inches
Collection of the Victoria University Library, Toronto

197
Duncan Grant
British, 1885–1978
Abstract Design Bookmark, 1948
Watercolor
8 × 3 inches
The Henry W. and Albert A. Berg
Collection. The New York Public Library,
Astor, Lenox, and Tilden Foundations.
Shown only at Ithaca

198
Duncan Grant
British, 1885–1978
Floral Bookmark, 1953
Watercolor
7 × 2 inches
The Henry W. and Albert A. Berg
Collection. The New York Public Library,
Astor, Lenox, and Tilden Foundations.
Shown only at Ithaca

199
Duncan Grant
British, 1885–1978
Regenitalization, 1960s
Oil on magazine cover
7 × 5¼ inches
Collection of Douglas Blair Turnbaugh

200
Charles John Holmes
British, 1868–1936
Notes on the Post-Impressionist Painters: Grafton Galleries, 1910–11, 1910
Philip Lee Warner, London
8¹⁄₁₆ × 5³⁄₈ inches
Collection of the Victoria University Library, Toronto